THE LIBRARY OF GREAT PAINTERS

TOULOUSE-LAUTREC

Painted in 1895, Paris
AT THE MOULIN ROUGE:
THE CLOWNESSE CHA-U-KAO
29 1/2 × 21 5/8"
Collection Dr. Oskar Reinhart, Winterthur, Switzerland

Virtually nothing is known about the woman in the foreground of the present picture except that she was one of the dancers at the Moulin Rouge. She appears here dressed as a *clownesse*, a costume which she seems to have been in the habit of wearing. For some reason – perhaps connected with his study of Lesbians – this girl caught Lautrec's eye in 1895 and he at once painted four pictures of her. One (Collection William Powell Jones, Gates Mills, Ohio) is a study for this picture and must have been posed in the studio.

After 1896, Lautrec ceased to frequent the Moulin Rouge and this seems to be his last painting inspired by the types who frequented that music-hall. On the left, walking arm-in-arm with the *clownesse*, is Gabrielle la Danseuse who served him as model for several paintings in 1890–1891; behind Cha-U-Kao and to the right is Tristan Bernard (page 125). If we set this picture beside *The Dance* (page 89), *La Goulue Entering the Moulin Rouge* (page 95), *At the Moulin Rouge* (page 97), *Preparing For the Quadrille* (page 99) and *Between Two Waltzes: La Goulue* (1891; Collection Bernheim) we can see how cunning Lautrec was at devising pictorial formulas for conveying the characteristics of the different elements which made up the public at the Moulin Rouge. Everything is said in terms of dress, stance, gesture, and facial expression; that is to say, purely in pictorial terms.

Almost two years later, in 1897, Lautrec made a colored lithograph after this painting and a comparison of the two reveals a great deal about his manner of working. When they are placed side by side we can see how strong was his instinctive understanding of the technical differences between the two media. Where the painting is elaborate and replete with descriptive details, the color subdued and based on subtle tonal nuances, the lithograph has boldly simplified forms, large areas of strong color, almost no detail, and the minimum of depth and modeling. The more one studies Lautrec's paintings the more one realizes that the colors in them are dull by comparison with those he employed in colored lithographs and above all in posters.

Henri de

TOULOUSE-
LAUTREC

Text by

DOUGLAS COOPER

THE LIBRARY OF GREAT PAINTERS

HARRY N. ABRAMS, INC. *Publishers* NEW YORK

Standard Book Number: 8109-0512-4

Library of Congress Catalog Card Number: 66-19657

TABLE OF CONTENTS

TOULOUSE-LAUTREC

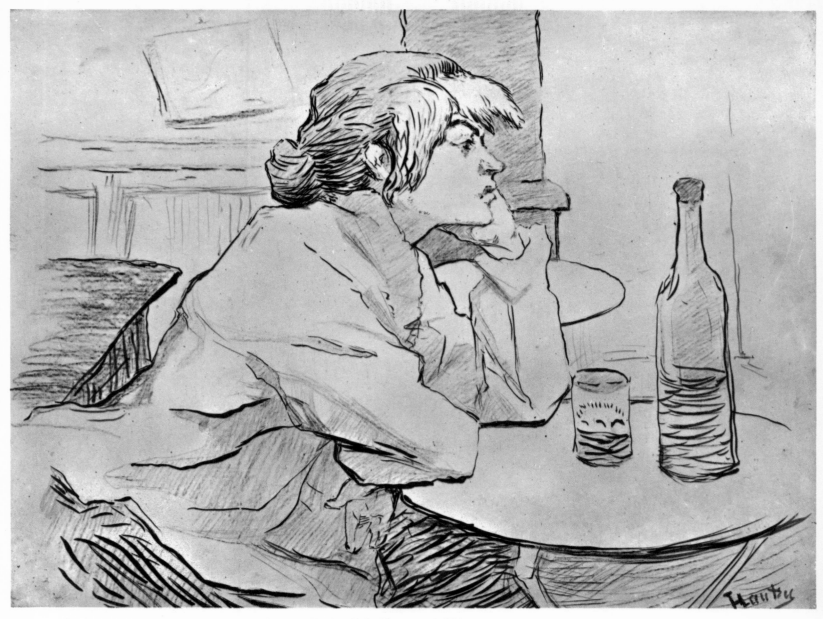

THE MORNING AFTER. 1889. Indian ink and blue chalk, 18⁷/₈ × 24³/₄". *Museum of Albi*

H. d Toulouse Lautrec

Henri de Toulouse-Lautrec is one of the stranger figures in the galaxy of great French artists. Of noble birth, rich, mischievous, dissolute, and a dwarf: his characteristics are not those which one readily associates with the creation of great art. And yet it was this curious combination of personal characteristics which provided the mainspring of his artistic urge. Thus any serious study of Lautrec's work must begin with an elucidation of his personality.

Lautrec was descended on his father's side from the semi-royal Counts of Toulouse; that is to say, he came of a family which could trace its ancestry back, without a

break, to the time of Charlemagne. His ancestors had been, for the most part, noted as brilliant soldiers (incidentally, Lafayette was the painter's great uncle), able administrators, or faithful courtiers, but at the beginning of the nineteenth century an artistic strain showed signs of developing in the family as well. This strain seems to have originated with Henri's great-grandfather, Count Alphonse de Toulouse-Lautrec the First – several of whose drawings and pastels are still extant – and within two generations most of his descendants had taken to drawing as part of their daily routine. In her recent book *Notre Oncle Lautrec* (Geneva, 1953), **Mary Tapié**

de Céleyran, a distant cousin of the painter, has provided a fascinating glimpse of the family circle in which Henri de Toulouse-Lautrec grew up and has shown how, from earliest youth, his artistic talent had every opportunity to manifest itself. "Everyone rode, men and women alike," she writes, "everyone went shooting or fishing, and in the evening when the lamps were lit, the talk was still inclined to be of sport rather than of literature. But they all drew.... And Henri's grandmother, Gabrielle de Toulouse-Lautrec, used to say, laughing: 'If my sons kill a gamebird, it provides them with three pleasures: shooting, eating, and drawing it.' Henri conformed to this heredity, and with his tiny hand he traced circles and lines which before long began to assume lifelike forms. His figures, though clumsy, were already full of that humor which was to be the essence of his talent, for he observed everything with a keen eye and was passionately interested in watching his father and uncles amusing themselves by drawing or modeling in clay."

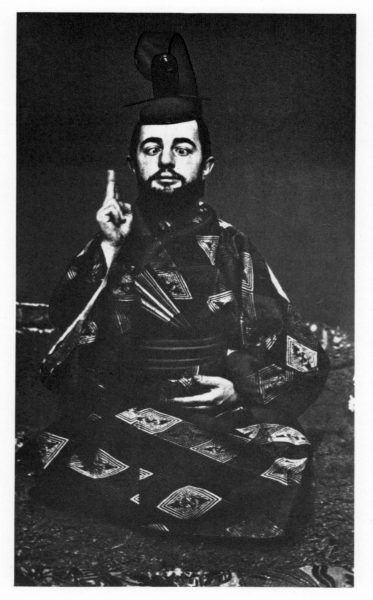

LAUTREC IN JAPANESE SAMURAI COSTUME. c. 1892
Photograph by M. Guibert. *Collection Bibliothèque Nationale, Paris*

Now, this family background was to prove an inestimable advantage to Lautrec. For when, ultimately, he decided to devote his life to art he did not first have to overcome the opposition of his parents, nor, since they were rich, was he forthwith plunged into poverty. Admittedly he had to give proof of his talents before his father could be induced to pay a proper allowance to a son who, through incomprehension, he tended to look upon as "an outsider." Yet he was never cut off and it is important to realize that at no time was Lautrec ever dependent for his living on commercial success. In these respects he was more favored than any of his great contemporaries, with the exception of Cézanne and Degas.

Lautrec inherited the eccentric and mischievous traits in his character from his father — Count Alphonse the Second — whose eccentricities are almost legendary. But whereas his father's habits were apt to be outrageous and often caused embarrassment to his friends and relatives, his son, who had considerable charm, always remained within the limits of practical joking and was everywhere welcomed with affection. Count Alphonse dressed in the most singular fashion, half-warlike and half-sporting. He might be seen in a Buffalo Bill hat and a coat of mail, or attired as a Kirghiz horseman; almost inevitably Red Indian or Japanese weapons would be among his accoutrements. Even his horse was apt to be equipped with a Cossack saddle and harness. Another of his habits was to milk his mare during a ride in the Bois de Boulogne, drink a cup of the milk and then continue his ride unabashed. On one occasion too he was discovered by his servants in the middle of the night, with a lighted candle in one hand and a hatbox in the other, looking for mushrooms in the garden. Nothing so extreme is recorded of his son, although he too had a passion for dressing up, and photographs exist of him disguised as a choirboy, a Samurai, and a Pierrot, as well as in female attire. Evidence is not lacking of Lautrec's exhibitionist tendencies, and we have not fully comprehended his art until we have recognized that a mischievous sense of fun is one of its prominent characteristics. Lautrec did not hesitate to make fun of anyone, as some of his drawings of Yvette Guilbert and of his lanky cousin, Gabriel Tapié de Céleyran, testify. But he was equally remorseless in portraying himself, as we can see from the many drawings and lithographs which contain half-cruel, half-witty self-caricatures. Sometimes too his mockery was directed against his father — for whom in fact he had a considerable respect — as in the drawing of 1889 where he appears naked except for a bowler-hat, or in the lithograph of 1893 called *At the Moulin Rouge: A Boor! A Real Boor!* (page 12), where Count Alphonse, again wearing a bowler-hat, is seen gobbling a sandwich. Lautrec cultivated his sense of fun in public for practical reasons. Chief among these was a desire to compensate for and distract atten-

tion from his deformed and unlovely appearance, which should perhaps be described as grotesque rather than ugly. He was not born a dwarf, but became one through misfortune. As a result of two accidents in childhood, both his legs, which were broken, stopped growing, while the remainder of his body developed normally. He was therefore grotesquely ill-proportioned, measured only four feet six inches in height and, owing to the weakness of his little legs, needed a cane to help support the weight of his body. In addition he had a largish head with heavy eyebrows, a large nose, "thick, flabby, purple lips," a short and bushy black beard, and two large but friendly eyes staring out from behind pince-nez.

Lautrec was as conscious of his abnormal appearance as any court dwarf, and his sensibility was quickly wounded by adverse comments. Yvette Guilbert recounts in her memoirs that on one occasion she was taking him to task for having "distorted" her appearance unmercifully when she carelessly added: "Really, Henri, you're a genius at distorting!" "In a voice as sharp-edged as a knife," she says, "he rounded on me with his answer: 'But – naturally!'" Lautrec himself might laugh at his appearance or even exploit his deformity, but he never allowed himself to become a subject of general merriment, because he was haunted by the idea of being a misfit. After his accidents, his inability to continue riding and

CARICATURE OF GABRIEL TAPIÉ DE CÉLEYRAN. 1894. Ink, 13 × 8 5/8".
Museum of Albi

QUICK SKETCH OF YVETTE GUILBERT. 1893. Chalk, 6 7/8 × 5 5/8".
Sketchbook, Print Room, Louvre, Paris

indulging in sporting activities of all kinds meant that he could no longer take part in the life of his father and his other relatives. And so, when he ceased to be a companion, Count Alphonse lost interest in his son's doings. To some extent, no doubt, this accounts for the fact that Lautrec developed a taste for disreputable company – circus or music hall artistes, pimps, prostitutes, perverts, and the like – in which he felt less exceptional than in that aristocratic social world to which he belonged by upbringing. But that he had to make a deliberate effort to adapt himself to this new world for the sake of his art is made clear in a letter to his grandmother where he says: "I am leading a Bohemian life and I find it difficult to accustom myself to such a milieu. Indeed one of the chief reasons why I do not feel at my ease on the Butte Montmartre is that I am hampered by a host of sentimental ties which I must absolutely forget if I want to achieve anything."

With a mixture of charm, impudence, and coarse but playful wit, Lautrec succeeded in getting himself accepted

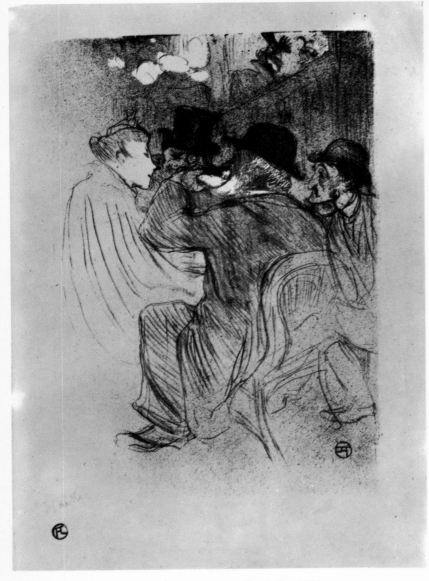

AT THE MOULIN ROUGE: A BOOR! A REAL BOOR! December 1893.
Lithograph, 18 × 9 5/8″

vocation was knowledge rather than salvation, analysis not cure. There is nothing fabricated about the content of his pictures: at the same moment and in the same country any dispassionate observer could have seen as much. So that when Lautrec shows us what he has seen in bedrooms, operating theaters, brothels, or bars, we can accept it without question, but at the same time we must recognize his courage in daring to record it all so frankly. For Lautrec had no ulterior motives and never attempted to moralize. His work is without bitterness or mockery, without sentimentality or emotionalism: indeed his emotional detachment, which is one of his salient characteristics, challenges comparison with that of Degas. And yet this comparison reveals a profound difference between the two artists. For whereas Degas was obsessed with the possibilities and the means of art and, having chosen his subject and made his notes, was able to preserve an emotional detachment by shutting the door of his studio on the world, Lautrec, to whom technical mastery meant far less, seems to have become increasingly detached from the subjects of his paintings the more assiduously he went out into the world in pursuit of life. Moreover, where Lautrec the artist could derive amusement from a mere nothing, Degas was amused by nothing at all when his art was at stake. The mood of the one is usually witty and lighthearted, while the mood of the other is always serious. For Lautrec accepted man as he found him, while Degas could not help seeing man as no better than a higher form of animal. Now, it was principally Lautrec's ability to observe human beings without indulging in physical, moral, or social criticism which saved his work from falling into caricature or becoming mere illustration – risks which Degas never ran – and this is an essential part of his greatness. No matter how dissolute the life he lived, nor how disreputable the company he kept, he never adopted the superior tones of an aristocrat but also never became *déclassé*. That is to say that, in his contacts with other human beings, he behaved without any affectation and almost, one might say, identified himself with the inhabitants of the Parisian underworld.

Lautrec knew just what he wanted to communicate through his pictures, but he also knew that in order to live up to his aims he had to be free to go wherever he liked. He was never troubled by the thought that, in order to devote himself wholeheartedly to art, an artist should retire into 'an ivory tower' and shut himself off from the world. With Lautrec, art and life were not merely interdependent, they were one: he lived what he painted. Thus the work is the man, and more than half our enjoyment of it depends on coming to terms with the charming and engaging personality of its creator.

It is not primarily as a painter, in the strict sense of the word, that Lautrec merits the adjective "great". We

in this other world on terms of equality. For, as so many of his friends have borne witness, in whatever company he found himself, Lautrec was always at ease and able to behave naturally. Everywhere, therefore, he was regarded as a jovial companion or a good friend, and since his companions had no reason to suspect his motives in frequenting them, they too could behave naturally. Lautrec's ability to penetrate in this way almost unnoticed behind the facade of gaiety, garishness, and glamour into the sordid intimacy of dull and disenchanted lives, greatly favored his artistic needs. For Lautrec was obsessed with discovering life as it is, not as it might be or appears to be. Yvette Guilbert, for example, reports him as saying to her one day: "Everywhere and always ugliness has its beautiful aspects; it is thrilling to discover them where nobody else has noticed them." And it is significant that Lautrec once admitted that had he not been a painter he would have liked to be a surgeon. His

must not overlook the real difference that exists between those of his contemporaries who attempted by pure "painterly" means to re-create their sensuous experiences – Manet, Monet, Cézanne, Degas, even Vuillard and Bonnard, for example – and Lautrec, who was a tireless observer and recorder of facts and therefore not greatly concerned with effects and sensations. The importance of Lautrec's work rests more on what the artist has to say about human beings and life generally than on the artistry (undeniable though it be) with which he says it. Actually, as a painter Lautrec was a fine technician, but he seems also to have been aware of certain personal limitations; so when he found that he did not need to cultivate a virtuoso technique in order to achieve what he wanted, he did not strive further to master the full possibilities of his medium, whether oil paint, tempera, or gouache. This accounts for the fact that his handling of paint was never of prime consequence in the realization of his vision – as it was for example with Manet, Degas, or Cézanne – and explains why for Lautrec it was sufficient to evolve a personal form of brushwork which was lively but which did not in itself contribute to the visual stimulation of his pictures.

Similarly. though he could in fact be inventive in solving compositional problems, he was quite apt to take over, with the minimum of adaptation, a compositional formula which had been invented by some other artist.

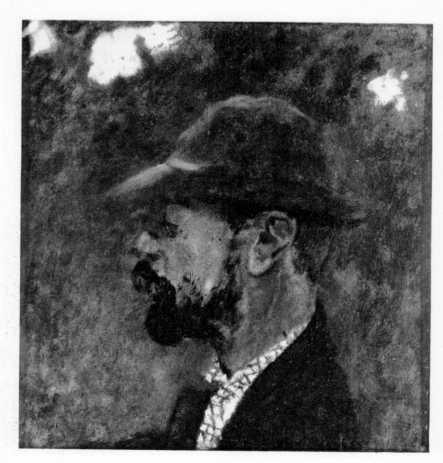

Edouard Vuillard: PORTRAIT OF TOULOUSE-LAUTREC 1898. Oil, 10 × 9″. *Museum of Albi*

In the field of graphic art. however. exactly the opposite is true, for Lautrec's achievements in lithography were, from the technical angle. highly original and significant. Like many other great artists of his generation – for instance, Gauguin, Seurat, Hodler. Munch, and even to some extent Van Gogh – Lautrec depended largely for his effects on an expressive use of line. Lithography – which had become increasingly popular during the latter half of the nineteenth century and had been brilliantly exploited by Daumier, Chéret. Redon, and Gauguin before him – was therefore a medium perfectly suited to his needs. Once Lautrec had discovered the possibilities of this medium – and despite one attempt in 1885 this did not occur until 1891–1892 – his daring knew no bounds. He explored all kinds of technical possibilities, developed a remarkable sense of color, and in the space of less than ten years had revolutionized the technique of lithography somewhat as Daumier had done fifty years earlier and as Picasso was to do again fifty years later. This discovery opened the way to much of Lautrec's artistic development, for in his hands color lithography became a rival technique to oil paint. He quickly learned how to obtain in his lithographs effects similar to those in his paintings; but the special demands of lithography inspired his bold new style of poster design, using simplified forms, broad areas of

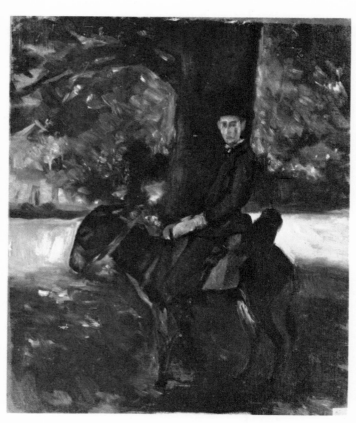

LE COULTEUX RIDING A DONKEY. 1881. Oil on canvas, 18 ⅛ × 15″ *Museum of Albi*

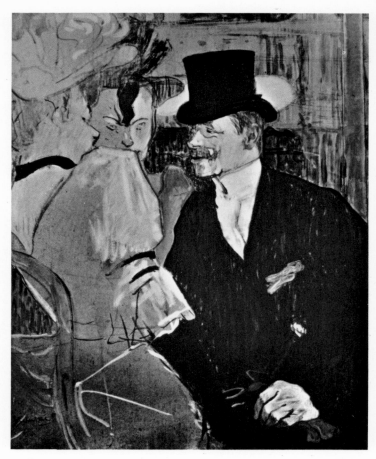

THE ENGLISHMAN AT THE MOULIN ROUGE. 1892. Oil on cardboard,
33 3/4 × 26". *Collection Adelaide M. de Groot, New York*

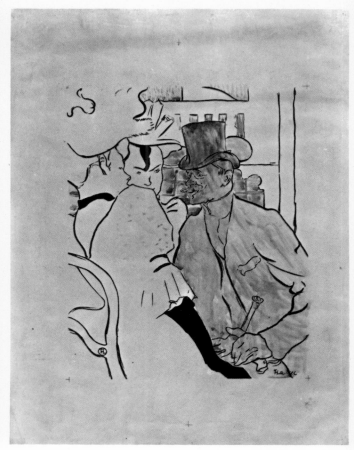

THE ENGLISHMAN AT THE MOULIN ROUGE. 1892.
Colored Lithograph. 18 1/2 × 14 5/8"

unmodeled color, and a very limited degree of spatial illusion. At the same time his lithographic discoveries affected the style of his painting. Yet Lautrec's instinctive feeling for the different technical requirements of these two media was so acute that his handling of each remained pure and he was never guilty of confusing them.

Stylistically, therefore, Lautrec's paintings and lithographs represent two different aspects of his work, just as they do with Daumier. But Lautrec's work differs from that of Daumier in that its two aspects cannot be considered separately, for they are bound together by a common inspiration: the same subjects are treated in the same spirit in both media. Whether Lautrec was painting a picture or making a lithograph, he made use of the same drawings and sketches from life. These sketches were vital notes made on the spot (page 11) though at the time he gave no thought to which medium they might ultimately be called on to serve. Their sole purpose was to stimulate his creative impulse by reminding him of some particular visual experience, whether of a gesture, a movement of the body, or a facial expression. In short, they were the raw material from which either a painting or a lithograph might spring. There are in fact several examples of the same composition being executed in both media, though in such cases – for example *The Englishman at the Moulin Rouge*, or *La Goulue and Her Sister at the*

Moulin Rouge – the painting always seems to have served as a preparation for the lithograph and never the reverse. This much is apparent from the broad and summary way in which these painted versions are executed. From this we must conclude that Lautrec himself did not regard one medium as being more important than the other, just as he made no distinction between "commercial" and "pure" art. So we must accept his point of view and not try to create artificial divisions in his work.

Henri-Marie-Raymond de Toulouse-Lautrec-Monfa, to give him his full name, was born at Albi on November 24, 1864, in the Hôtel du Bosc, the ancestral home of his paternal grandmother. He began to show artistic inclinations in earliest youth, for at the age of four, when he had not yet learned to write, he signified his presence at the christening of a cousin by drawing a cow in the register. By the age of ten his passion for drawing was well developed and he would cover the pages of his school books with sketches of animals, boats, or figures which show how sharp were his innate powers of observation. Probably Lautrec's artistic urge was so strong that he would anyway have become a painter, even against the wishes of his family. However, other interests might have prevented his talent from developing at an early

age, and he might never have wanted to devote himself exclusively to art, but for two tragic accidents. In two falls – one on a highly polished floor in the Hôtel du Bosc at Albi in May 1878, the other in a field at Barèges, where he rolled down a slope into a ditch, in August 1879 – he broke first his left and then his right leg. Delicate and rachitic since birth, Lautrec was forced on each occasion to undergo a long convalescence. And it was during these years of enforced idleness – between 1878 and 1881 – that he first began to paint seriously. Indeed he worked with such passion that he is recorded as having made some three hundred drawings in 1880 alone. His parents spared neither money nor care in their efforts to secure for him a complete physical recovery. Yet there came a time when both he and they had to accept the fact that something irreparable had occurred. So it was that, at the age of seventeen, Henri recognized that he would never again lead an active outdoor life, and it was then that he decided that art should become his profession.

During his early school years in Paris, before the age of ten, Henri de Toulouse-Lautrec had been sent to a famous riding school and had begun to accompany his father to the races. "In our family," he is reported to have said, "once baptized, one is in the saddle." So it is not surprising that when, after his accidents, someone asked him what he missed most he should have replied without hesitation: "Horses." One should not imagine

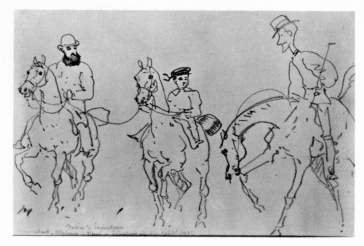

René Princeteau: COMTE ALPHONSE AND HIS SON HENRI DE TOULOUSE-LAUTREC ON HORSEBACK. About 1874. Pencil drawing, 6 × 8 3/4″
Museum of Albi

that he was a backward, brainless, or inattentive school-boy. Quite the contrary: during his first year at the *lycée* in Paris, he was placed fourth out of forty boys, all of whom were older than himself. And a few years later he began to translate a book on falconry, which had been given him by his father, in order to perfect his knowledge of English. Moreover, at the age of seventeen, despite the fact that for the previous five years he had been educated at home by his mother and a succession

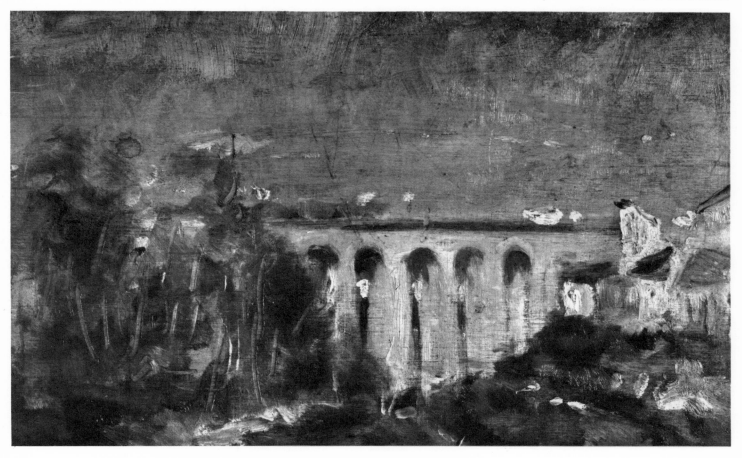

THE VIADUCT OF CASTEL-VIEIL NEAR ALBI. 1880. On wood, 5 9/16 × 9 3/16″. *Museum of Albi*

15

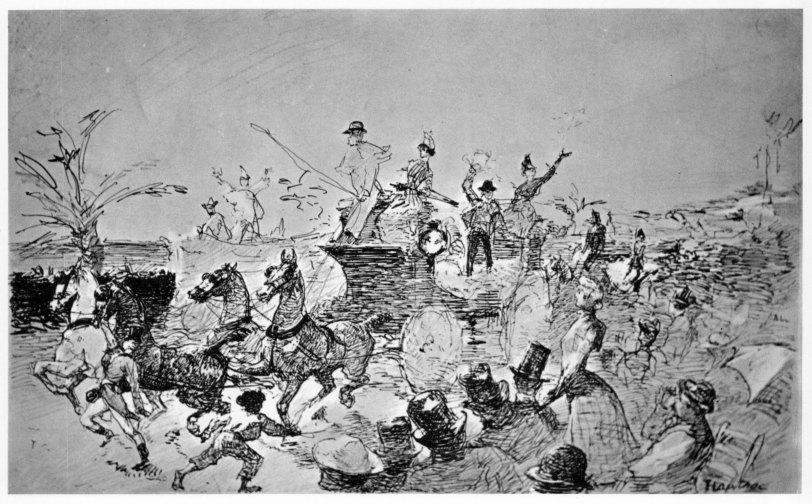

NICE: BATTLE OF FLOWERS. 1881. India ink, 12 5/8 × 19 5/8". *Museum of Albi*

of tutors, he passed his baccalaureate brilliantly. There-after he was free to develop according to his own inclin-ations, and in March 1882 he left home to study art in Paris.

Now, at this date the paintings and drawings which Lautrec had done were no more remarkable than those of any other gifted boy of his age. His choice of subjects was limited and personal, but one must remember that his field of vision was limited by circumstances and that, for obvious reasons, he felt most at home with subjects which he knew intimately from experience. At best he could look on with longing eyes while the horses were saddled and unsaddled in the stables of one of his family's estates, or watch his father and uncles riding off to hunt accompanied by their dogs and falcons. For the rest, he had to be content with what he could see from the windows of his sickroom at Amélie-les-Bains or Nice, where he spent much of his convalescence, or from a Bath-chair or carriage during one of his brief outings. "You probably think my menu is full of variety," he wrote to his young friend Étienne Devismes from Nice in January 1879, "but it isn't. The only choice lies between horses and sailors: the former are more successful. As for

views, I am quite incapable of doing any or even of suggesting them". So he covered hundreds of pages of sketchbooks with rapid studies of dogs, horses, and riders, of tandems, mailcoaches, and dogcarts, of fishing smacks, schooners in full sail, and American men-of-war, as well as of grooms, fishermen, and sailors. These he elaborated at leisure into more ambitious water colors and oils. Lautrec was not wrong in judging that his horses (page 18) were "more successful" than the rest, but if one considers this group of works as a whole one is bound to admit that artistically they do not amount to very much. Admittedly they are full of life — which is no mean achievement for an almost self-taught boy between the ages of fourteen and eighteen — but the drawing is on the whole weak and the painting fumbling. However, in view of Lautrec's subsequent development, one feature about them is strik-ing: the most successful are all concerned with charac-teristic gestures and violent movement. As soon as Lautrec was faced with a static model — for example an American sailor or a jockey — his drawing became stiff and self-conscious. Apparently he had an innate faculty for seeing and being able to memorize every detail of a movement or gesture.

16

SAILOR WRITING. About 1879. (From a youthful sketchbook.) Watercolor. 5¹/₂ × 8⁵/₈".
Collection Clifford A. Furst, New York

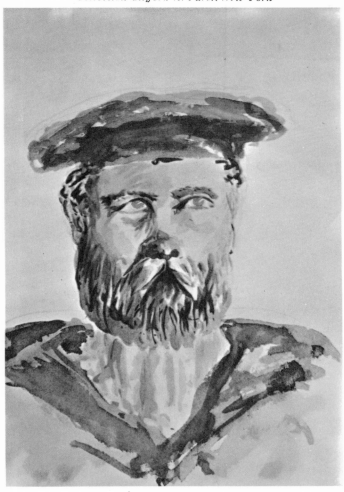

HEAD OF A SAILOR. About 1879. (From a youthful sketchbook.)
Watercolor, 8⁵/₈ × 5¹/₂". *Collection Clifford A. Furst, New York*

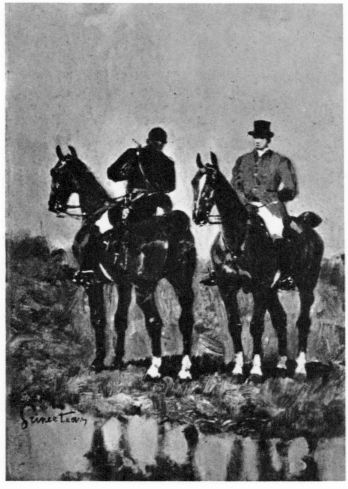

René Princeteau: TWO HUNTSMEN. About 1880. Oil on canvas.
19³/₄ × 15³/₄". *Private collection.*

17

CARRIAGE WITH FOUR HORSES. About 1880. (From a youthful sketchbook.)
Pencil, 6¹/₄ × 10¹/₈″. *The Art Institute of Chicago*

HUNTSMAN. About 1880. (From a youthful sketchbook.)
Pencil, 6¹/₄ × 10¹/₈″. *The Art Institute of Chicago*

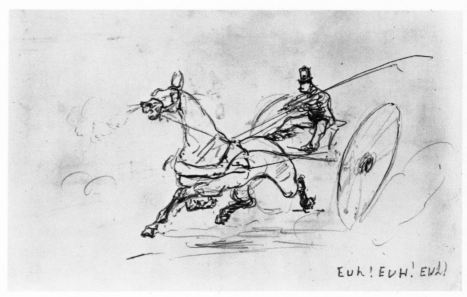

TROTTER (EUH! EUH!) About 1880. (From a youthful sketchbook.)
Pen and ink, 6¹/₄ × 10¹/₈″. *The Art Institute of Chicago*

18

During his convalescence, if not earlier, Lautrec became friendly with his father's strange acquaintance, René Princeteau, a deaf-mute who was well-known for his paintings of horses and dogs (pages 15, 17). This man was the first to assume responsibility for Lautrec's artistic training, and any progress that is apparent in his series of sporting pictures between 1880 and 1882 must be largely attributed to Princeteau's influence and encouragement. When Lautrec arrived in Paris, Princeteau was waiting for him, and since he admired the boy's "great connoisseurship of horses and dogs" he took him into his studio, taught him to prepare canvases and set him to copy some of his own pictures.

Now, in the building where Princeteau had his studio lived another animal painter, John Lewis Brown, and it was under the aegis of these two socially successful artists that Lautrec was introduced to the fashionable life of the Bois de Boulogne, to the Parisian racecourses and to the Cirque Fernando. No less important is the fact that at about the same time his father introduced him to Forain, from whom he was to learn a great deal and gain entry into the world of the theater. Before long, however, Lautrec had exhausted the benefits of Princeteau's training and felt the need of a more rigid discipline. So, through the good offices of a friend who was studying under Léon Bonnat, a highly successful academic artist, Lautrec managed to enrol in the same studio. Bonnat — who said to him one day: "Your painting isn't bad. It's

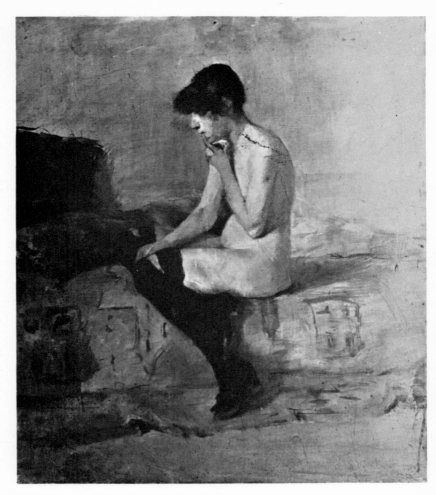

SEATED NUDE. 1882. Oil, 21 5/8 × 18 1/8″. *Museum of Albi*

clever, but still it isn't bad. Your drawing on the other hand is simply atrocious." – made Lautrec concentrate on drawing from life and taught him the principles of composition. As a result, his work rapidly became firmer and more controlled, and it was this experience that proved the decisive step towards the evolution of his adult artistic personality.

Lautrec spent the summer of 1882 at his family home of Céleyran and we need only look at his animal studies and portraits of relatives and workers on the estate (pages 20, 21), executed during those few weeks, to discover the progress that he had made during his six months' absence. Most of these pictures – such as *Young Routy* (page 61) – represent outdoor scenes, but the way in which they are painted shows that, in the meanwhile, Lautrec had become familiar with Impressionism, especially with the openair painting of Manet's last years. Moreover, his handling of figures had become more accomplished. The young artist is still not in control of the pictorial means, and no one would claim that these pictures are more distinguished than hundreds of others by similarly gifted students. Nevertheless, they are significant because they show how quickly Lautrec developed "modern" and unacademic tendencies. It is also interesting to compare them with the scenes of Dutch peasant

NUDE MALE MODEL. 1882. Charcoal, 6 1/4 × 10 1/8″. *The Art Institute of Chicago*

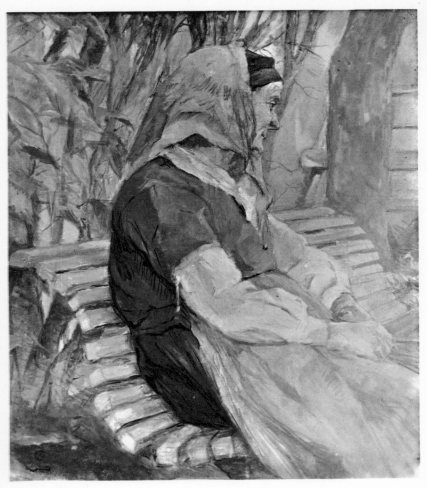

WOMAN SEATED ON A BENCH AT CÉLEYRAN. 1882. Oil. 20⅛ × 17⅜"
Museum of Albi

part of their training, exercises in this genre. Thus in 1883–1884 one finds Lautrec executing an allegory such as *The Spring of Life*, or else *A Merovingian Scene*, or *A Prehistoric Settlement*. At the same time Cormon paid proper attention to drawing, and the Museum of Albi owns a large collection of drawings by Lautrec from plaster casts and studio models of all kinds made at this time.

Cormon was not, however, as strict a master as Bonnat, and Lautrec regretfully wrote to his uncle that "my former master's raps put ginger into me, and I didn't spare myself. Here I feel rather relaxed and find it an effort to make a conscientious drawing when something not quite as good would do just as well in Cormon's eyes." So a great deal of the remarkable progress that Lautrec made between 1883 and 1885 must be attributed to the relentlessness with which he forced himself to work on his own, studying and drawing every head he could and paying models to sit for him in his studio. "I can't manage it, I can't succeed," Lautrec wrote to his grandmother in 1883. "I am obliged to pretend to be deaf and batter my head against the wall. Yes, and all that for an Art which runs away from me and will never know all the worry and pain I suffer for it." Nevertheless, mastery was not long in coming, as a picture like *Fat Maria* (page 63) proves, and by the summer of 1884 there was no longer any doubt that art was his true vocation. At last success seemed within sight, for he was

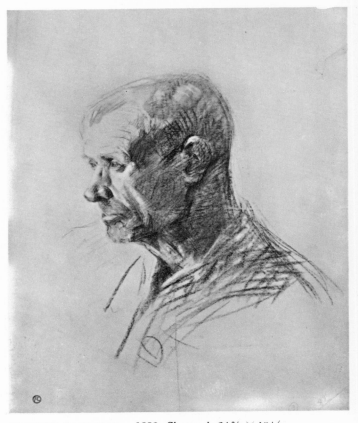

WORKMAN AT LE BOSC. 1882. Charcoal. 24¾ × 19¼
Museum of Albi

life painted almost at the same time, in The Hague and in Drenthe, by Vincent van Gogh, then also at the start of his artistic career. Both are in their different ways inept, but where Lautrec's pictures are natural, calm, and sophisticated, Van Gogh's are uncouth, tense, and forceful; and where Lautrec paints in a light tonality without heavy shadows, Van Gogh makes great use of heavy chiaroscuro. Yet there is a real similarity between the work of these two young men, for in both one finds a similar concern with individual human beings and a warm humanity. This was the new note which they were to introduce into painting.

At first Lautrec hoped that, after studying for a while under Bonnat, he would be accepted at the Ecole des Beaux Arts. But things turned out differently. At the end of 1882 Bonnat unexpectedly closed his studio and Lautrec then went, with a group of fellow students, to study under Fernand Cormon, another academic artist. Here he remained for more than two years working extremely hard, for he was determined at all costs to succeed in order to prove to himself and his family that he was "not a failure at everything." Cormon was especially noted for his elaborate costume pictures of historical and literary subjects, and he set his pupils, as

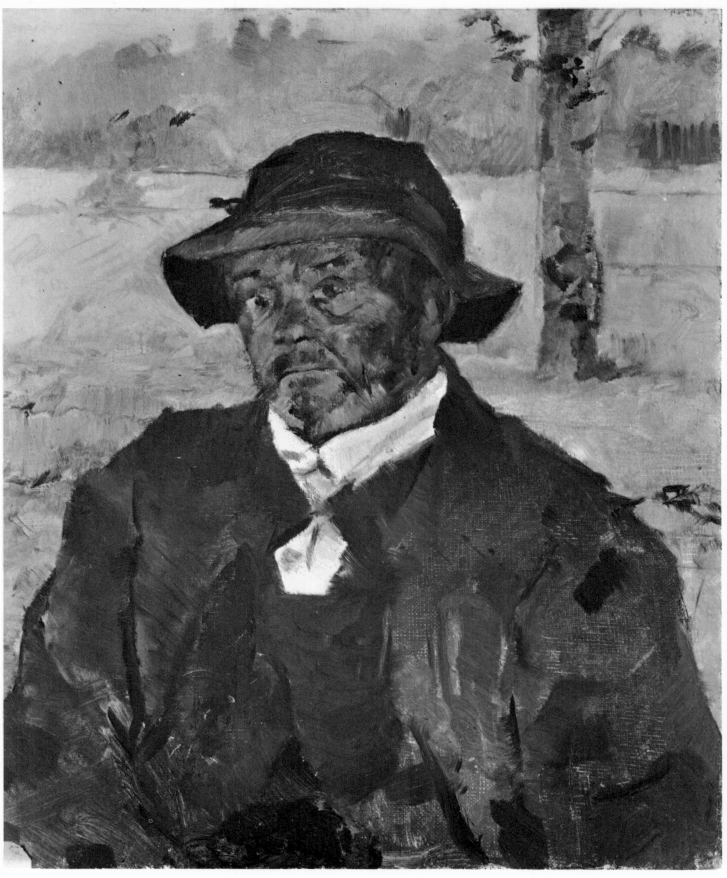

AN ELDERLY LABORER AT CÉLEYRAN. 1882. Oil on canvas, 16 1/8 × 13″. *Museum of Albi*

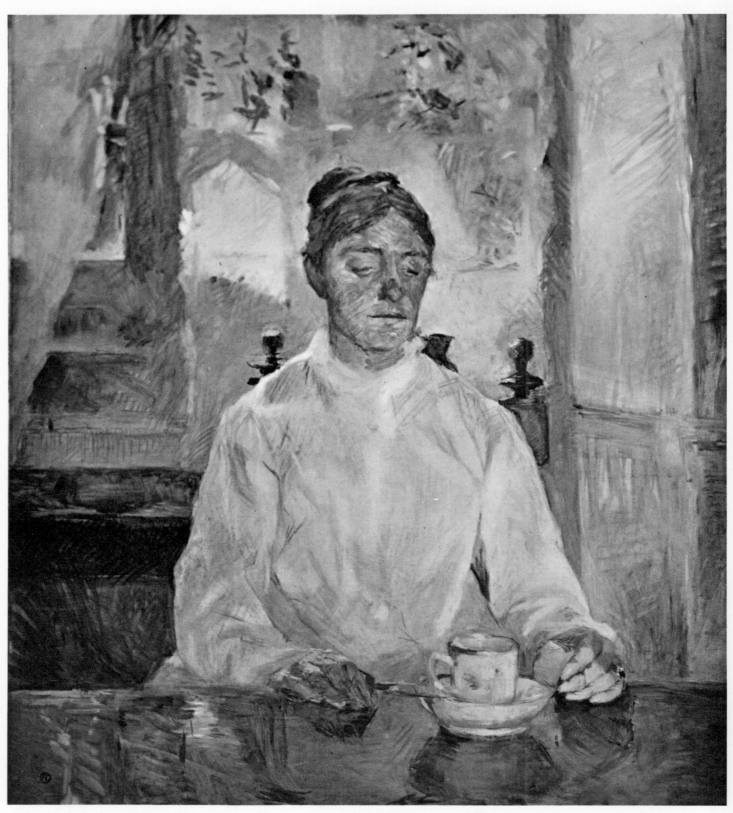

PORTRAIT OF THE ARTIST'S MOTHER AT BREAKFAST. 1883. Oil, 36 1/4 × 31 1/2″. *Museum of Albi*

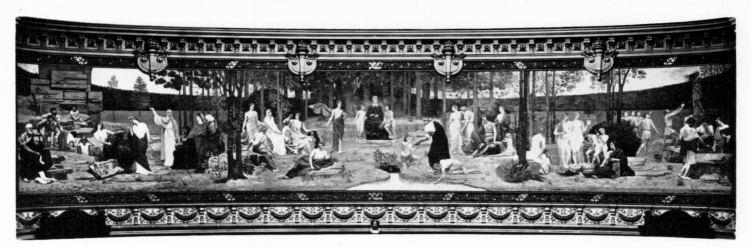

Puvis de Chavannes: THE SACRED GROVE *(Le bois sacré).* 1884. Canvas mural, 181 ⅛ × 410″. *Museum of Lyons*

"congratulated by Bonnat" and chosen by Cormon to "collaborate with him and Rachou in illustrating a magnificent edition of Victor Hugo's works." But Lautrec was shrewd enough to pursue his own aims without falling a victim to Cormon's stock in trade. "I'm here to learn my trade," he told his teacher, "and not to be swallowed up."

This tendency to independence in Lautrec was encouraged through his friendship with a group of other adventurous young men—Louis Anquetin, François Gauzi, Henri Rachou, Grenier, and Émile Bernard (page 65) – whom he found among his fellow pupils at Cormon's. All these budding artists were dissatisfied with the unprogressive attitude of the École des Beaux Arts and were enthusiastic for the ideas, achievements, and innovations of the great independent artists of the day. In their company, Lautrec's taste and understanding rapidly developed, and he made regular visits to all the Paris exhibitions. In this way his discovery of Manet and the Impressionists was soon followed by the discovery of Degas and the

Japanese masters. Something of the attitude of these young men to academic art burst out in an immense and mischievous parody of Puvis de Chavannes' *Grove Sacred to the Arts and Muses* (above) executed by Lautrec in the winter of 1884. Puvis' painting, commissioned by the Museum of Lyons as a staircase decoration, had created something of a sensation when it was exhibited at the Salon in that year. Lautrec based his parody on the right-hand section of the original, adding a few ironical touches here and there, but he filled the wood with a crowd of typical top-hatted and bewhiskered Salon artists (marshaled by a policeman) who have come to look at the Muses, although they show by their casual behavior that they are not in the least overawed by the spectacle. In the middle of them all, his back to the Muses, stands Lautrec himself.

Under the joint influences of the dull but effective academic teaching which he received from Bonnat and Cormon, and the eye-opening experience of discovering other artistic idioms which aroused his spontaneous

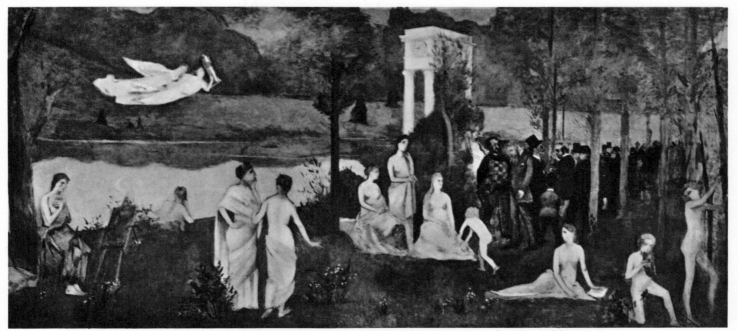

THE SACRED GROVE (parody of the panel exhibited by Puvis de Chavannes in the Salon of 1884) 66⅞ × 145⅝″.
Collection Henry Pearlman, New York

23

DANCER IN HER DRESSING ROOM. 1885. Oil on plaster transferred to canvas.
45 × 39 1/2". *Mrs. Mark C. Steinberg Collection, St. Louis*

Coquiot, from whose book the following extract is quoted. "At Cormon's studio he wrestled with the problem of making an accurate drawing from a model; but in spite of himself he would exaggerate certain typical details, or even the general character of the figure, so that he was apt to distort without even trying or wanting to. I have known him deliberately try 'to make something pretty' of a model — even a portrait for which he was being paid — without ever, in my opinion, being able to bring it off. Lautrec himself would even say that he was trying 'to make something pretty.' The first drawings and paintings that he did after leaving Cormon's studio were always done from nature. He used to say that he could not work unless every detail had been attended to before he began The painter he loved best was Degas, and he worshipped him. His other favorites among the moderns were Raffaëlli, Renoir, and Forain. He was fascinated by the Japanese masters; he admired Velazquez and Goya; and, astonishing as it may seem, he had a high opinion of Ingres: in that respect he was following the taste of Degas."

It should not be necessary to analyze in detail the relative influence of each on the evolution of Lautrec's style, for so much must be obvious. Suffice it therefore to note that Velazquez represented fine painting and an elegant tradition of naturalistic portraiture; that Goya — one of whose etchings in *The Disasters of War* series is significantly entitled *"I saw this"* — represented fearless and truthful observation; that Ingres represented the rhythmic possibilities of line; that Renoir represented the great French tradition of painting adapted to a naturalistic presentation of bourgeois life; and that Forain pointed the way to the theater and the night life of Montmartre. This last was Lautrec's jumping-off point, and his first distinctive paintings — a series of four large wall decorations in the Auberge Ancelin at Villiers-sur-Morin, executed in the summer of 1885 (plate above) — were of theatrical subjects and were clearly inspired by Forain. But the influence of Degas and the Japanese was far more significant than any of these, because they taught Lautrec the importance of design, which was lacking in his earliest pictures, and made him realize how much depends on a pure use of the pictorial means. Thus it was their example which saved his work from the pitfall of *reportage*.

Lautrec seems to have been immediately struck by the work of Degas in 1883, and the two artists probably met in 1885, when Lautrec was sharing a studio with Grenier in the same building (19 bis Rue Fontaine) as that of the master. At once Lautrec realized that this was the living painter from whom he could hope to learn most for, in the words of Edmond de Goncourt, "... among those who copy from modern life, [Degas] it is who has best caught the spirit of that life." Degas opened Lautrec's eyes to a range of modern subjects — women at their toilet,

enthusiasm, Lautrec gradually became master of the pictorial means and simultaneously his own artistic personality began to evolve. This was, however, no easy achievement. Lautrec really struggled to turn himself into a proficient artist for, like two of his contemporaries who were then unknown to him, Paul Gauguin and Vincent van Gogh, he knew that he had something urgent to communicate and that it was incumbent upon him to find an appropriate means of doing so. But whereas Gauguin, who was less naturally talented and had less feeling for humanity, evaded certain technical difficulties by creating the style called Synthetism and cultivating 'primitive' simplifications, Lautrec and van Gogh, both passionate, persevering and, in different degrees, desperate characters, slaved — and not in vain — to master the problems of good draftsmanship so that they could go on to forge a pictorial idiom which would be capable of transmitting their intense feeling for life.

As he developed Lautrec owed a great deal to other artists, both directly through personal contacts and indirectly through studying their works. This much is evident from looking at his pictures. But fortunately we need not waste time speculating on the nature of these influences because François Gauzi has left a vivid record of the mentality of his fellow pupil and an account of his artistic tastes. "In art he was always sincere," Gauzi told

Edgar Degas: CAFÉ-CONCERT. 1882. Pastel, 8 1/4 × 16 7/8". *Collection Durand-Ruel, Paris*

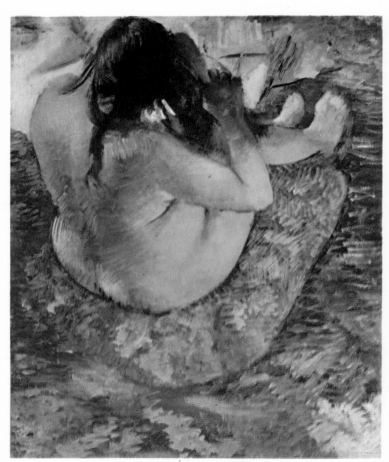

Edgar Degas: WOMAN COMBING HER HAIR. C. 1881.
Oil on canvas, 29 1/8 × 24". *Collection Durand-Ruel, Paris*

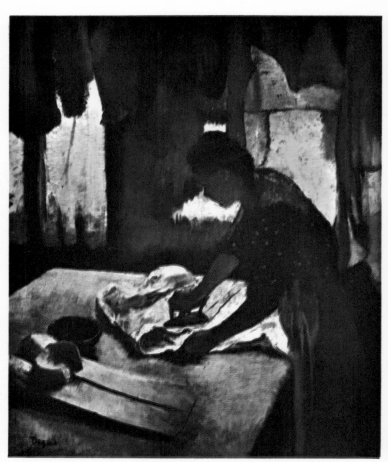

Edgar Degas: LAUNDRESS. 1882. Peinture à l'essence, 31 7/8 × 25 5/8".
Collection Mme. Georges Durand-Ruel, Neuilly-sur-Seine

25

THE ARTIST'S MOTHER. 1885. Charcoal, 25 1/4 × 18 1/2".
Museum of Albi

aggerations as he permitted himself were more often humorously applied to clothes or ornaments than to faces.

Lautrec's mature style evolved rapidly for, as his friend Rachou said, "... he had already outgrown Cormon's studio while he was still working there." So in 1885 he ceased to be a student and began to work independently, though he continued to pay frequent visits to Cormon's during the next two years. Moreover, until 1887, when he rented a studio of his own at 27 Rue Caulaincourt, he was obliged to share one with either Grenier, Rachou, or Gauzi. Thus he remained on close terms with his erstwhile fellow pupils, and so it was inevitable that, in the spring of 1886, he should meet Vincent van Gogh, then a new recruit at Cormon's.

During the years 1886–1887 Lautrec painted in a rather tight Impressionist manner reminiscent of Pissarro. But with the advent of the year 1888 he began to evolve a style of his own based on larger areas of color and expressive outlines. At the same time he adopted a much freer form of brushwork, using long sweeping strokes for drawing outlines and a network of shorter strokes in the enclosed areas for creating texture and surface modeling. His color schemes too became bolder and more bril-

Louis Anquetin: PORTRAIT OF TOULOUSE-LAUTREC. 1889. Charcoal, 24 × 15 3/8". *Museum of Albi*

dancers, scenes in cafés and music halls, or on the racecourse, laundresses ironing – and at the same time demonstrated unconventional methods of handling them. Indeed from 1886 onwards one finds Lautrec constantly using compositional devices which had been invented by Degas. Lautrec also drew on the experience of Degas – as well as on contemporary photographs – in evolving his style of portraiture, a genre which, numerically at any rate, formed an increasingly important part of his work after 1887. These portraits represent the summit of naturalism in Lautrec's work, because in them he displayed an ability not always apparent in the rest of his work to keep his impish or sardonic tendencies so well under control that the balance between art and reality was perfectly held. Because he was well-to-do, Lautrec could afford to choose his sitters, and as a rule he took only close friends or those who had a special appeal for him as models. But it is fascinating nevertheless to study the devices he used to preserve an air of informality, for then one becomes aware of his cleverness in characterizing a sitter by a telling use of gesture or facial expression without having recourse to symbolical or material attributes. Only rarely did Lautrec indulge in distortion or caricature for the sake of effect – the portraits of Yvette Guilbert and Oscar Wilde are obvious examples – and even then such ex-

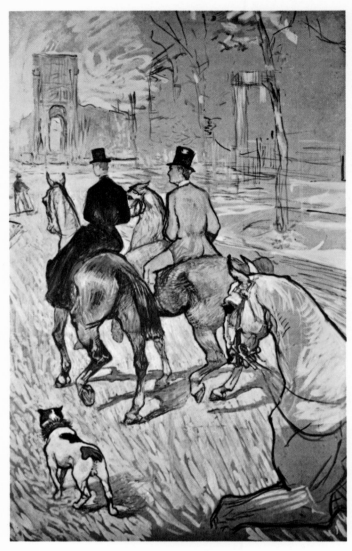

RIDERS GOING INTO THE BOIS DE BOULOGNE. 1899. Gouache on cardboard, 33 1/4 × 19 3/4″. *Collection Dr. Marjorie Lewisohn, New York*

stant, except during the last two years of his life when the destructive effects of alcoholism deprived his hand of much of its cunning. Apart from that, his work shows no appreciable change in style or in spirit. All that happened was that from year to year he would vary his subject matter slightly, sometimes for topical reasons, sometimes because he had a fixation about a particular personality, and sometimes because he had moved into a new circle of friends. Thus, when the Moulin-Rouge became the rage of Paris in 1889, Lautrec immediately abandoned his old haunt the Moulin de la Galette and began a great series of pictures in the new gathering place. Again, his series of brothel pictures originated at a famous establishment in the Rue d'Amboise where he was commissioned to decorate a salon; but he quickly moved from there in 1894 when a more luxurious, fashionable, and fantastic establishment was opened in the Rue des Moulins. In 1891 he turned his attention to surgical operations and Dr. Péan (pages 28, 29), because Gabriel Tapié de Céleyran, his cousin and constant companion, had just begun to work under the great surgeon; in 1895 he suddenly took an interest in bicycle racing (pages 32, 125) because his friend Tristan Bernard, whom he had met a few years previously in the *Revue Blanche* circle, had just been appointed Sporting Director at the Vélodrome Buffalo; in 1896 he was attracted to the law courts by two famous financial scandals, those of Arton and Lebaudy. And the same sort of considerations governed

liant and his paint more dry. The explanation of this marked change seems to be partly that Lautrec felt himself handicapped by the exigencies of a meticulous Impressionist technique when he needed an idiom which would allow him to record what he saw quickly and easily, and partly that he was keeping pace with the new ideas of such friends as Van Gogh and Emile Bernard. For Lautrec was not concerned with re-creating his optical sensations. His aim was to catch life on the wing, and he wanted to preserve a stylistic continuity between his hasty, instantaneous sketches and the more considered paintings or lithographs into which they developed. This supposition seems to be borne out by the fact that, as soon as he had evolved a personal idiom, his work became more spontaneous and more vital, with the result that for ten years after 1888 he was at the height of his powers.

Lautrec is one of the few painters whose development need not be studied chronologically beyond a certain point. After 1888, when he evolved his mature style, until 1901, when he died, his work remained remarkably con-

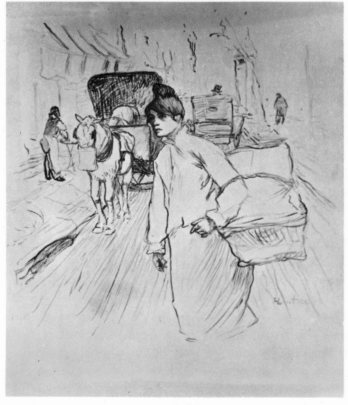

THE LAUNDRESS. 1888. Ink, 29 × 22 1/2″.
Photograph by courtesy of M. Knoedler & Co., New York

27

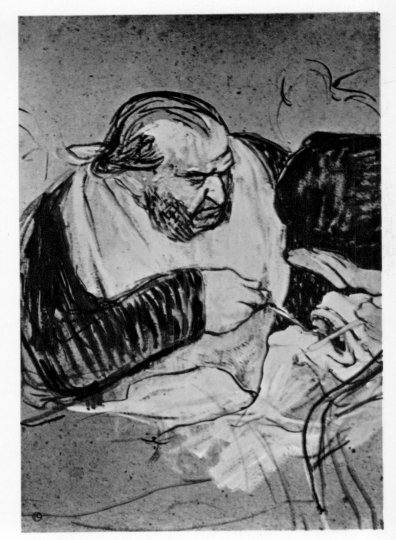

LOÏE FULLER IN THE DANCE OF THE VEILS. 1893. Oil, 24 × 17 3/8″
Museum of Albi

DR. PÉAN OPERATING. 1891. Oil. 29 × 19 3/4″. *Private collection*
Photograph courtesy M. Knoedler & Co., New York

his choice of individuals to portray. He might be fascinated by seeing different people in different circumstances adopting almost identical attitudes, or by finding that a similar type of form would fit a variety of different figures, as in the painting *Portrait of Gabriel Tapié de Céleyran*, and two portraits in lithograph, also of 1894, one entitled *Adolphe* or *The Sad Young Man*, the other of the racing bicyclist Zimmermann (pages 32, 111). But more frequently Lautrec would suddenly become obsessed with a personality, or with some aspect of the performance of an actor or actress, dancer, cabaret, or music hall artiste, who was enjoying a popular success, and would persist in continuing to portray them until he felt that he had extracted the essence of their character. For example, Lautrec frequented the cabaret Le Mirliton as early as 1885, and the figure of its proprietor, Aristide Bruant, appears in some of his early pictures; but it was only after they became friendly in 1888 that Lautrec began to concern himself with the personality of the singer, and his interest continued until 1892,

that is to say so long as Bruant's success lasted. Similarly, though Lautrec had made use of the characteristic silhouette of Yvette Guilbert (then at the beginning of her career) in the background of the poster for *Le Divan Japonais* (1892) and in a project for a poster *Les Ambassadeurs, Gens Chics* (1893), it was not until after he had met her in 1894, by which time she was famous, that he embarked on his long series of portraits of her. Again he portrayed Marcelle Lender in three lithographs in 1893 and 1894, but when she made a great success in the revival of *Chilpéric* in February 1895 he produced eight lithographs and one painting of her in a single year. With Oscar Wilde, whom he first met in about 1892, he behaved in much the same way; only at the height of his notoriety, in between his two trials in 1895, was Lautrec impelled to do a portrait of him and then it was immediately reproduced in the *Revue Blanche*. May Belfort attracted his attention in 1895 (though she had been appearing in Paris for some years) because she was performing at the cabaret Les Décadents with Jane Avril;

28

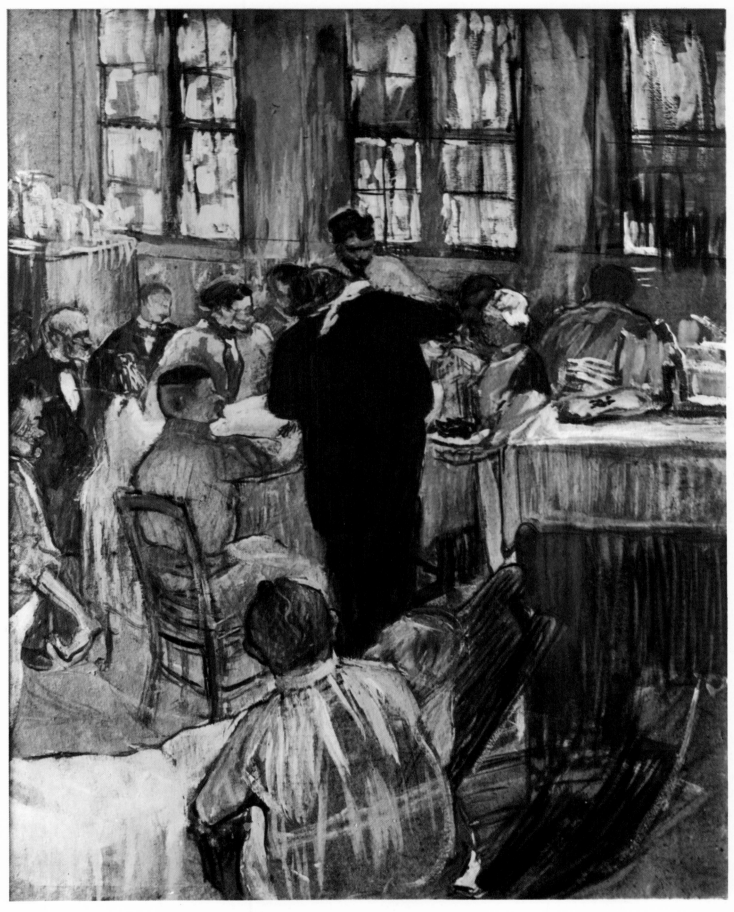

DR. PÉAN OPERATING. 1891. Oil on millboard, 22³/₄ × 18¹/₈". *Private collection*

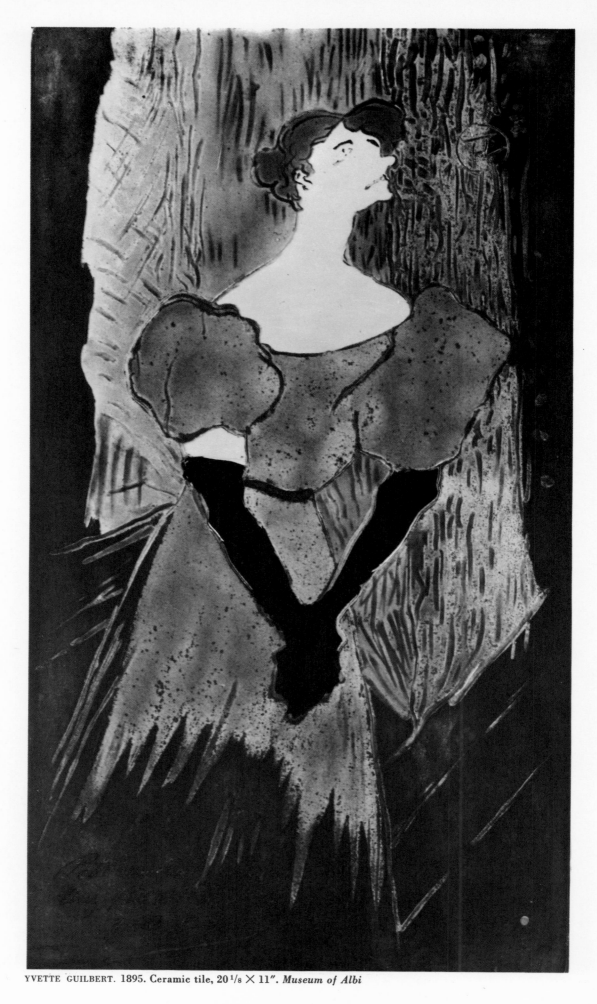

YVETTE GUILBERT. 1895. Ceramic tile, 20 1/8 × 11″. *Museum of Albi*

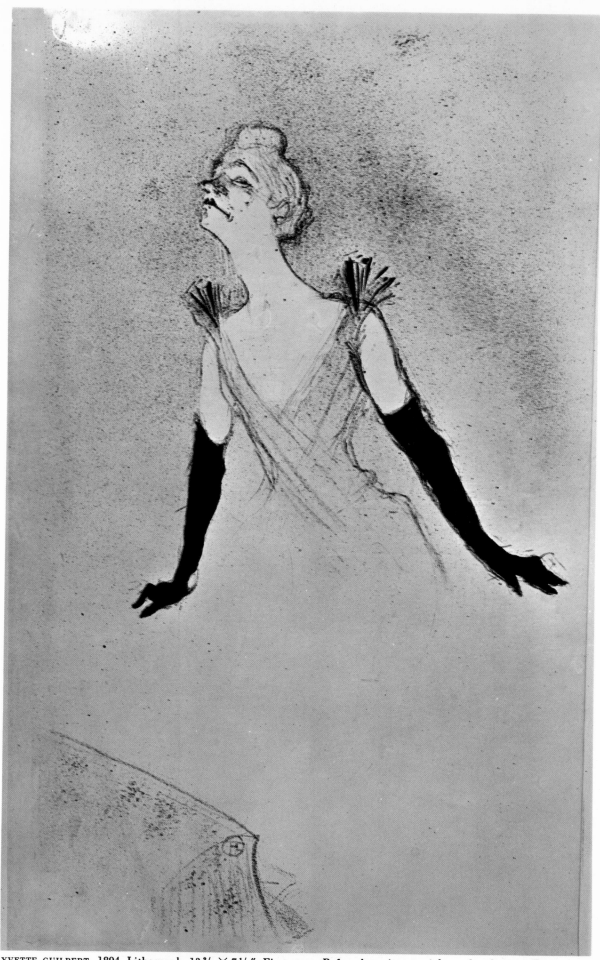

YVETTE GUILBERT. 1894. Lithograph, 13 ³⁄₈ × 7 ¹⁄₄″. First state: Before lettering on right and at bottom. Rare

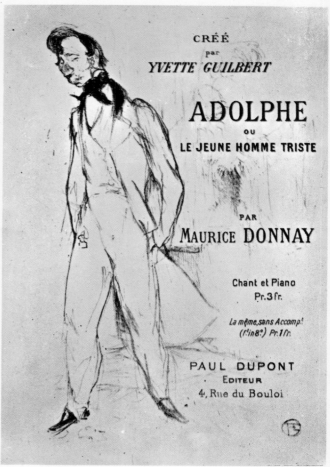

ZIMMERMANN AND HIS BICYCLE. 1895. Lithograph, second state, 9 × 4 15/16″

ADOLPHE, or THE SAD YOUNG MAN. 1894. Lithograph, 10 1/16 × 6 9/16″

immediately he executed five paintings and as many lithographs of her in a matter of weeks. Always the same pattern repeats itself. Not that this is in any way in Lautrec's disfavor, but it does help to underline the fact that he was primarily a recorder of the life of his time rather than a dedicated artist. In fact, but for the importance he attached to calculated artistry in the presentation of his subjects, it might not have been possible to differentiate between Lautrec's work and that of a reporter like Guys on the one hand or that of illustrators like Willette, Steinlen, and Forain on the other.

The real turning point in Lautrec's work is marked by his first circus picture, *Cirque Fernando: The Equestrienne* of 1888 (page 75), in which he broke with Impressionism and with the convention of representing space in terms of strict linear perspective. All of a sudden he ceased to concern himself, as he had done hitherto, with effects of light, took liberties with natural appearances for the sake of the general rhythm, boldly used broad areas of local color, and tried to create an illusion of depth by means of a new sort of pictorial logic. In this he showed himself to be very much a man of his time, for the stylistic principles on which his picture is based correspond with those adopted at the same date, and for very similar reasons, by Seurat, Gauguin, and the Nabis.

But in contrast to Gauguin and the Nabis, Lautrec was not prepared to sacrifice human truth to an artistic formula. He could not fail to realize therefore that *The Equestrienne* was marred by an element of artificiality (amounting almost to caricature) which results from a conflict between pictorial necessity and reality. The problem for Lautrec was to discover a means of pictorial representation in which the spatial illusion of reality could be reconciled with a flat design. He found his solution, though at the cost of reducing the spatial illusion, through studying Japanese prints and following in the wake of Degas.

Japanese prints had first attracted the attention of French artists in the early 1860s, and the influence of the Japanese style had quickly spread. Whistler was one of its most active propagators, but in 1868 Manet represented a Japanese print in the background of his *Portrait of Zola*; in 1876 Monet painted a portrait of a woman in Japanese costume; and at about the same time Japanese motifs appeared in paintings by Renoir. Writers as well as artists took up the cult of things Japanese. Large collections of Japanese works of art were assembled in Paris; in 1875 Duret and Cernuschi visited Japan; in 1883 the Galeries Georges Petit in Paris held an important ex-

hibition of Japanese art (which Lautrec certainly saw), and this was followed by another and more important one in 1893 at Durand-Ruel's gallery. Now, although many artists where influenced by the discovery of Japanese art, each seems only to have taken from it those elements which suited his immediate purpose. Thus Manet seized on the surface contrasts of dark and light; Degas absorbed the principle of cutting figures at unexpected angles and using abruptly receding diagonal lines to give an illusion of depth; while Gauguin and van Gogh adopted the emphatic outlines, the use of pure colours, and the calligraphy. Lautrec, on the other hand, who like Degas owned a considerable collection of Japanese prints — which he began to buy in about 1883 — took over and adapted to his purpose more elements of the Japanese style than anyone. It was from Japanese art that he learned how to give unity to a composition through linear rhythm, how to achieve a decorative effect through a subtle play of contrasting curves and angles, and how to suggest character and feeling through expressive outlines. He discovered that modeling could be simulated without violent contrasts of light and shade, and whenever Lautrec needed an effect of light he chose (as Degas and Daumier had before him) a directed shaft coming from below (pages 35, 42, 97, 127), because this meant that he could flatten the object illuminated while bringing out its salient features in half-relief. From the Japanese,

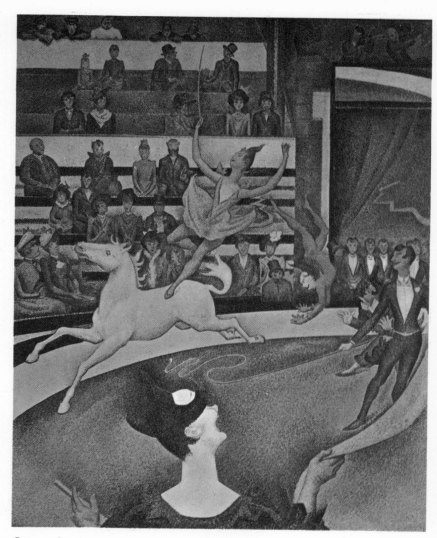

Georges Seurat: THE CIRCUS. 1890–1891. Oil on canvas, 73 × 59 1/8". *Louvre, Paris*

LA GOULUE AND VALENTIN. 1894. Lithograph, 11 3/4 × 9 1/16". First state: Before lettering

Lautrec learned to use silhouettes and simple masses of flat color, and they also revealed to him the possibility of incorporating purely decorative elements in a composition without destroying the naturalistic effect. Finally, and perhaps most important, he discovered ways of simulating spatial recession: setting the eye level more than half way up the canvas; resorting to flat, parallel, unconnected planes; off-centering a composition; and using very abruptly receding diagonals, often in false perspective. But Lautrec did not adopt the simpering mannerism and mask like expressions of Japanese art, and never reduced a face to a conventional formula. When he simplified forms, making fantastic shapes out of coiffures, hats, or dresses, it was in order to bring them into the rhythm of his picture and to emphasize character. And this is where he contributed so largely to the movement known as *Art Nouveau*. For, *Art Nouveau* was a blend of stylization, invention, decoration, and humor, developed largely as a result of oriental influence on European art, and it was a movement which expressed itself primarily in linear terms. Thus *Art Nouveau* is in many ways comparable with the Rococo

JANE AVRIL ENTERING THE MOULIN ROUGE AND PUTTING ON HER GLOVES 1892. Pastel and oil on millboard, 40 × 21³/₄″. *The Home House Trustees, London*

AT THE GAIETÉ ROCHECHOUART: NICOLLE. December 1893. Lithograph, 14 1/2 × 10 1/4″

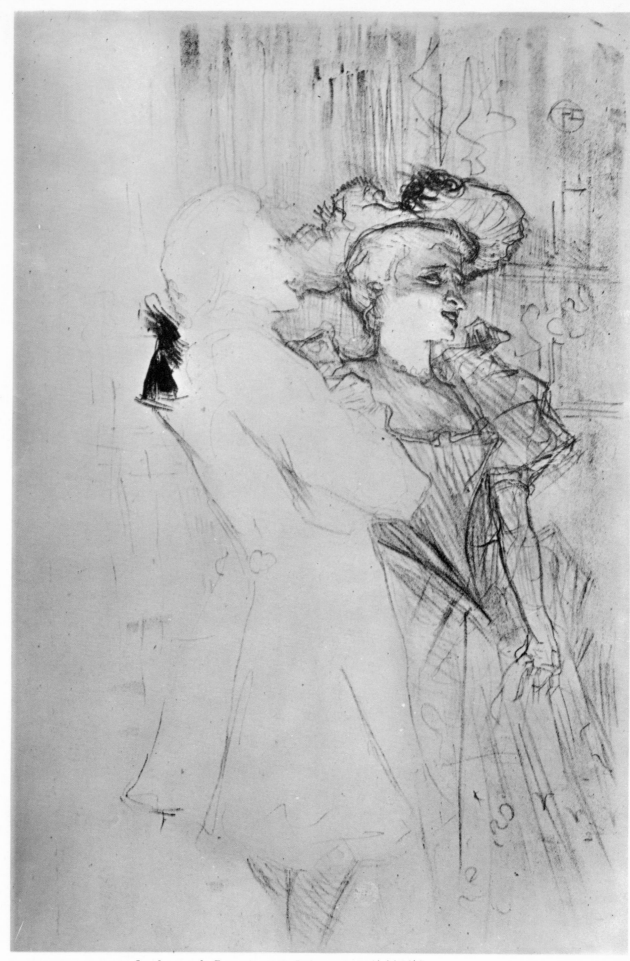

LENDER AND AUGUEZ in *La chanson de Fortunio*. 1895. Lithograph, 14 1/2 × 7 3/4"

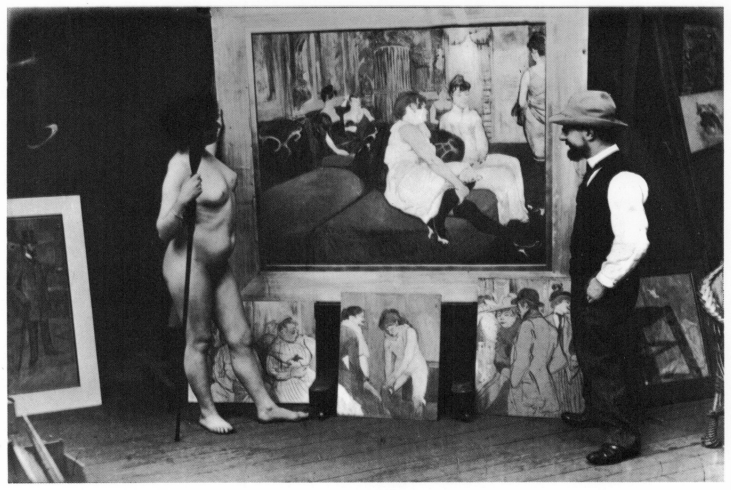

LAUTREC AND A MODEL IN HIS STUDIO, in front of *Au Salon* of 1893. Photograph by M. Guibert. *Collection Bibliothèque Nationale, Paris*

of one hundred and fifty years earlier. But where the Rococo was, so to speak, the end of the Baroque, *Art Nouveau* was (as its name implies) a conscious attempt to make a new beginning, to recapture "style," an element

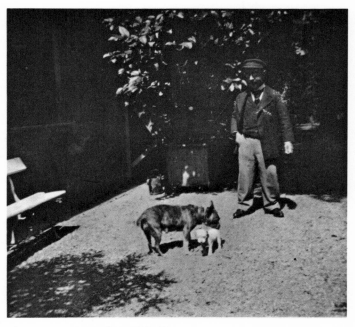

LAUTREC AT MALROMÉ WITH DOGS
Collection Bibliothèque Nationale, Paris

which many people thought had been lost in art at that date.

The Japanese influence can be identified in Lautrec's *The Equestrienne* – notably in the flattened and rhythmic figure of the ringmaster – but in his two big compositions, *At the Moulin de la Galette* (1889, page 77) and *At the Moulin Rouge: The Dance* (1890, page 89), it is very pronounced. Now, the basis of Lautrec's mature style was laid in these three great pictures, but in posters, where he was not obliged to concern himself with the representation of an actual scene, he felt free to exploit the stylistic possibilities suggested by Japanese art more fully. This he proceeded to do.

Until about 1840, posters were relatively small sheets with a text, printed in black and white; these were usually hung up indoors. But the perfection of lithography as a technique of reproduction opened up new possibilities both in the field of color and as regards size. By 1835 already, Parisian publishers had begun to advertise their books with colored posters designed by popular illustrators of the day, and by 1845 large pictorial posters advertising shops, hotels, fashionable seaside resorts, and even properties for sale, had begun to appear on the walls of Paris. The printer chiefly responsible for this

Jules Chéret: POSTER. About 1893. Colored lithograph, 48 3/4 × 34 5/8".
Museum of Modern Art, New York

that had been seen hitherto, and for the next twenty-five years his leadership in this field was unchallenged. Chéret changed the character of posters entirely by giving more prominence to the pictorial image than to the lettering and by introducing a note of hilarity. In consequence it soon became fashionable to admire posters for their pictorial and artistic rather than for their publicity value. Zola, for example, writes in his novel *L'Oeuvre* (1886) of a group of young artists emitting "cries of admiration" at the sight of a three-colored poster in the Rue de Seine advertising a circus. Simultaneously amateurs began to make collections of posters, and then the complications began, for as only a small number of each design was printed, they had to resort to tricks of all sorts to satisfy their lust for possession, even bribing billstickers to hand them over in pristine condition, or peeling them off the wall when they were still wet. In 1889 two famous poster exhibitions were held: one in Paris of Chéret's creations, and another in Nantes which was international. These were followed by a second exhibition of Chéret's work in Paris in 1890. The popular success of these exhibitions was immense, Chéret was awarded the Legion of Honor, poster collecting became all the rage, and there was talk of art coming down off the walls of the sitting room into the street. Dealers in posters opened shops, and the popular demand was so great that in 1896 the Imprimerie Chaix, which was owned by Chéret, started publication of a monthly album – *Les Maîtres de l'Affiche* – which consisted of small scale color reproductions of the most famous posters of the day.

What more natural, then, than to find that Lautrec, who had a longing for popular acclaim, who had the makings of a great illustrator and was naturally endowed with a dash of showmanship, should have taken up poster designing? From the moment he left Cormon's studio he undertook what we would now call "commercial" work, for his first lithograph, in 1885, was a design for the cover of one of Bruant's songs, and through the 1890s he continued to provide each year little illustrations for the covers of new ballads by his friend Dihau. Moreover, he was not above executing deliberately comic pictures which he sent (between 1886 and 1890) to the *Salon des Arts Incohérents* where all the humorous illustrators exhibited. And at the same time Lautrec contributed humorous illustrations such as *Gin Cocktail* (1886; page 40), *The Trace Horse of the Omnibus Company* (page 71), *First Communion*, and *Masked Ball* (all 1888) to newspapers and reviews like *Le Courrier Français*, *Le Mirliton*, *Paris Illustré*, and *La Chronique Médicale*. But Lautrec had no great success with these illustrations, partly because every editor already had his team of illustrators – Forain, Steinlen, and Willette were the most sought after – and partly because the public

development was Rouchon, and it was also his idea to employ young painters to make the designs. Gradually the idea caught on and more and more painters began to enter the commercial field. Thus in 1868 Manet designed a poster for Champfleury's book *Les Chats*, and in 1872 Daumier designed one for a coal merchant. However, a second and even more humorous type of artistic poster designed by caricaturists and illustrators – Gill, Grévin, Cham, Randon, and others – was more common.

The real development of the artistic poster on a big scale began when the hand press was supplanted by the mechanical press, an innovation for which Jules Chéret was responsible in France. Chéret, an artist by training, had learned the technique of mechanical printing in England, where he was employed for several years by Rimmel, the perfumer, before returning to Paris in 1866. He made an immediate success with his posters – all designed and printed by himself – which were much more spirited, witty, and attractively colored than anything

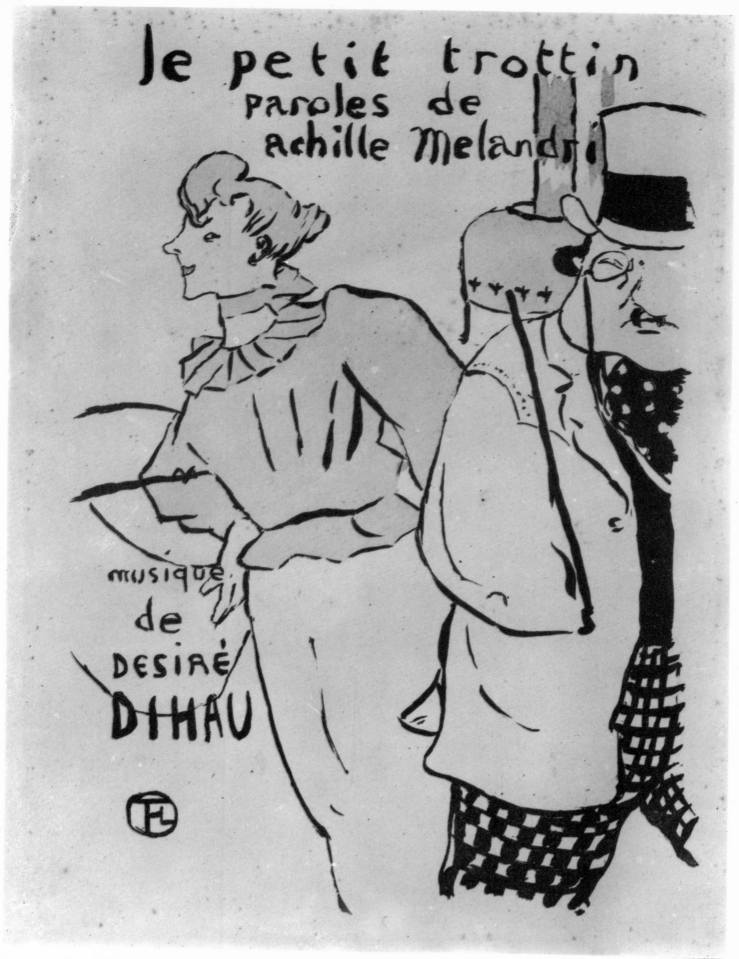

THE LITTLE ERRAND-BOY (le petit trottin). 1893. Lithograph, 10 3/4 × 7 5/16″. First state: Before insertion of the name and address of the publisher

39

GIN COCKTAIL. 1886. Charcoal, 18 3/4 × 24 3/8". *Museum of Albi*

wanted outright caricature and did not see the humor in his type of ironical social comment. He could not even make his name known through the sale of his lithographs because, until 1894–1895, when print collecting once more came into fashion, no-one would buy them. So when, in 1891, Lautrec was asked to design a poster for the Moulin Rouge – the poster to announce its opening in 1889 had been designed by Chéret – he leaped at the opportunity. The result was the most vigorous and uncompromising poster yet seen on the walls of Paris. From every point of view it was a novelty, not least on account of its complexity and its bright colors. In place of the light but essentially pretty color and composition of a poster by Chéret, with capering Harlequins, Pierrots and Columbines, or a cohort of masked revelers, or a bevy of "appetizing Chérettes," as they were called, kicking their legs in the air and rocking with laughter, Lautrec boldy devised a rather serious

image with no sentimental or lascivious appeal. His poster, in fact, depicted just what a spectator could see "every night of the week." In the center, the focus of all eyes, is La Goulue solemnly dancing and displaying to the full her billowing white petticoats. Across the foreground sidles her gaunt partner, Valentin, drawn as a transparent silhouette but outlined in such a manner as to emphasize his personality. In the background is a line of spectators in pure silhouette. Here the influence of the Japanese is unmistakable in the very foreshortened perspective lines of the floor, the dehumanized mask which serves as a face for Valentin, and the boldly cut-out figures. The *Art Nouveau* tendency is no less apparent in the meaningless trifoliate form on the left, which is echoed in the top right corner, as well as in the stylized hat ornaments. Yet for all its brilliance this poster was a beginner's effort, because its color arrangement was too elaborate and because the lettering was not integrated

40

into the general composition. For his next poster, *Le Pendu* (1892; page 42), commissioned by a newspaper, *La Dépêche de Toulouse*, to advertise a series of articles on crime, Lautrec abandoned color in favor of a black-and-white design in the manner of Daumier and omitted all lettering, this being printed on separate sheets which were stuck above and below the drawing. But when he came to work on the poster for the Divan Japonais and on the advertisement for *Reine de Joie* (page 50), a popular novel, he reverted to color, albeit in a more simplified form, and found a way of incorporating the lettering as a decorative element into the design. From that moment his supremacy in this field was beyond question. Lautrec's advance on Chéret, to whom he owed a great deal even though he broke away from the style which his predecessor had created, is obvious, but it is also easy to measure his superiority over any other young painter working in this field. For in 1891 Bonnard, too, designed his first poster – *France Champagne* – a garish and clumsy design imitative of Chéret, and he followed this in 1892 with the jacket for *Reine de Joie* for which Lautrec designed the poster. The two works have only one element in common: *japonaiserie*. Whereas Lautrec's poster had a bold, clear design enlivened by witty characterization and was pleasing to look at, Bonnard covered the jacket with a rambling decoration which was overladen and incoherent. Where Lautrec showed a real grasp of form, an acute sense of the visually effective, and an ability to create something new with his borrowings, Bonnard's sense of form was deliquescent, he failed to produce a telling or humorous effect, and the element of *japonaiserie* was applied to his design as a smart and piquant embellishment. Lautrec's poster was an effective image, Bonnard's jacket a meaningless pattern.

Altogether Lautrec designed thirty posters. His most productive years were 1893–1895, when his output was four or five each year, and 1896, when it rose to eight. His remaining posters date from 1891–1892 (six in all) and 1899–1900 (two). Some were commissioned by actors and cabaret artistes such as Bruant, Jane Avril, May Milton, Caudieux, and May Belfort; others by newspapers and reviews – *Au Pied de l'Echafaud, La Revue Blanche, Irish and American Bar, L'Aube* – or by publishers – *Babylone d'Allemagne, Napoléon*; while the rest were executed for a photographer (Sescau), a furniture maker *(L'Artisan Moderne)*, a manufacturer of bicycle chains *(La Chaîne Simpson)*, an English manufacturer of confetti *(Confetti)*, and an American manufacturer of printer's inks *(Au Concert*; page 53). In this field he quickly achieved international renown, and rightly, for this series of posters shows an incredibly fertile imagination at work.

Never did Lautrec adopt a formula: all his posters

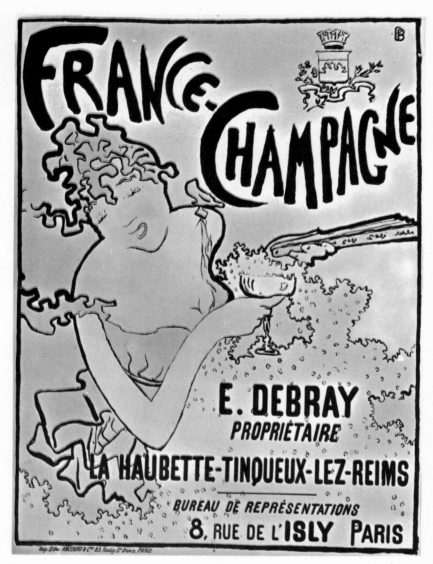

Pierre Bonnard: FRANCE-CHAMPAGNE. 1889. Poster, 30 3/4 × 19 5/8"

are different, and for each occasion he was ready to devise an appropriately striking image. They are also remarkable because this eye-catching effect does not destroy the pleasing and decorative qualities of the whole and because it is produced with great economy in the use of the pictorial means. This is beautifully demonstrated in his greatest poster, *Jane Avril at the Jardin de Paris* (1893; page 52). The full-length figure of the dancer is set in a very shallow area of space and framed by an encircling line which comes out of one end of the neck of the double bass and rejoins it again at the other. We feel that we are seeing Jane Avril magnified through a sort of quizzing-glass held up by the hand in the bottom right corner. By its scale, its weight, and the fact that there is no color elsewhere in the design, this figure dominates the composition, but Lautrec has balanced it by his exaggerations in the drawing of the instrumentalist (or such parts of him as one sees) in the immediate foreground. Furthermore, these two figures are cunningly linked in a single plane by a use of false perspective, and they are related to each other by a rhythmic corre-

41

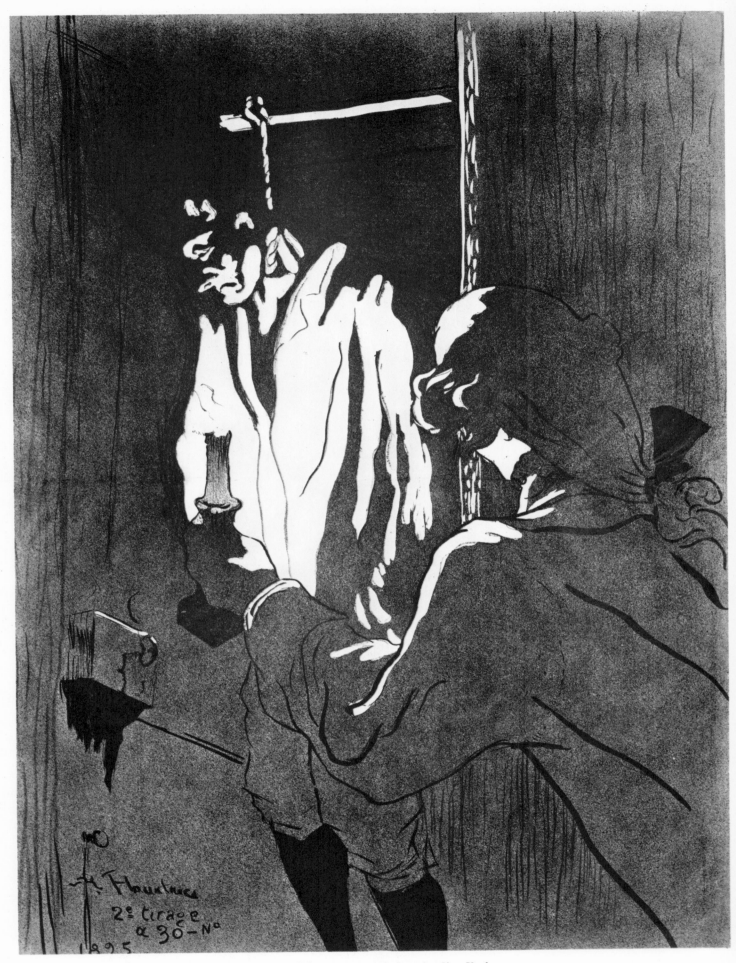

THE HANGED MAN *(Le Pendu)* 1895. Poster, 27½ × 18¾". *Museum of Modern Art, New York*

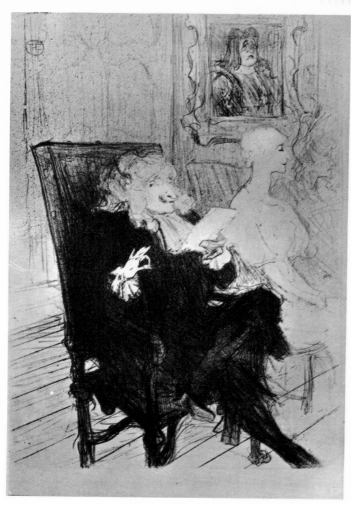

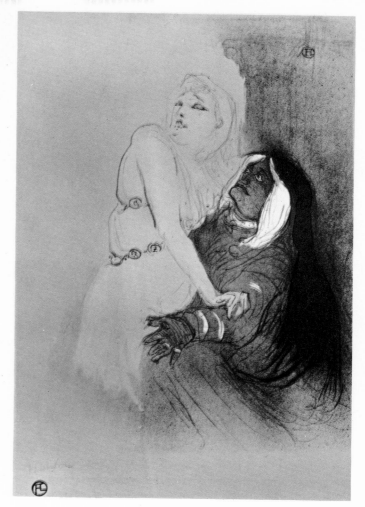

LELOIR AND MORÉNO in *Les Femmes Savantes*. 1894. Lithograph,
14 3/4 × 10 3/8″

AT THE RENAISSANCE: SARAH BERNHARDT IN PHÈDRE.
Lithograph, 13 1/4 × 9 1/16″

spondence between the form of his locks and the bottom
of her skirt. This is an outstanding example of how
Lautrec could take a few elements of reality, juggle with
them and produce, for example, an image suggesting
vivacious gaiety simply by the way he used pure color and
linear rhythm. In this respect he was both a pioneer
and a master.

Lautrec did not confine his "commercial" work to
posters. He always took a great interest in the theater,
as is proved by the preponderance of theatrical subjects
among his lithographs: portraits of famous actors and
actresses — Marcelle Lender, Jeanne Granier, Cléo de
Mérode, Réjane, Polaire, Brandès, Lucien Guitry, and
Coquelin *aîné* — as well as episodes during performances —
Leloir and Moréno in *Les Femmes Savantes*, Lugné-Poë
in *L'Image*, Bartet and Mouny-Sully in *Antigone*, Sarah
Bernhardt in *Phèdre*, Réjane and Galipaux in *Madame
Sans-Gêne*. Always it was the personality of the actor or
some characteristic of his performance which fascinated
Lautrec rather than the actual content of the play. But
through his friendship with two artistically minded actor-
managers, Antoine and Lugné-Poë, whom he met in the

circle of the *Revue Blanche*, Lautrec was persuaded to
make his contribution to the practical needs of the
theater as well. Between 1893 and 1897 he lithographed
programs for nine theatrical productions, as well as a
prospectus to advertise the 1895–1896 season at the
Théâtre de L'Oeuvre. These are not on the whole
successful works, for they are tasteful and insipid, yet
exceptions must be made for the brilliant and witty *La
Loge au Mascaron Doré* (1894), which owes everything
to Degas, and for the program for *L'Argent* (1895), which
is as bold in conception as a poster. The weakness of these
programs arises out of Lautrec's failure to find a correct
formula for the occasion; his drawing spreads across the
page leaving no room for the text, which therefore has
to be crowded into a corner and printed over the design,
with the result that it is difficult to read. He does not
seem to have been happy working on such a small scale
except when, as in a menu-heading or an invitation card
(pages 44, 46), no more was needed than a humorous
drawing and a brief inscription of some sort.

The more one studies that part of Lautrec's work which
can be called "commercial" — posters, programs, covers for

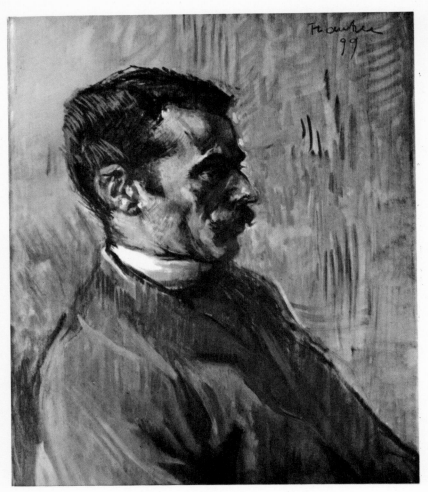

PORTRAIT OF A WARDER IN THE CLINIC AT NEUILLY. 1899. Oil, 16²/₈ × 14¹/₈″.
Museum of Albi

experienced a few brief attacks of madness, which were followed in January 1899 by a complete mental breakdown. During three months he was interned in a sanatorium, where he rapidly recovered and, to prove his sanity to the doctors attending him, made some portraits of other inmates and the attendants, and then started on an elaborate series of circus scenes form memory (page 46). These last, stilted and awkward, lack the *brio* of his earlier work; nevertheless, one cannot help admiring the astonishing retentiveness of his visual memory when one considers that probably for the first time he was working without a direct visual stimulus.

When Lautrec left the sanatorium in May he painted a few pictures in bars at Le Havre while waiting for a boat to take him to Bordeaux. He did not try to work seriously again, however, until he returned to Paris in December 1899. But then he also resumed his drinking habits, and from this date his work rapidly deteriorated. Gone is the biting, swinging line and the clearly defined image of the draftsman; instead his paintings are executed in a "painterly" style based on tonal values. There is no obvious explanation for this sudden change, unless it be that Lautrec could no longer control his hand sufficiently to continue working in the dry, precise style of the

INVITATION ALEXANDRE NATANSON. February 1895. Lithograph, 10⁷/₈ × 6¹/₈″. First state: Before lettering

songs (pages 32, 39), books, or catalogues, and so on – the more impressive it seems. His images were always visually comprehensible and pointed, they also reflected the life of the day; the general effect of his design was decorative but not too elaborate; and lastly his posters were easy to read because (unlike nearly all of his contemporaries) he used good clear lettering as a vital element in his design. Remove the lettering from any of Lautrec's posters and one is left with an incomplete design, a picture without a purpose.

Lautrec led a full and busy life, the many facets of which are reflected in the works of his great period (1888–1898). Almost any violent manifestation of life seems to have attracted him, especially if it was accompanied by some display of creative artistry. Nevertheless, he worked regularly and extremely hard all the time. But in order to achieve what he did, Lautrec was obliged to lead an increasingly dissipated life, which involved making a nightly round of the cabarets, dance halls, and bars of Montmartre, living in brothels, and drinking to excess. All this was too much to ask even of the most robust constitution, yet for many years his hand did not falter. However, after 1897 his physical and mental condition began noticeably to deteriorate. Then, in 1898, he

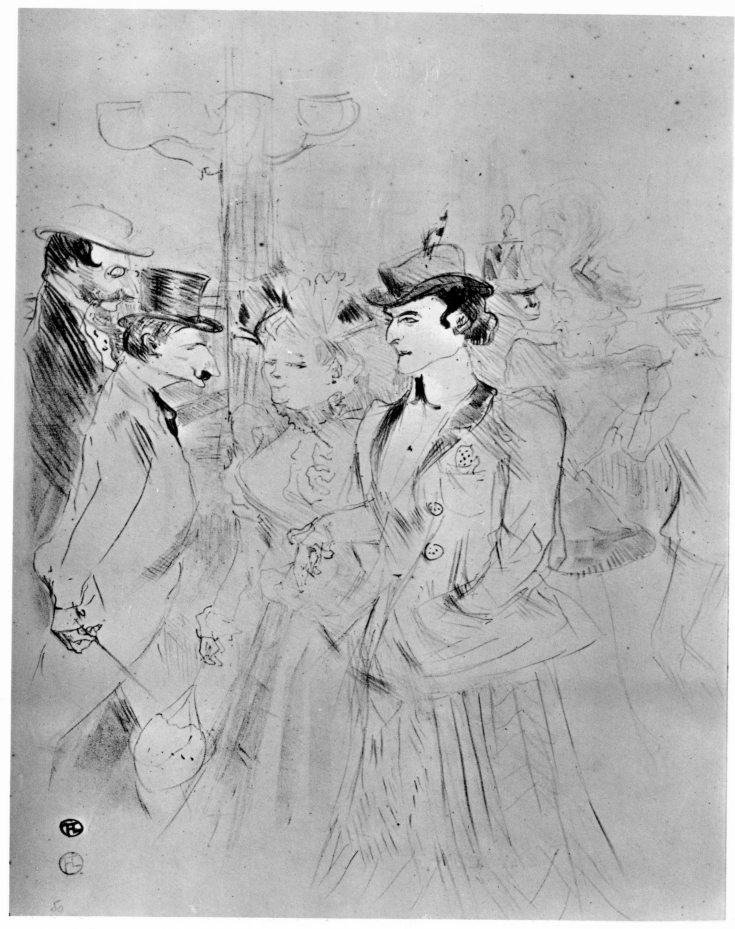

THE FOYER (Le Promenoir). 1899. Lithograph

COUNTRY OUTING (Partie de Champagne). 1897. Lithograph, 15 3/4 × 22 1/2″

INVITATION TO A GLASS OF MILK. May 1900. Lithograph, 10 7/16 × 8 1/16″. (Henri de Toulouse-Lautrec will be overjoyed if you will accept a glass of milk Saturday, May 15 at about half past three in the afternoon)

AT THE CIRCUS: The Equestrienne. 1899. Drawing in black and colored crayon, 13 1/8 × 9 1/8″. *Private collection*

previous decade. Yet he slipped easily into this new manner of painting, although it seems unnatural to him, and in his best late pictures – *In a Private Room at the "Rat Mort"* (page 145), or *The Modiste* (page 149) for example – his sensuous use of paint suggests that perhaps he had lost something of value to his work by suppressing a natural aptitude. But in most of them – *At the Races* (1899), the *Messalina series* (1900; page 151), the *Bois de Boulogne* (1901) or *An Examination at the Faculty of Medicine* (1901) – he fumbled, and the greater number of these pictures can only be described as a heavy-handed and tragic aftermath to a decade of exceptional brilliance. This last period was, however, of short duration. In March 1901 Lautrec had another breakdown and on September 9 of that year he died at Malromé, aged thirtyseven.

The problem of situating Lautrec as an artist is not easy, because he cannot be reckoned among the very great, not even in his own period, although one would not wish to deny the obvious importance of his very personal contribution. From a historical point of view, he was a vital link in the chain of reaction against Impressionism, against *la belle peinture* as such, and against the cosy, smug little bourgeois world which the Impressionists depicted. Yet although Lautrec was very much a *fin-de-siècle* artist, he was not a reactionary. Stylistically he takes his place along with Seurat, Gauguin, and van Gogh, and stands in sharp contrast to belated Impressionists such as Bonnard, Vuillard, and the other Nabis. Yet his work as a whole suffers from one consistent weakness: his evasive handling of spatial problems. Being of his time he had a respect for the flat surface of the canvas, which inhibited him from giving his subjects that deep spatial setting which they needed. But he was not prepared to flatten his figures as the Synthetists and the Nabis did, because this made them too artificial, nor on the other hand did he try to create a spatial illusion with color applied in the manner of the Divisionists, probably because the technique seemed to him too laborious. Much of Lautrec's painting is therefore vitiated because his figures, so vital and naturalistic, are forced to exist like bas-reliefs against a sort of backcloth with vague spatial indications. Nothing is, as it were, exactly situated. Here a gulf is fixed between Degas and Seurat on the one hand, and Lautrec on the other. However, it must be emphasized that Lautrec introduced a new element of real humanity into art, and greatly enlarged the scope of its subject matter. All the same, he was not a great innovator, though he made one contribution to painting which is unique: his open-minded and outspoken attitude towards sex. Man's sexual activities form the subject of many of Lautrec's greatest pictures and lithographs, yet this was not in itself greatly daring during the 1890s since eroticism was very much in the

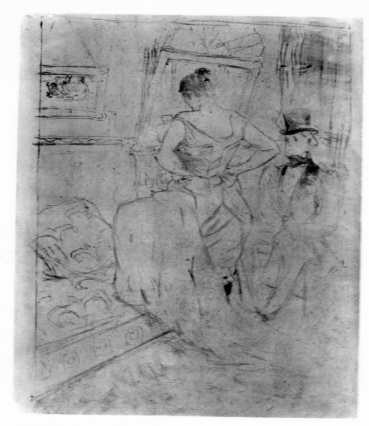

A PASSING FANCY. 1896. Lithograph, 20 1/2 × 15 3/4″

air. Lautrec's daring was in recording frankly and dispassionately without prettification or *galanterie* what he observed in a bar, in the salon of a *maison close*, or even in the privacy of a bedroom, and in leading us to the conclusion that fundamentally there is nothing to choose between the instincts and behavior of one class of woman and another. No less remarkable is his ability to handle sexual themes in such a way that his pictures are never salacious or disgusting, because he never played up the element of grossness or vice, and resisted the temptation to be shocking or sensational.

As an artistic personality, Lautrec is entitled to a high place among his contemporaries because he made no concessions to popular taste. That is already a great deal. No less remarkable is the fact that his pictures were about life at a moment in the evolution of art when this was not exactly fashionable. However, if we wish to situate Lautrec in a true perspective we must take into account the literature of the period, for it is impossible to detach his work from a background formed by the novels of naturalist or realist writers like Flaubert, the brothers Goncourt, Zola, and Maupassant. But we must not stop there, because Lautrec's pictures are also precious historic documents which tell us as much as, if not more than, many a novelist or historian can about the life and moral outlook of his generation. That gives them a special value in addition. For the rest, Lautrec was one of the most amazing and engaging personalities in the history of art.

PETIT HOMME, GRAND ARTISTE. c. 1890.
Collection Bibliothèque Nationale, Paris

POSTERS AND LITHOGRAPHS
IN COLOR

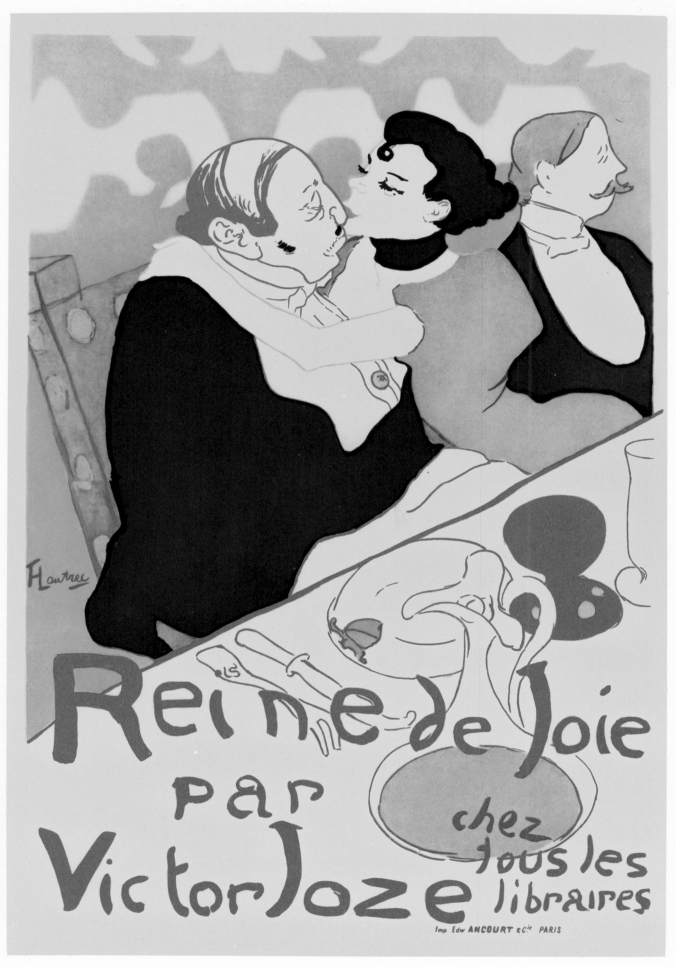

REINE DE JOIE. 1892. Colored lithographic poster, 51 1/8 × 35 1/4"

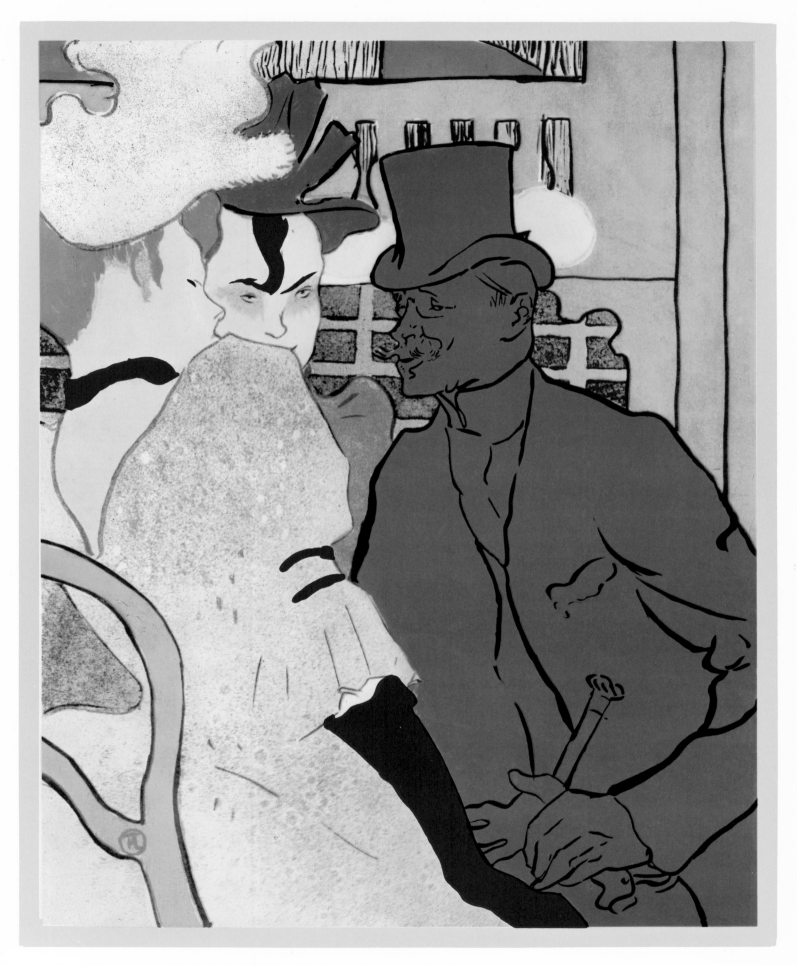

THE ENGLISHMAN AT THE MOULIN ROUGE. 1892. Colored lithograph, 18 $1/2 \times 14$ $5/8$"

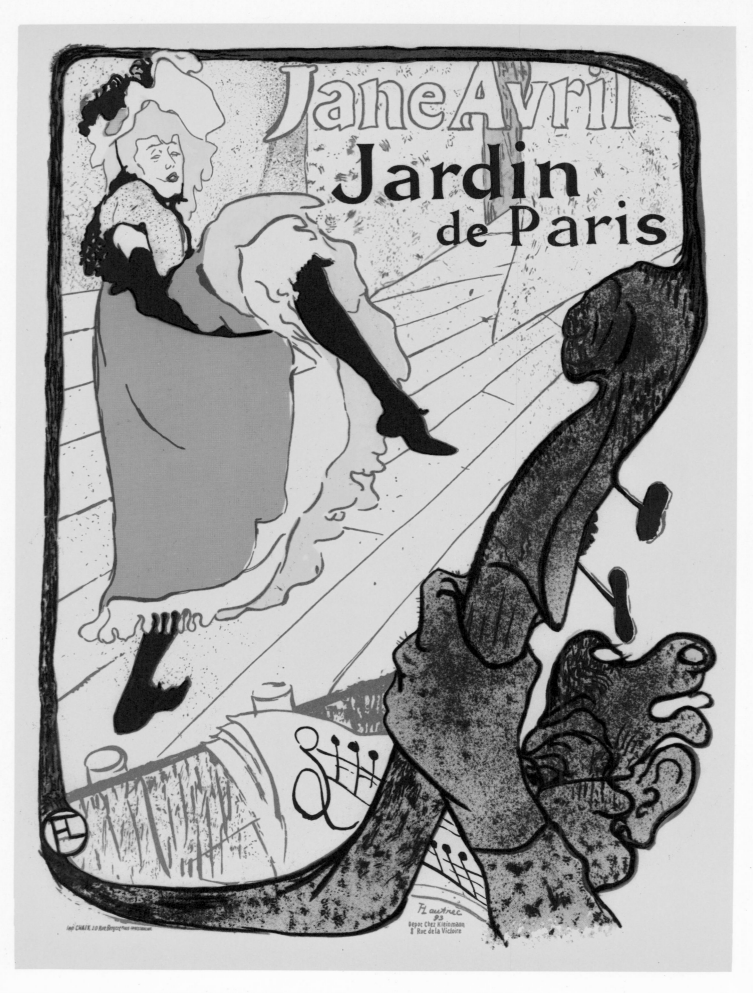

JANE AVRIL AT THE JARDIN DE PARIS. 1893. Colored lithographic poster, 51 $^1/_8$ × 37 $^3/_8$"

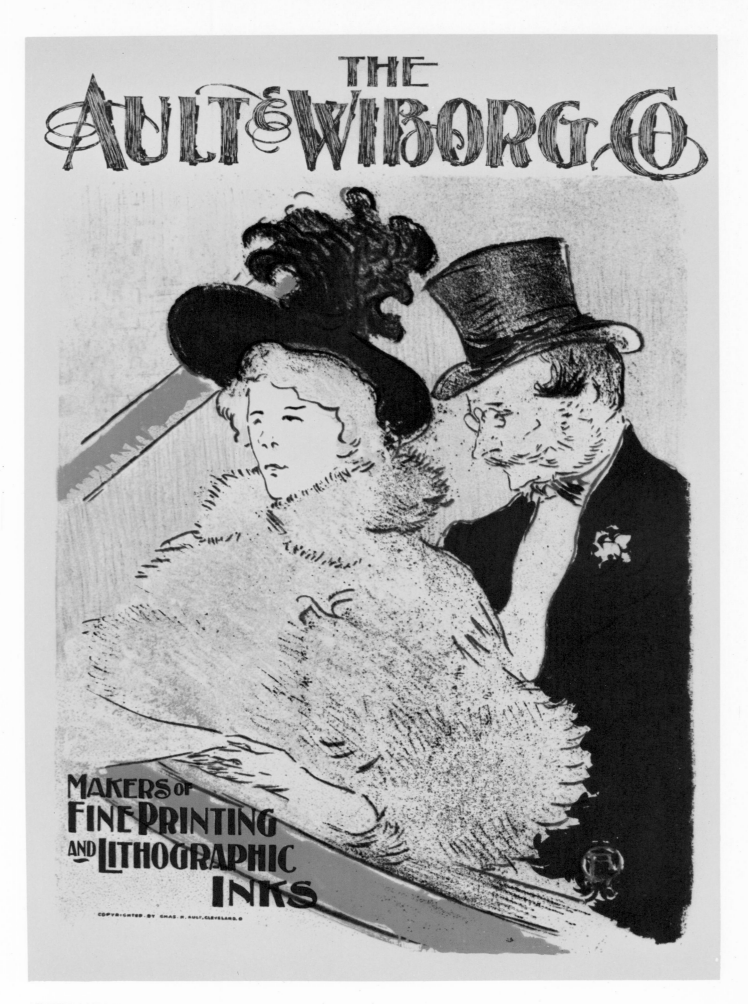

AT THE CONCERT. 1896. Colored zincographic poster, 12 $\frac{9}{16} \times 9 \frac{13}{16}$"

THE ACTRESS MARCELLE LENDER. 1895. Colored lithograph, 12 × 8 ³/₄"

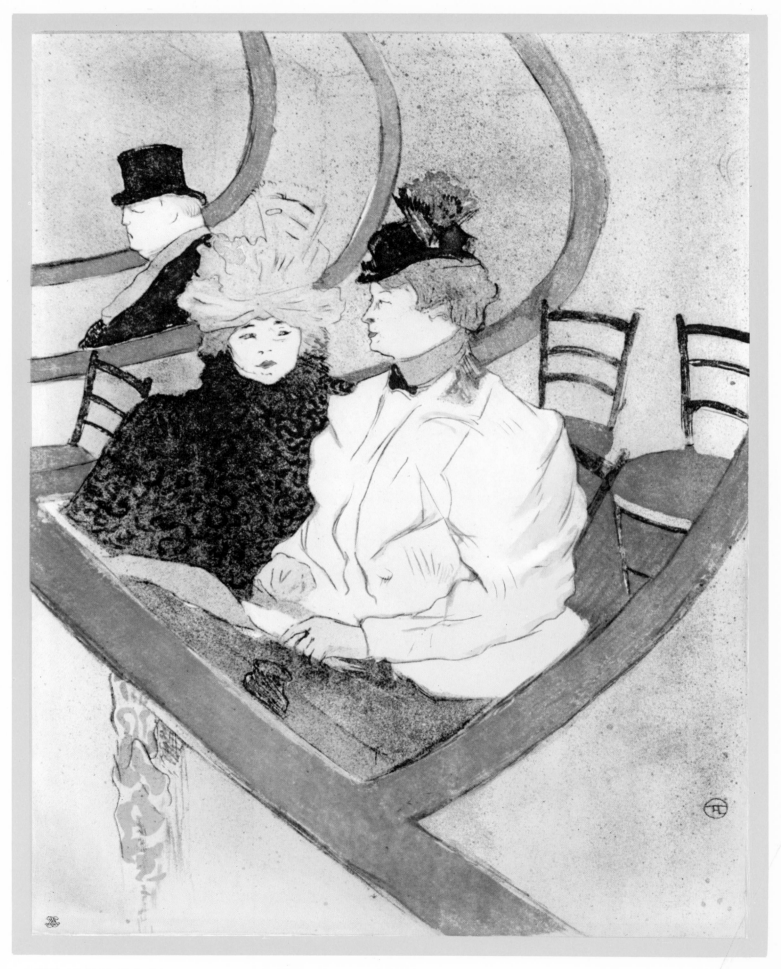

A BOX AT THE THEATER. 1897. Colored lithograph, 20 1/8×15 3/4"

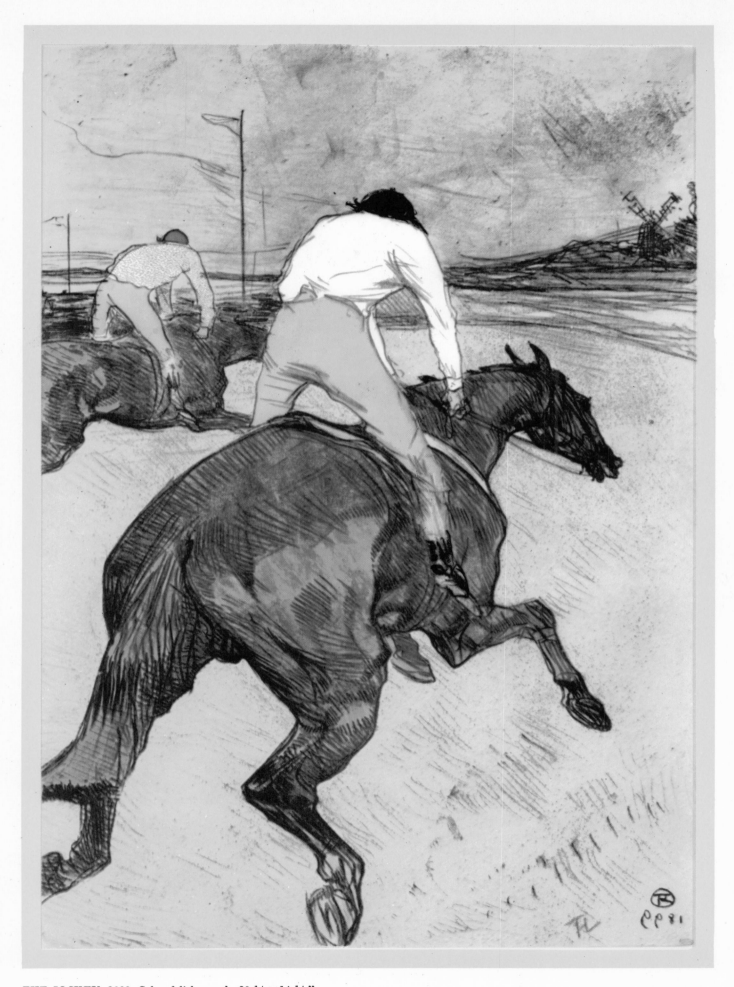

THE JOCKEY. 1899. Colored lithograph, 20 $\frac{1}{4}$ × 14 $\frac{1}{8}$"

PAINTINGS AND PASTELS
IN COLOR

Painted in 1881
THE FALCONER:
COMTE ALPHONSE DE TOULOUSE-LAUTREC
$9^1/_4 \times 5^1/_2''$
Museum of Albi

This painting, executed probably at Céleyran or Le Bosc in the autumn of 1881, when Lautrec was seventeen, shows his father (1838–1913) setting out on a hunting expedition with one of his falcons. He is dressed in picturesque fashion as usual – a white Circassian tunic and a turban – and even his horse is equipped with an Arab bridle.

The ineptness of Lautrec's draftsmanship at this stage is clearly evident in the clumsy and rigid fore leg of the horse, and in the confused placing and anatomy of its hind legs. Nevertheless this is a lively group.

It is interesting to compare this painting with a similar drawing of a jockey made at Nice in the summer of the previous year (in a sketchbook belonging to The Art Institute of Chicago). Both have the same faults, but the drawing is much more schematic. Lautrec's most successful childhood works were those in which he represented violent movement, for example *Trotter* (page 18).

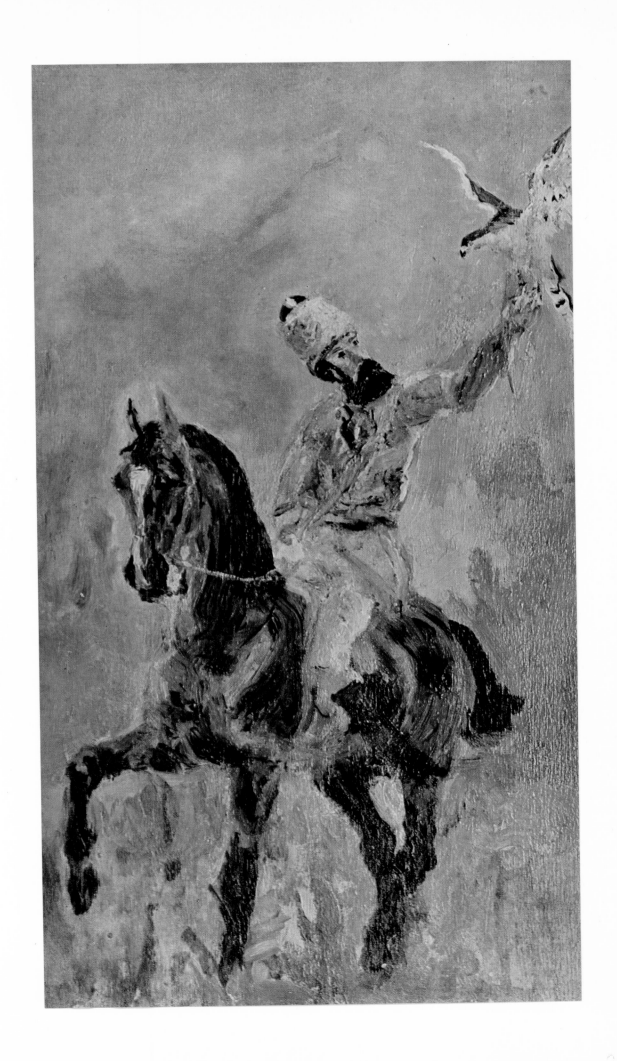

Painted in summer 1882, Céleyran
YOUNG ROUTY
$23^{5}/_{8} \times 19^{1}/_{4}''$
Collection Comte d'Anselme, Paris

This picture illustrates the considerable technical progress which Lautrec made during the six months which he spent working under Bonnat in Paris in the spring of 1882. His drawing has become more sure and his brushwork less clumsy, but at the same time Lautrec shows here that he can paint in a "modern" idiom.

This is not an "academic" painting in the sense that Bonnat would have understood the term, for both in conception and in execution it clearly owes a great deal to the open-air painting of Manet, in particular to pictures such as *Portrait de Mme. Manet à Bellevue* and *Fillette sur un Banc*, both of 1880. Gone are the brown shadows and chiaroscuro effects which Lautrec used in his paintings between 1879 and 1881; instead, light is suffused throughout the whole picture and this light is translated into terms of color.

Lautrec posed his sitter, a farm hand, with the light coming from behind his back, so that the whole foreground plane (his face and shirt) is illuminated indirectly. This in itself was daring because it meant that he had to tackle difficult technical problems and a difficult color analysis. Yet in the handling of the face at least, with its subtle tonal modulations from orange to blue, Lautrec was successful. *Young Routy* is not, however, a true Impressionist picture because the artist has not broken down local colors into the component colors of the spectrum, because, that is to say, he makes the blue-gray-yellow color harmony evoke the effect rather than the quality of light. Moreover, no Impressionist painter would have outlined the boy's shoulder and the brim of his hat with white high-lights as here. Note also the draftsmanly treatment of the ear and chin.

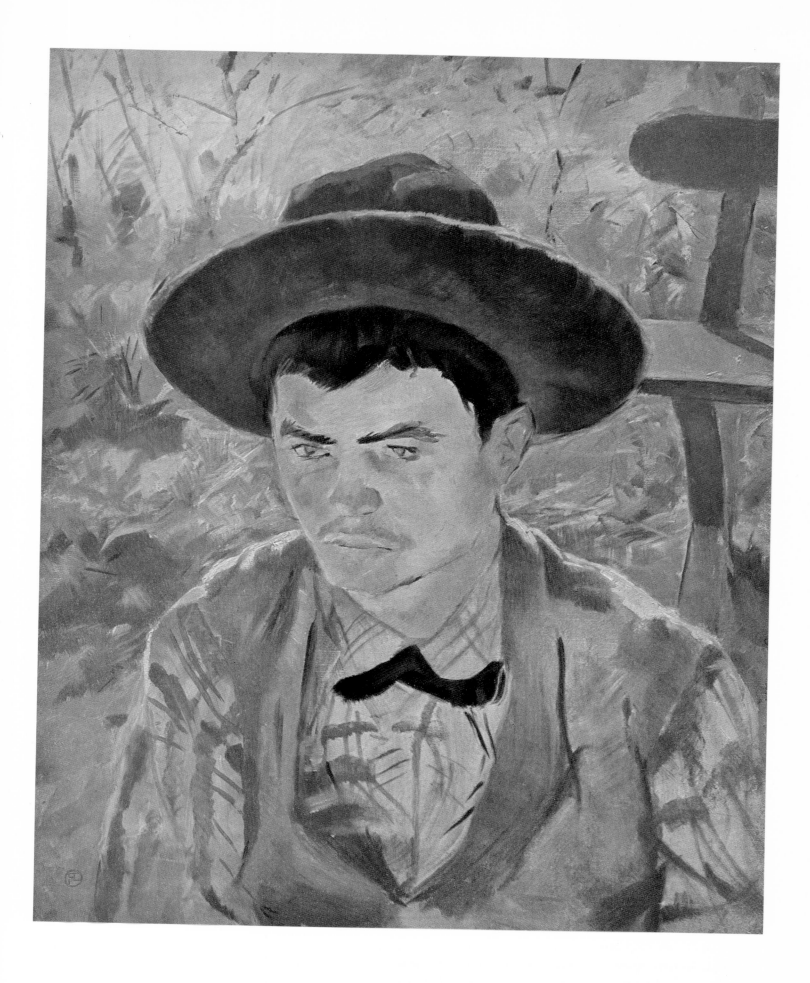

Painted in 1884, Paris
FAT MARIA
31 1/2 × 25 5/8"
Collection Baron von der Heydt, Ascona, Switzerland

This picture is the exact opposite of *Young Routy*. In a sense it is
a retrograde step, because Lautrec has exchanged the open air and
sunlight for the seclusion of the studio with its diffused light. Con-
sequently his picture has a certain air of unreality, his brushwork
is less free, and he has reverted to using chiaroscuro. But against
this we must set the fact that the composition is more deliberate,
the drawing more assured, and the physical reality of the body
more felt. The hands are out of scale with the rest, and the handling
of the legs in the foreground is inept, yet the upper part of the body
is well-realized.

In conception this picture clearly owes something both to Courbet
and to Degas. But where Degas would have remained emotionally
aloof from such a subject, Lautrec has not hesitated to draw our
attention to the contempt and disillusion which is written on the
face of this ageing prostitute.

This picture may be compared with the not-dissimilar *Nude
Sewing* by Gauguin, in the Ny Carlsberg Glyptotek, Copenhagen,
executed in 1880 – a more competent but less original work.

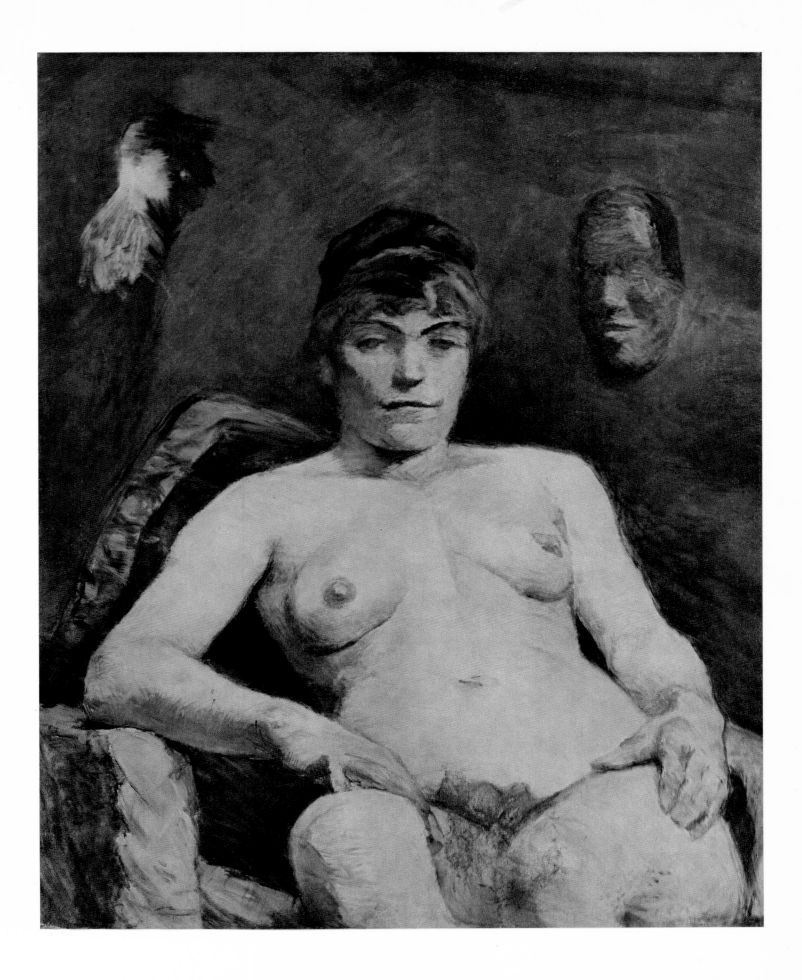

Painted in winter 1885, Paris
PORTRAIT OF ÉMILE BERNARD
21¹/₄ × 17³/₄"
Collection Arthur Jeffress, London

This charming portrait of a fellow-student at Cormon's marks a great advance. Here at last Lautrec has begun to display that technical mastery which he went to Paris to learn. Once again this is not an "academic" but a "modern" portrait, which in conception and execution owes a great deal to the Impressionists, especially to Renoir. It is a well-composed picture, finely and fluently painted, and the figure has an easy naturalistic pose. According to Émile Bernard, this portrait required thirty-three sittings, during ten of which Lautrec worked almost entirely on the background.

Émile Bernard (1868–1941) entered Cormon's studio in 1885, and this portrait was painted towards the end of that year when Lautrec was already working on his own. Bernard was a more revolutionary student than Lautrec and seems to have taken his academic training less seriously. For, at the beginning of 1886, Cormon found him painting a nude in streaks of emerald and vermilion and thereupon dismissed him. A few months later Bernard went to paint in Brittany, where he fell in with Gauguin at Pont-Aven. Then, after his return to Paris in the autumn of 1886, Bernard became very friendly with van Gogh, who had begun to work at Cormon's a few months previously; during 1887 Bernard and van Gogh frequently worked together in the neighborhood of Asnières, where the former had a small studio. In 1888, after Gauguin's return from Martinique, Bernard went to join him again at Pont-Aven during the summer, and together they evolved the style known as Synthetism.

Bernard always claimed that he was actually the inventor of the style, and indeed his first attempts at simplification probably were made in 1887. But Gauguin, a far more intelligent and gifted painter, was able to take over Bernard's ideas and perfect them in practice.

In the 1890s Émile Bernard settled in Cairo, and on his return from there in 1904 went to Aix-en-Provence to seek out his so-called *"premier maître d'élection"*, Paul Cézanne, about whose work he had written a laudatory article in 1892. The friendship between Bernard and Lautrec was of short duration, and never intimate.

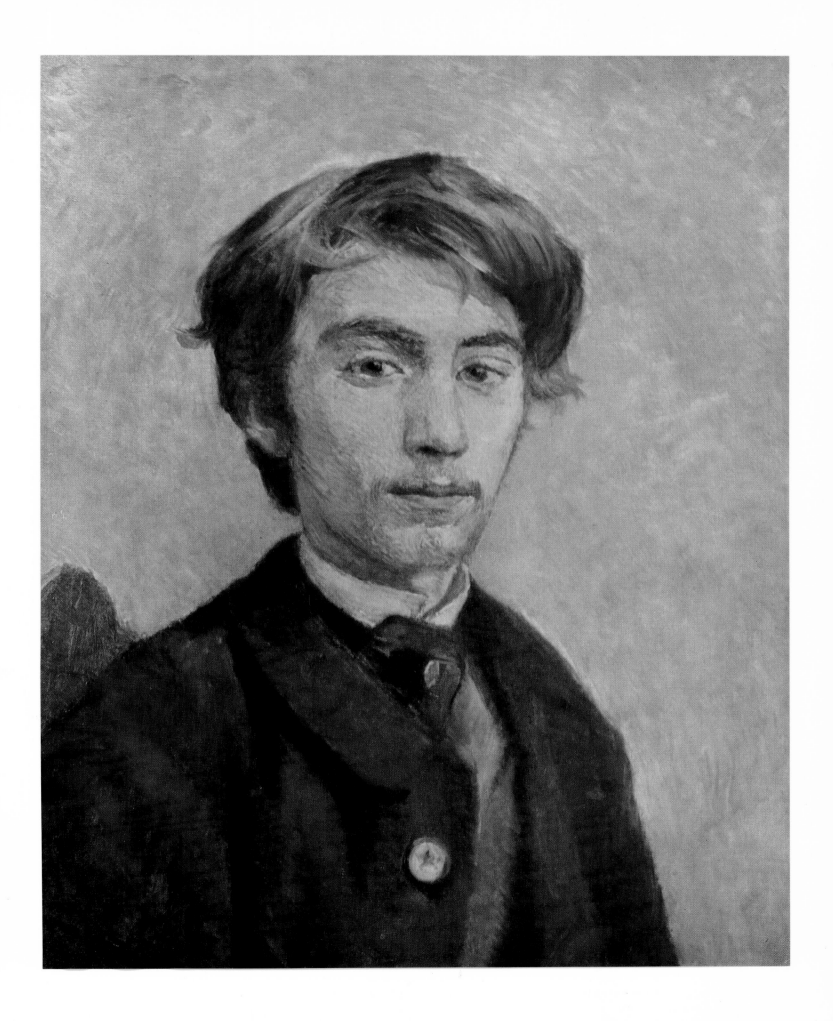

Painted in summer 1887, Malromé
PORTRAIT OF THE COMTESSE A. DE TOULOUSE-
LAUTREC IN THE SALON AT MALROMÉ
21¹/₄ × 17³/₄"
Museum of Albi

All Lautrec's portraits of his mother reveal the respect and affection he felt for her. Between 1880 and 1885 the Comtesse was the subject of three charcoal drawings and three oil paintings, all serious and dignified portraits, which are of particular interest because in this one subject it is possible to follow the stages of her son's artistic progress. Of the oil paintings, the first (1882) shows his mother seated on a bench in the garden at Malromé reading, and is painted in an Impressionistic manner like *Young Routy;* the second, an interior scene (1883) showing the Comtesse at breakfast (page 22), is a blond harmony of white and gray reminiscent of Berthe Morisot, which makes an interesting contrast with the present picture, the third of the series.

This portrait of Lautrec's mother is based on a painstaking, academic charcoal drawing executed in 1885 (page 26). Again, it is painted in an Impressionistic manner, influenced this time by Monet and Pissarro. Yet Lautrec has not blindly followed Impressionist usage, for there is nothing casual about the composition with its elaborate play of lines and curves in the furniture. More significant is the fact that the figure of the Comtesse, like that of *Young Routy,* stands out from and dominates her surroundings and is not enveloped in a general effect of light. She has been brought into the immediate foreground and, even though this is not a portrait of great psychological insight, the emphasis is on her human presence.

Lautrec's mother (1841–1930) was a quiet, cultivated lady, who took charge of her son's early education and remained devoted to him throughout her life. After separating from her husband, she lived at the Château de Malromé, near Bordeaux, which she bought in 1883; but in 1893, when Dr. Bourges, with whom Lautrec lived in Paris, got married, she took an apartment in the Rue de Douai in order to provide her son with a home. In 1922 the Comtesse presented the contents of Lautrec's studio to his native town of Albi, where they are now exhibited in the Museum in the Palais de la Berbie.

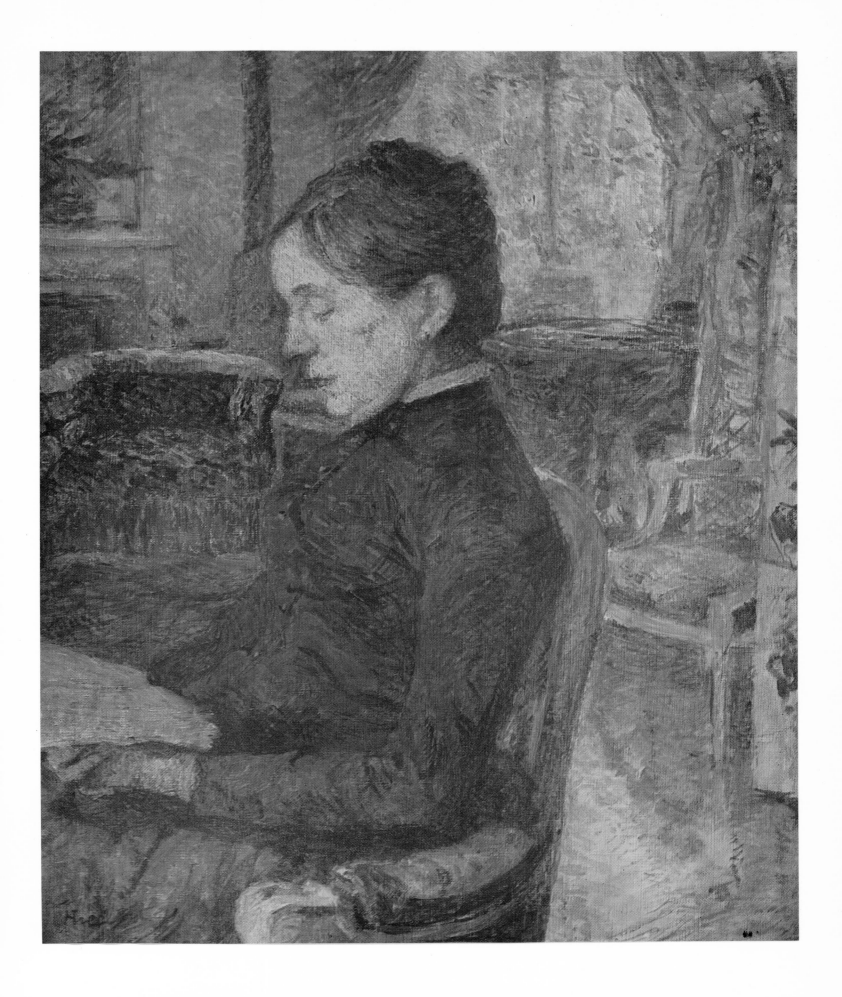

Painted in 1887, Paris
PORTRAIT OF VINCENT VAN GOGH
22 1/2 × 18 1/2"
Collection Ing. V. W. van Gogh, Laren, Holland

Vincent van Gogh arrived in Paris in March 1886 and joined Cor-
mon's studio soon after, but he did not come to know Lautrec until
the autumn of that year. However, from then until Vincent's depar-
ture for Arles in February 1888, the two artists were on very friendly
terms. This portrait, executed probably towards the end of 1887, is
exceptional in being a pastel, a medium which Lautrec only used for
this picture, for the sketch for the *Salon in the Rue des Moulins*
(page 119), and for a few small sketches. It is clearly the product of
close observation of the subject, yet it seems to have been com-
pleted in one sitting; at all events it is an excellent likeness and is
unusually free and effortless.

Both in his choice of colors and in his curious method of working
with a series of hatchings, Lautrec appears to have been influenced
by van Gogh's own style of painting. Van Gogh's influence on the
development of Lautrec's style, both at this date and subsequently,
was more considerable than is generally realized, for it can be traced
in a great many pictures, especially, for example, in the *Portrait of
Justine Dieuhl* (1891). In addition it would seem that Lautrec's
characteristic brushwork — long, broad strokes of rather dry paint —
was to some extent inspired by van Gogh's example in pictures such
as *The Italian Woman* or the *Portrait of Père Tanguy*, also of 1887.

Temperamentally Lautrec and van Gogh were too different ever
to become intimate friends, and we do not know what Lautrec
thought of van Gogh's painting. The latter, however, always had a
considerable respect for Lautrec's work and persuaded his brother
Theo, the manager of the firm of dealers Boussod and Valadon, to
purchase some of his canvases. Van Gogh was perhaps influenced by
Lautrec in his painting *Mlle. Gachet at the Piano* (see page 86).

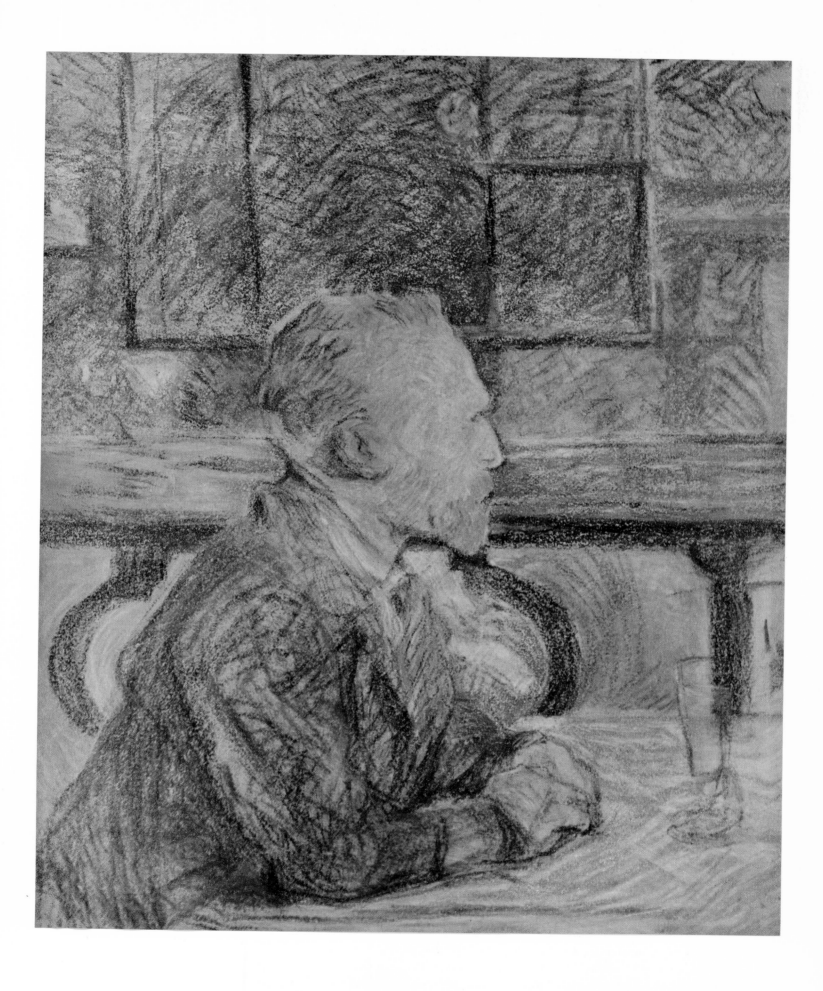

Painted in June 1888, Paris
THE TRACE-HORSE OF THE OMNIBUS COMPANY
31¹/₂ × 20¹/₈″
Collection Jacques Dubourg, Paris

In the field of illustration, Lautrec's output was considerable and it was a type of work which appealed to him. Among the books which he illustrated were Clemenceau's *Au Pied du Sinaï* (1898) and Jules Renard's *Histoires Naturelles* (1899); in 1896 he began on a series of illustrations for Edmond de Goncourt's novel *La Fille Elisa* but this project was never completed.

Most of Lautrec's illustrations were done for periodicals such as Bruant's *Le Mirliton* (1886–1887), *Le Figaro Illustré* (1893–1894), *L'Escarmouche* (1893–1894), *La Revue Blanche* (1894–1895), or *Le Rire* (1894–1897). His first drawing to be reproduced in a paper was *Gin Cocktail* (page 40), which appeared in *Le Courrier Français* on September 26, 1886.

The present drawing is one of a series of four designed to accompany an article by Émile Michelet on "L'Été à Paris", which appeared in *Paris Illustré* on July 7, 1888. It represents the lower end of the Rue des Martyrs, a steep hill in Montmartre leading up from the Boulevard de Clichy towards the Sacré-Coeur. The trace-horse is waiting to be harnessed to the next omnibus which has to climb the hill. On the left, Lautrec himself, wearing a top hat and check trousers, is standing on the rear platform of an omnibus. Bruant had a well-known song about a driver talking to his horse, to which, perhaps, this drawing contains an allusion.

Maurice Joyant, Lautrec's school friend, biographer, and dealer, says that he was as meticulous in his attention to detail when preparing an illustration of this sort as when executing a painting. He began by making a large sketch in charcoal, from which he would then make a series of tracings in Indian ink or wash, until arriving at a drawing with clear and definite outlines suitable for mechanical reproduction. This method of working offered the additional advantage of being labor-saving. There is little color in this drawing because it was to be reproduced in black-and-white.

Painted in 1888, Paris
"IN BATIGNOLLES..."
36¹/₄ × 25⁵/₈"
Collection Andrew Goeritz, London

In 1888 Lautrec painted several pictures of women, Montmartre models, which were acquired by Aristide Bruant and hung on the walls of his cabaret Le Mirliton. Bruant christened these pictures with the titles of some of his own songs about different parts of Paris – *A Montrouge, A la Bastille, A Grenelle,* and *A Batignolles,* the present picture. The refrain of the song in question was:

> *Quand a s'balladait sous le ciel bleu*
> *Avec ses cheveux couleur de feu*
> *On croyait voir eun auréole*
> *A Batignolles.*

This picture is still impressionistic in style and owes a great deal to Manet. At the same time it is more ambitious than the pictures which Lautrec had painted hitherto and the broad, free brushwork is indicative of the gradual development of a more personal style. Note how the background of foliage is painted in such a way as to suppress any illusion of space. The painter has been interested above all by the luminosity of the girl's pale face beneath its "halo" of "flame-colored hair."

72

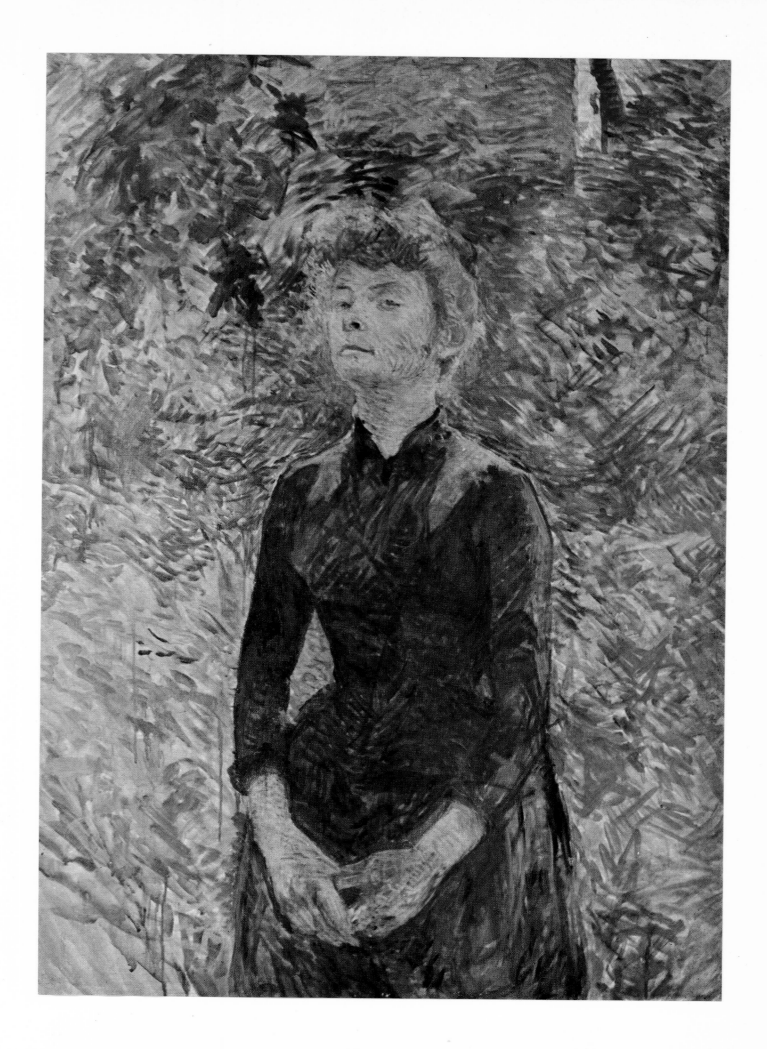

Painted in 1888, Paris
CIRQUE FERNANDO: THE EQUESTRIENNE
38 3/4 × 63 1/2"
The Art Institute of Chicago

This picture is of great significance in the work of Lautrec because it was his first attempt at a composition with several figures, his first great pictorial experiment, and his first circus scene. In it he broke with the naturalistic representation which he had used hitherto, and tried to create a sense of space and movement by new means.

The pictorial space is limited by the curving balustrade of the ring, which divides the picture roughly in half, and the effect of depth is further reduced by looking down on the ring, the plane of which thus rises up the surface of the canvas. The whole action therefore appears flattened, and this effect is heightened by the fact that the distance separating the ring master from the two performing clowns is not precisely indicated, and by the exaggerated fore shortening in the drawing of the cantering horse. As a result all the performers appear to be roughly on the same plane.

It is most instructive to compare this picture with Seurat's last work, *The Circus* (page 33), which resembles it in so many respects. We do not know exactly when Lautrec painted *The Equestrienne*, though it was probably at the end of 1888. At all events, it hung in the foyer of the Moulin Rouge from its opening in October 1889, and we can be sure that Seurat had seen it before starting work on his own composition, which dates from 1890–1891. Thus the resemblance between the two works cannot be purely accidental. But there is a very significant difference between them in terms of stylistic evolution, for whereas *The Equestrienne* was a sudden experiment, *The Circus* was the product of all the pictorial science which Seurat had acquired since embarking on *Une Baignade* in 1883. This is not of course the only reason why Seurat's picture is the more successful. The composition of *The Circus* is firmer, and the picture is not marred by caricature; in addition, Seurat's linear design is allied to a scientific method of applying color which simulates light values and conjures up a greater sense of depth.

It is interesting to note the importance of linear rhythms and expressive outlines in this picture because from now on Lautrec began to rely increasingly on these elements. Note, too, the very simplified use of color here by contrast with *"In Batignolles ..."*

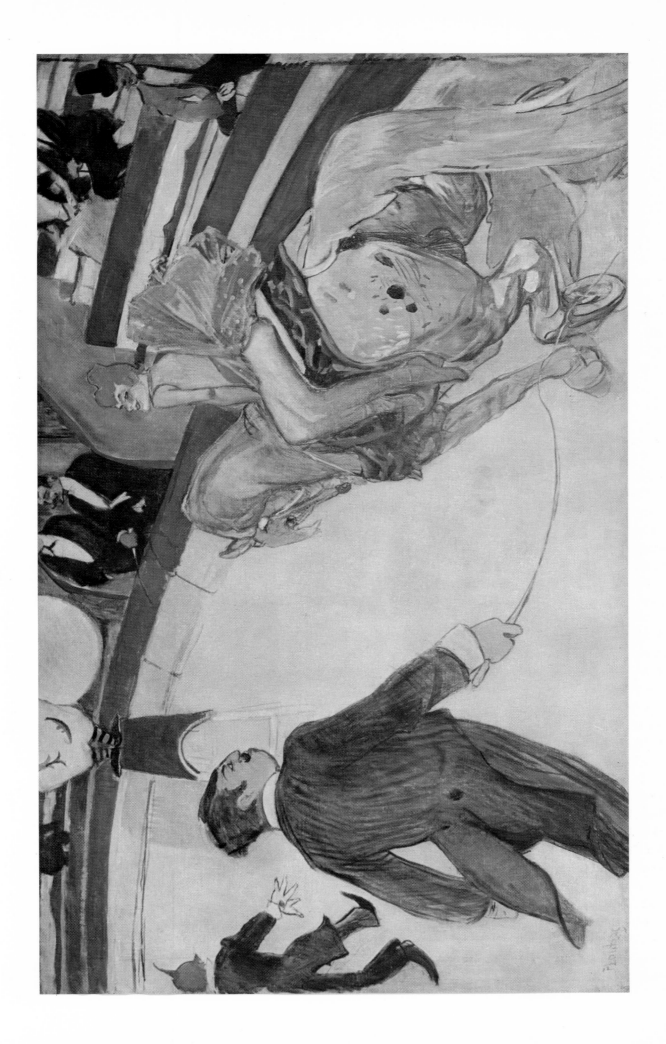

Painted in March 1889, Paris
AT THE MOULIN DE LA GALETTE
35 1/2 × 39 1/4"
The Art Institute of Chicago

Lautrec's second big composition marks a great advance on *The Equestrienne*: the spatial organization is more coherent and the element of caricature has disappeared. The picture is composed in two planes: a background plane with a frieze of dancers and spectators which occupies the upper third of the canvas, and a foreground plane in which are three women and a man in a bowler-hat. The spatial depth of the principal, foreground plane is limited by the abruptly receding diagonal of the back of the bench on which the women are sitting, and this is set off against the counter-diagonals of the floor boards drawn in false perspective.

The picture is further held together by an elaborate structure of verticals and horizontals both in the foreground and in the background; by a contrast of empty and crowded spaces; and by the tension created by the opposing profiles of the girl on the left and the man. Throughout, the Japanese influence is clearly visible.

This was one of the first pictures in which Lautrec developed his characteristic style of painting, using rather liquid paint applied thinly and in broad brush-strokes; the transparency created by allowing the canvas ground to show through gives an added feeling of luminosity and space.

Any crowd scenes which Lautrec had attempted hitherto – *Le Quadrille de la Chaise Louis XIII* or *Bal Masqué*, both of 1883, for example – had been sketchy, confused, and illustrative. Here at last he showed himself capable of managing a more elaborate composition, but already he adopts his typical solution of a few sharply characterized figures in the foreground set off against a vaguely indicated crowd behind.

Lautrec himself attached considerable importance to this picture, which was exhibited at the Salon des Indépendants in March 1889. The man in the bowler-hat is the painter Joseph Albert, a friend of Lautrec and the original owner of this picture. According to Arsène Alexandre, it was through Albert that Lautrec met Degas. The influence of Degas on the conception of this picture immediately becomes apparent when we compare it with his *Café-Concert* (page 25) executed in 1882.

The Moulin de la Galette was the first of the great Montmartre dance-halls frequented by Lautrec, who made several drawings and paintings of the spectacle there between 1886 and 1892. Renoir made a painting of the Moulin de la Galette in 1876.

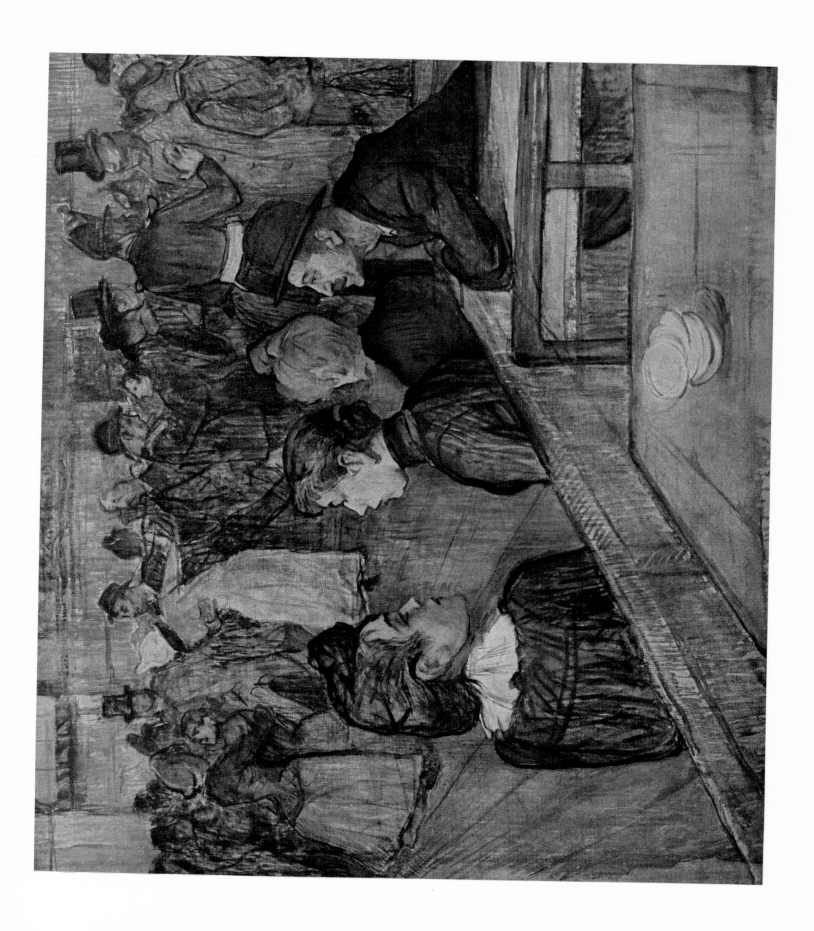

Painted in 1889, Paris
RED-HAIRED GIRL IN A GARDEN
29 1/2 × 23 5/8"
Collection Mrs. Siegfried Kramarsky, New York

At the corner of the Boulevard de Clichy and the Rue Caulaincourt, in which Lautrec had his studio, was a large garden belonging to Père Forest. This garden, which contained an archery range and a *buvette* was open to the public, although it was not greatly frequented. Between 1888 and 1891 Lautrec often made models pose there for him because he liked to escape from the atmosphere of the studio and try painting out-of-doors. Yet the pictures he painted there were not open-air paintings in the strict sense because in them Lautrec was not concerned with the play of light, as he had been for example in *Young Routy* or the Portrait of his mother (1883: page 22).

If we compare the present picture with the portrait of the artist's mother in the salon at Malromé (page 67) and *The Laundress* (page 81), we notice that he does not differentiate between the quality of indoor and outdoor light. Nor does he make any greater effort to render a landscape background than a domestic interior. "Nothing exists but the figure," Lautrec once said to Joyant. "Landscape is nothing, and should be nothing but an accessory. Landscape should be used only to make the character of the figure more intelligible."

In order to perfect his technique, Lautrec painted several pictures each week which were exercises. These he referred to as his *impositions* in order to distinguish them from the more creative work which he was producing at the same time. The present picture is a typical *imposition*, a study painted in a drier and more rigid style than either *The Equestrienne or At the Moulin de la Galette.*

The girl, Rosa by name, who posed for the present picture, was one of Lautrec's favorite models. She had posed in 1888 for "*In Montrouge ...,*" a companion picture to "*In Batignolles ...,*" and also for a portrait in an interior known as *La Rousse au Caraco Blanc.* She reappears as *The Laundress* (page 81).

Painted in 1889, Paris
THE LAUNDRESS
36 5/8 × 29 1/2"
Collection Mme. Dortu, Le Vésinet, France

This picture was probably another of Lautrec's self-imposed technical exercises. At all events it is painted in the same tight manner, and was posed by the same model as in the previous color plate. The subject has been borrowed from Degas (page 25), though Lautrec has treated it in a very different manner. For, where Degas was concerned in his pictures of laundresses with complicated chiaroscuro effects and with the angular movements of the women ironing or carrying their heavy baskets, Lautrec's picture shows us a woman who has paused from her labors to look out of the window.

This is a sad picture. But Lautrec has not needed to concentrate on the face of his model, as in *Fat Maria* (page 63), to make us aware of physical fatigue and melancholy; the expression is in the body itself, in the contrast between the strong, rigid arm and the undulating, sagging outline of the back.

Painted in 1889, Paris
PORTRAIT OF M. SAMARY
29 1/2 × 20 1/2"
Collection Jacques Laroche, Paris

This portrait was Lautrec's first important theatrical painting and shows the young actor Henry Samary (1864–1902), of the Comédie Française, in the role of Raoul de Vaubert in *Mademoiselle de la Seiglière*, a comedy by Jules Sandeau (1811–1883). It is a curious portrait because it is a fanciful costume piece rather than a study of character, while the quizzing-glass and the supercilious smile on the actor's face add to it a note which almost amounts to caricature.

The Japanese influence is visible in the false perspective of the floor boards and the placing of the figure. Note also Lautrec's evasive handling of the spatial problem in his use of painted curtains.

Henry Samary's sister, Jeanne Samary, was also a famous member of the Comédie Française and was painted several times by Renoir in 1879.

Painted in 1889, Paris
WOMAN AT HER TOILET
17³/₄ × 21¹/₄″
Collection Mr. and Mrs. William Goetz, Los Angeles

This is the earliest example of a type of subject which Lautrec was to paint frequently during the next ten years. Undoubtedly he took over the theme from Degas, but characteristically he was more concerned with the evidence of female artifice than with the design made by the woman's body. Note once again how, by a cunning use of diagonals, Lautrec has succeeded in placing the mirror, the woman, and the chair in a single foreground plane which is the focus of interest and the limit of the pictorial space. The background is only vaguely indicated and is not related to the foreground. This picture is painted in a very dry medium mixed with turpentine *(peinture à l'essence)* on unprimed board. Lautrec learned this technique from Raffaelli.

This picture seems to have been painted towards the end of 1889, by which time Lautrec was more experienced in the handling of his new technique of painting. If we compare it with *The Laundress* (page 81) we can see the difference between an "imposition" and a freely conceived painting. Both here and in the *Portrait of M. Samary* expressive outlines have begun to be more important.

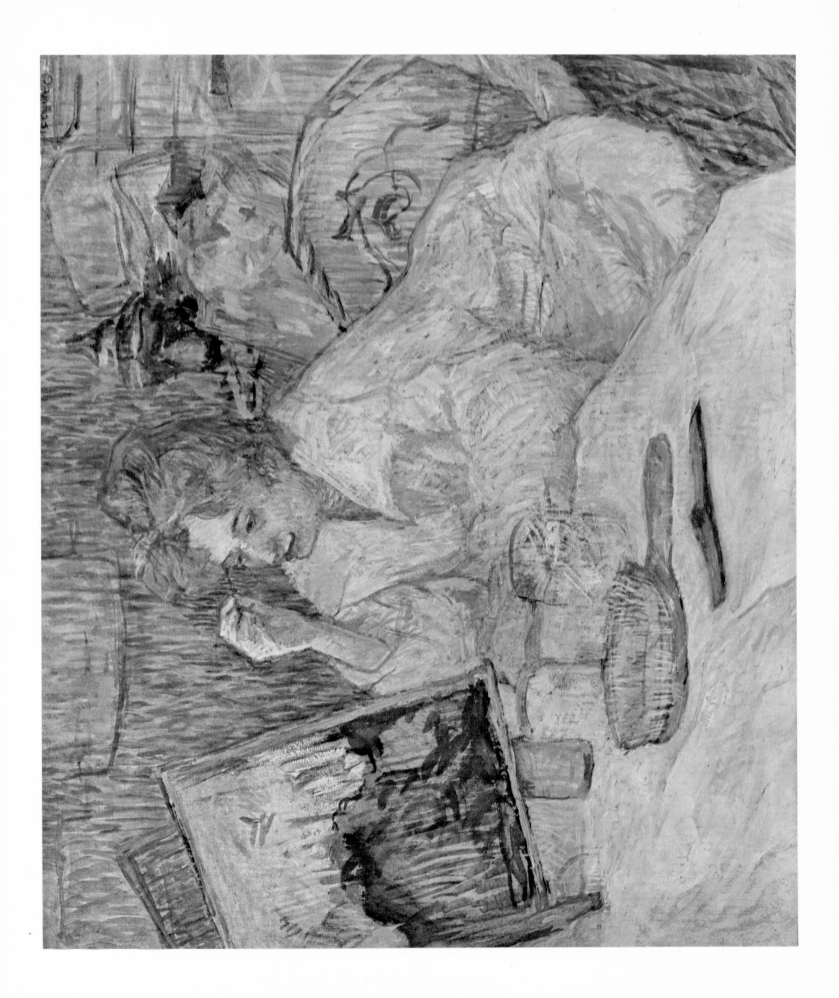

Painted in February 1890, Paris
MLLE. DIHAU PLAYING THE PIANO
26³/₄ × 19¹/₈"
Museum of Albi

The Dihaus cousins of Lautrec were a musical family from Lille. There were two brothers, Henri and Désiré, the latter a bassoon player in the orchestra of the Paris Opera, and their sister Marie (d. 1935). Mlle. Dihau achieved a certain success in Paris as a singer during the 1870s, but in later years she taught music and singing. Lautrec visited the Dihaus regularly in their apartment in the Rue Frochot, where he sometimes met Degas, another close friend whose work they admired immensely. This gave them an added prestige in Lautrec's eyes. Degas had painted two small portraits of Mlle. Dihau in her youth (in one of c. 1872 she is seated at the piano), and several pictures of performances at the Opera in which Désiré and his bassoon figure prominently in the orchestra-pit. One of these pictures, *L'Orchestre de l'Opéra* (of c. 1869), had been given to the Dihaus by Degas and was hung in their apartment, where Lautrec sometimes took friends to admire it.

Lautrec painted this portrait of Mlle. Dihau in the first weeks of 1890 and exhibited it at the Salon des Indépendants in March. At about the same time he painted the portrait of *Désiré Dihau Reading* in the garden of Père Forest; and in 1891 he did a portrait of Henri Dihau. Another small portrait in oils (1890–1891), and a lithograph (c. 1896) of Désiré are known; all are now in the Albi Museum. It is recorded that when Lautrec presented these portraits to the sitters "he inquired timidly and humbly whether they did not look ridiculous beside those of Degas."

There is a striking similarity between this portrait of Mlle. Dihau and van Gogh's *Portrait de Mlle. Gachet au Piano* which was painted at Auvers at the end of June 1890. Whether or not van Gogh saw Lautrec's portrait during the few days he spent in Paris in May is unknown, but at any rate his brother Theo had written to him about it enthusiastically in March. Vincent did, however, see this picture in Paris during a brief visit there at the beginning of July, that is to say after completing his own picture, and when he returned to Auvers wrote to Theo: "Lautrec's picture, portrait of a musician, is really astonishing. I was deeply moved by it."

Note the evidence of Lautrec's ineptness here in his handling of the music stand, which cuts into and is not differentiated from Mlle. Dihau's back. He has concentrated entirely on the expression in the sitter's profile and hands and has left all the rest vague.

Painted in 1890, Paris
AT THE MOULIN ROUGE: THE DANCE
45 × 59"
Collection Henry P. McIlhenny, Philadelphia

This was Lautrec's third and most successful major composition; it was painted about a year later than *At the Moulin de la Galette* (page 77). Here the arrangement is more elaborate, being based on three parallel planes: a background plane of a line of figures as before, though here the figures are static and more individualized; a central plane, in which La Goulue and her partner Valentin-le-Désossé are performing their violent dance; and a foreground plane traversed by impassive spectators, two women and a man, who are not involved in the action.

Again the depth of the pictorial space is limited by the placing of the foreground figures, which help to encircle the dancers; by the line of background figures which presses forward; and by the lines of the floor boards drawn in false perspective. As in *At the Moulin de la Galette*, recession is obtained by an abrupt diagonal running from the two women in the right foreground to the top-hatted man and the red-coated page in the left background; this time, however, it is felt and not drawn. The composition is further held together by the meandering lines of the shadows on the floor. The white-bearded figure in the right background is Lautrec's father; the group of four men in the center background are the artist's friends Varney, Guibert, Sescau, and Gauzi (behind); the woman in a black cape is Jane Avril.

This picture was acquired in 1890 by Joseph Oller, director of the Moulin Rouge, and hung in the entrance there. The Moulin Rouge, a music hall in the Boulevard de Clichy, was opened in October 1889. It had an immediate and sensationel success and was frequented by a fashionable public. Apart from the main dance floor, with a *promenoir* down each side and a gallery above for spectators, there was a large garden behind in which the crowds could sit or stroll. The nightly performance began with a concert of comic or sentimental songs – Yvette Guilbert made one of her first appearances there in 1890 – but the main attraction (between ten o'clock and midnight) was the dancing, particularly the quadrille performed by the famous Montmartre dancers – La Goulue, Valentin, Grille d'Egoût, Môme Fromage, and Jane Avril. Between 1890 and 1896 Lautrec executed at least thirty paintings of scenes at the Moulin Rouge, yet it is characteristic that they tell us a great deal about a few of the people who frequented it and almost nothing about its structure or appearance.

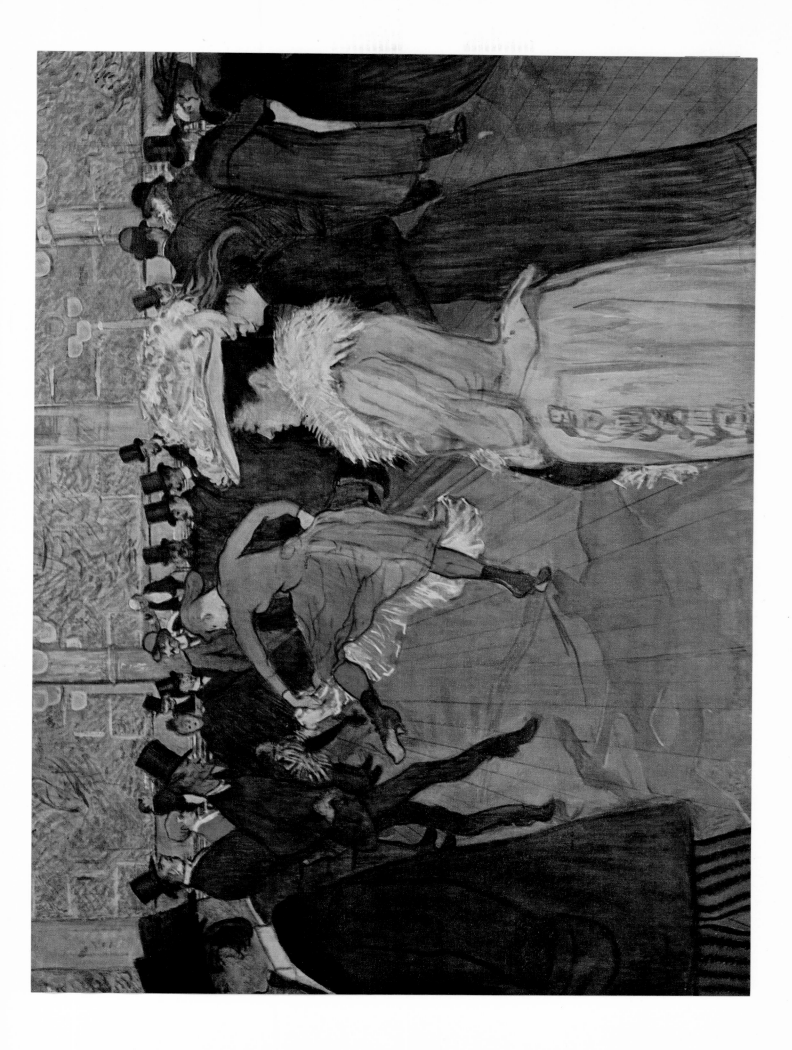

Painted in February 1891, Paris
LAST CRUMBS (A LA MIE)
19 3/4 × 27 1/2"
Museum of Fine Arts, Boston

As a picture of human degradation *A la Mie* is unique in Lautrec's work, but this vision of disillusionment, cynicism, and vice is a product of the artist's imagination. There exists a photograph by Paul Sescau showing that in fact this picture was posed by Lautrec's friend Maurice Guibert and a young, attractive Montmartre model. This is particularly interesting because it reveals that on this occasion at least Lautrec was prepared to disregard truth in order to achieve a desired effect.

Maurice Guibert was one of Lautrec's constant companions and appears, usually with Sescau, in many of his Moulin Rouge pictures. Lautrec never painted a straightforward, serious portrait of Guibert, although he made at least twenty drawings and caricatures of him – one of the last (1900) shows him in pursuit of a girl on the quayside at Bordeaux – and frequently included him among the crowd both in paintings and lithographs. Guibert was something of an amateur painter, though his profession was that of salesman for Moët et Chandon champagne. In real life he was jovial and charming and had nothing about him of the sinister *apache* who appears here.

This picture is yet another example of Lautrec painting under the influence of Degas, for it clearly derives from *L'Absinthe* (c. 1876). It was exhibited at the Salon des Indépendants in March 1891.

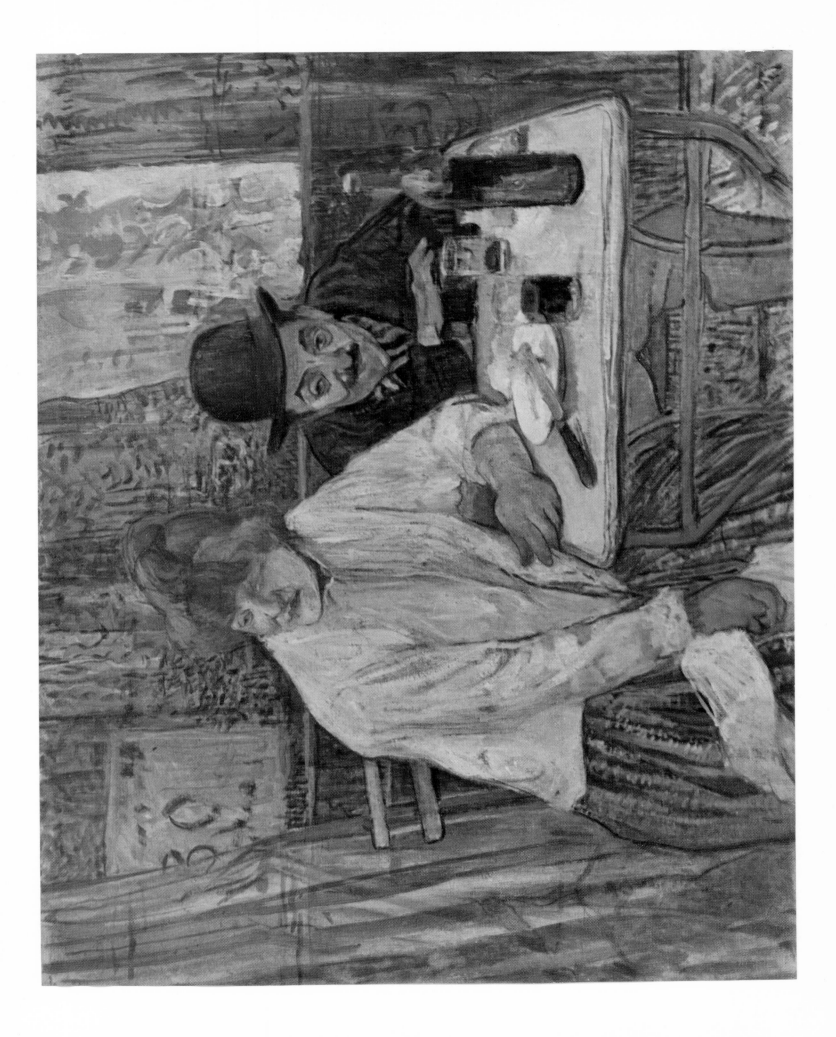

Painted in 1891, Paris
AT THE NOUVEAU CIRQUE: FIVE STUFFED SHIRTS
23⁵/₈ × 15³/₄"
Philadelphia Museum of Art

This is almost certainly a project for a poster which was never carried out. The broad, loose style in which it is executed is typical of the final sketches which Lautrec made before transferring his design on to the lithographic stone, and the conception is not that of a painting. Towards the end of 1891 Lautrec developed e great interest in poster designing, after completing his first for the Moulin Rouge.

The title by which this composition is often referred to – *La Clownesse au Cinq Plastrons* – is clearly erroneous. The foreground figure is a smartly dressed female spectator watching the dancer performing in the ring; looking across at her from the other side are five blimpish gentlemen in evening dress. The whole is a satirical comment on the fashionable audience attracted by the spectacle at the Nouveau Cirque.

The Nouveau Cirque, situated in the Rue Saint-Honoré, was opened in 1880. Lautrec painted several pictures of performances there in 1891 and 1892 (notably *Papa Chrysanthème* – see page 103), and in 1894–1895 added to these a series of lithographs and drawings of its famous clowns Chocolat and Footit.

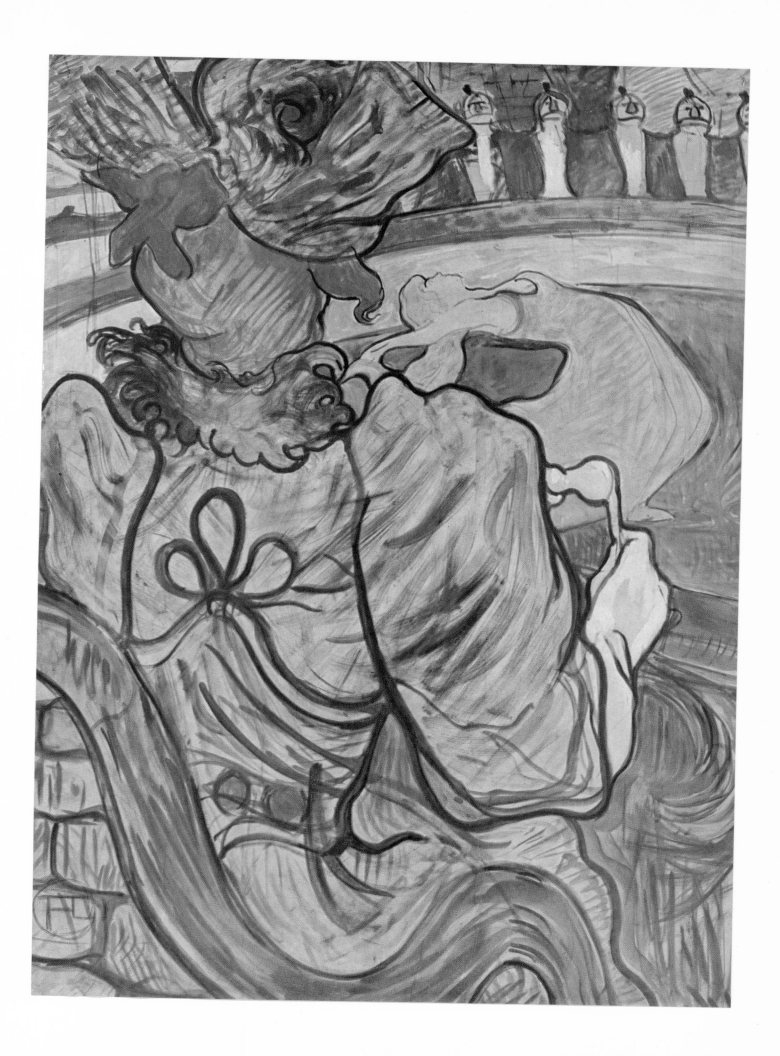

Painted in February 1892, Paris
LA GOULUE ENTERING THE MOULIN ROUGE
31 ¹/₂ × 23"
Collection Dr. and Mrs. David M. Levy, New York

In 1892 Lautrec concerned himself predominantly with the Moulin Rouge and two of its leading dancers, La Goulue and Jane Avril. Here La Goulue is entering the Moulin, accompanied by her friend Môme Fromage on the left and a young dancer on the right. The three women are brilliantly characterized by the differences in their costumes and coiffures, and these are given further point by the contrast between the fine, grasping hands of La Goulue and the coarse, insensitive hand of Môme Fromage. The lecherous man in the background appears like an incarnation of fate.

Louise Weber (1870–1929), known as La Goulue (The Glutton), was an Alsatian laundry-girl who was brought to Paris by the impresario Marcel Astruc in 1886. She first attracted attention at the Moulin de la Galette, where she was seen by Lautrec, who included her in several pictures in 1886–1887. In 1889 she played the leading part in a revue there; but then she moved first to the Jardin de Paris and in the autumn, when it opened, to the Moulin Rouge, where she became the star performer.

All those who knew La Goulue agree that she "was pretty and attractive to look at in a vulgar way" (Yvette Guilbert), but that she was also haughty, ferocious, brazen, coarse, and wanton. Her success was not, however, of long duration, for she ate and drank heavily. By 1895 she had already lost her charms and had grown too fat to perform in Montmartre; thereafter she was reduced to earning a living by performing a *danse du ventre* in a booth at suburban fairs.

She appealed to Lautrec to decorate this booth, and he, rising to the occasion, painted two large panels (now in the Louvre) in which she is shown giving a brilliant display in front of a smart, admiring audience composed of many of the artist's friends. By 1905 La Goulue had become too fat to perform any more, and the later years of her life were spent in penury. She was the subject of at least a dozen pictures by Lautrec painted between 1886 and 1895.

La Goulue's partner in the quadrille was Valentin-le-Désossé, who is shown dancing with her in *At the Moulin Rouge: The Dance* (page 89). Cadaverous-looking, he was an extraordinarily agile dancer with a body so flexible that his bones seemed (as his name implies) to be made of rubber. Valentin danced for the love of dancing and was not salaried like the women; he owned a small café in the Rue Coquillière, where he worked during the day.

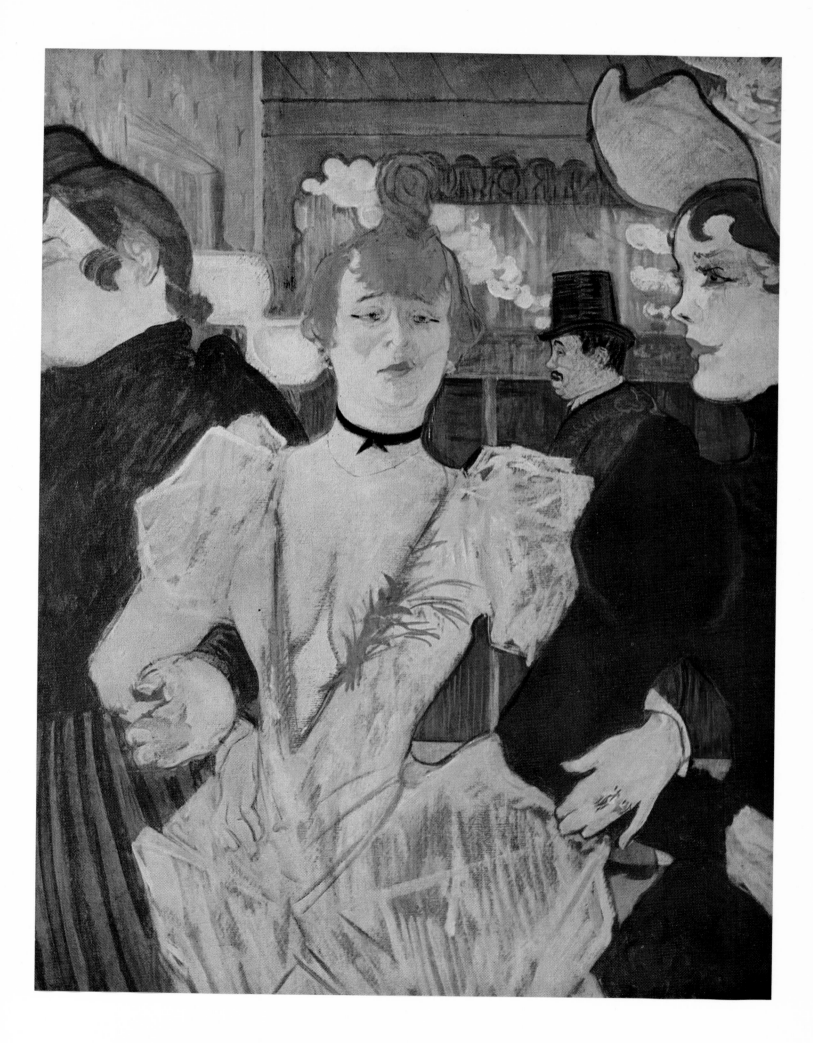

Painted in 1892, Paris
AT THE MOULIN ROUGE
47 1/2 × 55 1/4"
The Art Institute of Chicago

This is one of the few pictures by Lautrec in which his interest has shifted from the dance floor to the spectators in the surrounding *promenoir.* Here, seated at a table, are the critic Edouard Dujardin, with a yellow beard, La Macarona, a Spanish dancer, Sescau, Guibert, and, with her back to us, an unidentified woman. In the background La Goulue is arranging her hair in front of a mirror, while more to the left can be seen Lautrec himself accompanied by his lanky cousin Gabriel Tapié de Céleyran.

In its original form this picture was a straightforward conversation piece in which the spectator was imagined close to the table and looking down on the scene from just behind the back of the woman with orange hair. But Lautrec must have felt that this conception was too illustrative and banal, for at a later stage he enlarged his canvas by ten and three-quarters inches at the bottom and six and one-quarter inches on the right (the joins are visible even in the reproduction), adding a few inches at the top and on the left as well. Then he brought all the pictorial science at his command into play in order to transform the impressionistic or photographic image into a no less realistic but pictorially more effective one.

The principal group of people at table was off-centered and balanced against a close-up of a girl (Mlle. Nelly C.) who was added in the immediate right foreground. The placing (learned from Degas) of this figure, with its masklike face lit from below and cut on two sides by the frame, coupled with the abrupt diagonal of the balustrade which had to be prolonged, encloses the principal group in a sort of V and draws the eye right into the middle of the picture.

A comparison of this composition with *At the Moulin de la Galette* of 1889 (page 77), which it resembles in so many ways, shows how much Lautrec learned in the interval. Note how in both pictures the diagonal is emphasized, and especially how an illusion of space is created by the converging diagonals of the floor boards and the balustrade. Lautrec shows himself much more expert here in the handling of such Japanese stylistic devices. This is unquestionably one of Lautrec's greatest and most imaginative pictures. The curious but suggestive color harmony in yellow, orange, and green is related to his experiments in poster designing.

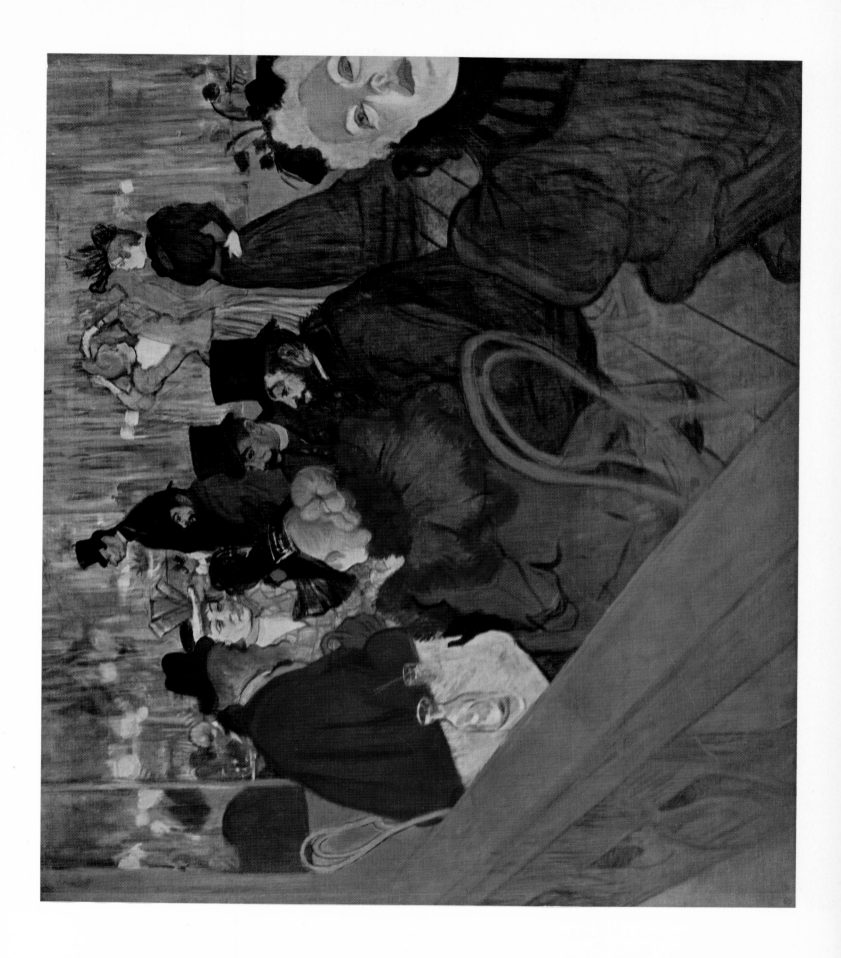

Painted in 1892, Paris
AT THE MOULIN ROUGE:
PREPARING FOR THE QUADRILLE
23 1/2 × 19 1/2"
National Gallery of Art, Washington, D. C. (Chester Dale Loan)

Here Lautrec takes us back on to the dance floor at the Moulin, where the famous quadrille is about to start. The fashionable public is wandering back to tables in the *promenoir* and in a few minutes the floor will have been taken over by the troupe of professional dancers, one of whom, looking arrogantly and disdainfully at the spectators, has already planted herself in position.

The *quadrille naturaliste*, as it was called, was a development of the can-can, a dance created by Céleste Mogador which had been all the rage at halls such as Mabille or Valentino between 1850 and 1870. After the Franco-Prussian War, the can-can went out of fashion until it was revived in the form of the *quadrille* by La Goulue and her partner Valentin. It was danced in groups of four people.

One sees here how close Lautrec could get to social criticism without spoiling his picture by moralizing or by caricature.

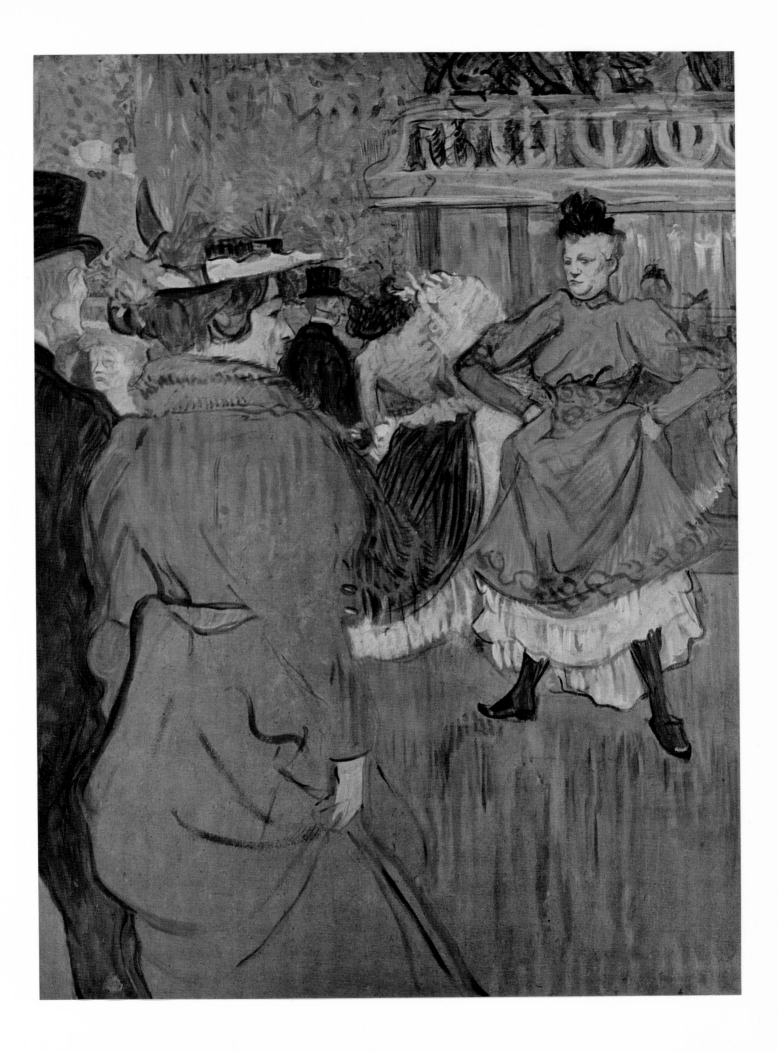

Painted in 1892, Paris
JANE AVRIL LEAVING THE MOULIN ROUGE
33⁷/₈ × 25¹/₂"
Wadsworth Atheneum, Hartford, Connecticut

Jane Avril (1868–1943), the other star performer at the Moulin Rouge whom Lautrec painted frequently in 1892, was the antithesis of La Goulue in type, for she was thin, graceful, refined, and intelligent. Born in Paris, the illegitimate child of a *demi-mondaine* and an Italian nobleman, she had a sad and difficult childhood, during which she was often beaten by her half-demented mother and forced to beg in the streets.

Jane Avril's ambition from an early age was to become a great dancer, but because she could not afford to be trained she always had to improvise her own dances, relying on her innate sense of rhythm and her natural grace to carry her through. Jane Avril appeared at the Moulin Rouge when it opened and for a while danced in the quadrille with La Goulue. But she preferred to dance alone, and so in a short time found employment for herself at other cabarets such as the Jardin de Paris, Les Décadents, and Le Divan Japonais; she even danced the role of Pierrot in a ballet at the Folies-Bergère. Nevertheless she went to the Moulin Rouge almost nightly as well.

Jane Avril was at the height of her fame in 1890–1894. Subsequently she appeared as Anitra in Lugné-Poë's production of *Peer Gynt* in 1896; in 1897 she appeared first in a quadrille at the Casino de Paris, then at the Palace Theatre in London in the Troupe de Mlle. Eglantine, for which Lautrec designed a poster. In 1900 Jane Avril set out on a tour of the French provinces, and in 1901 went to New York; soon after, however, she was back in Paris. By 1905 her career was over and she settled down to domestic life with her husband Maurice Biais, a draftsman. By 1933, however, she was destitute, and spent her last years in a home for the aged.

The numerous pictures of Jane Avril painted by Lautrec in 1892–1893 show her in the setting of the Moulin Rouge or performing her solo dance. There is a companion picture to the one reproduced here which shows her entering the Moulin and putting on her gloves (Courtauld Institute, London; see page 34). But it is noticeable that in nearly all of them she is walking or performing alone. Jane Avril was the only one of the Montmartre dancers who appreciated Lautrec's work and recognized that her fame was in part due to his pictures of her. She was of a serious turn of mind and could discuss books and pictures intelligently; Lautrec paid tribute to her artistic interests by portraying her examining prints in the colored lithogaph which he designed for the cover of *L'Estampe Originale* (1893).

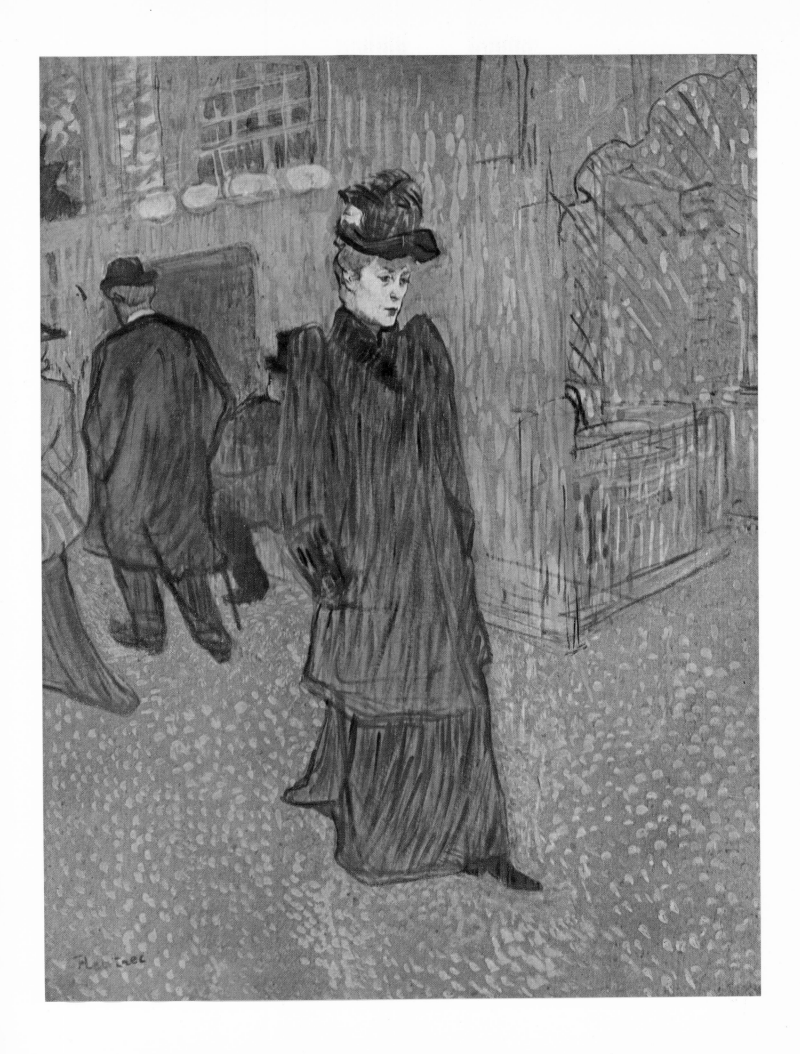

Painted in November 1892, Paris
THE BALLET "PAPA CHRYSANTHEME"
23¹/₄ × 31¹/₈"
Museum of Albi

In November 1892 a spectacular Japanese ballet entitled *Papa Chrysanthème* was staged at the Nouveau Cirque. On this occasion the central part of the ring was turned into a small lake with masses of artificial water lilies, lotuses, and other aquatic plants floating on its surface. Women in diaphanous veils postured and danced around the edge of this lake while the star performed a solo in the center, the whole scene being given additional brilliance by a swirl of colored lights. Lautrec was of course fascinated by such an exotic spectacle, of which he made two sketches in oils, this being one of them. The girl on the lotus leaf in the middle of the lake is imitating the veil dance of Loïe Fuller (page 28), an American dancer who created a sensation in Paris when she first appeared in the autumn of 1892.

In 1895 Lautrec designed a stained-glass window for Tiffany of New York which was based on his sketches of *Papa Chrysanthème*.

Painted in winter 1892, Paris
A CORNER IN A DANCE HALL
40 × 39"
Collection Chester Dale, New York

Here Lautrec takes us once again into the *promenoir* of some music hall or cabaret, though this time it is a less fashionable establishment than the Moulin Rouge. This picture has been said to represent the Moulin de la Galette, but the identification is doubtful. Dancers and prostitutes are wandering about among the tables at which clients are seated, and the woman in the long black coat has her eye on the man in the bowler-hat. All the elements of a short story are present, yet this is not in any sense a literary picture. As usual, Lautrec has overlooked the crowd and has concentrated on a few figures, making a picture out of the contrast in style between the three different types of woman. Here one sees him adopting a new solution for avoiding the problem of space, namely by looking up at the figures from below and thus shutting out the background.

This is an unusually sad picture for Lautrec, the mood being set by the morose and dreamy expression of the woman in the foreground. Again one is reminded of Degas' *L'Absinthe*, and even of Manet's *La Prune* (1877; Collection Arthur Sachs, New York). Here is another work in which the artist could easily have resorted to exaggeration or caricature to heighten his effect, but the fact that he has not done so brings home to us Lautrec's fundamental humanity and his ability to remain emotionally detached. In this picture Lautrec appears at his noblest and best.

104

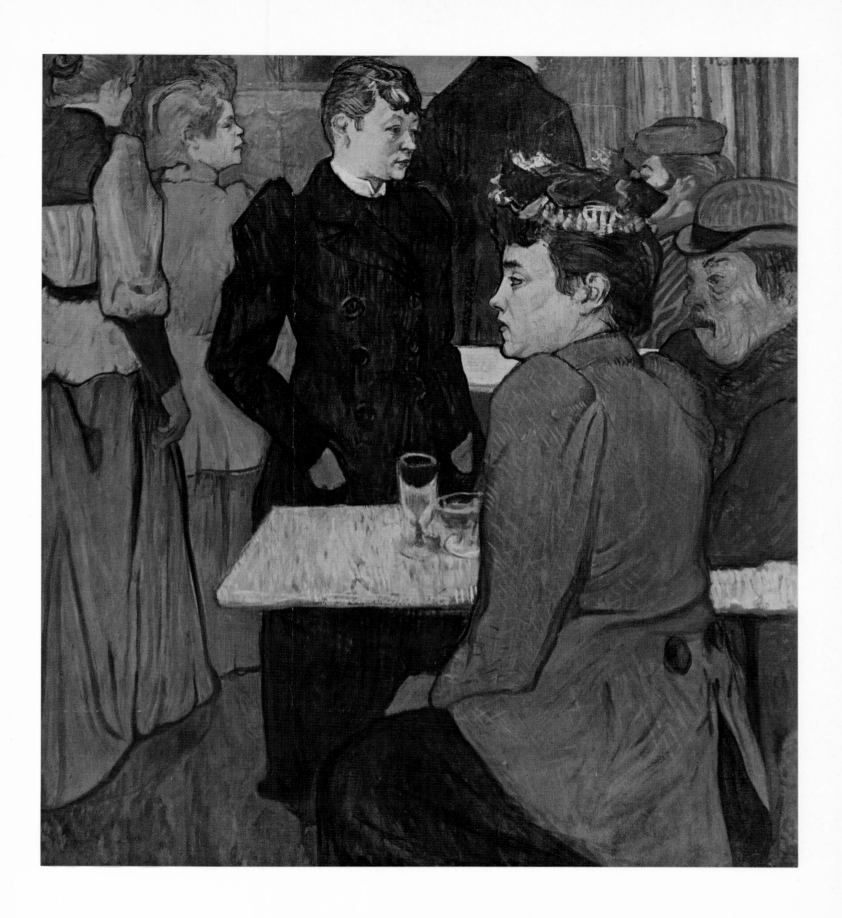

Painted in autumn 1892, Paris
THE KISS
15³/₈ × 22⁷/₈″
Collection Mme. Dortu, Le Vésinet, France

Through his life in Montmartre, Lautrec soon found himself on easy terms with the *madames* and the girls of the most frequented houses of prostitution, or *maisons closes* as they were called. But he does not appear to have looked for paintable subjects there until, towards the end of 1892, the *madame* who ran the establishment in the Rue d'Amboise decided to remodel her salon and called on Lautrec to provide decorations for the walls. This commission appealed to Lautrec, who thereupon set to work and soon completed sixteen panels which were a pastiche of the Louis XV style. In the center of each was an elaborately framed oval medallion containing a portrait from life of one of the girls of the house.

While he was working on this commission, Lautrec inevitably spent much time in the Rue d'Amboise and came to have an intimate knowledge of the girls and their ways. Thus he discovered that those who earned their living by catering to the sexual wants of men quite often fell violently in love with one another. Hence the numerous studies of Lesbians which Lautrec made from this time on. The present picture is one of the first of the series, and this particular pair of girls must have fascinated Lautrec because he painted them in bed no less than four times in 1892. Here we have a typical example of Lautrec's ability to treat a sexual subject without playing up the vicious or erotic element. The two figures are interlocked as a group, the composition is clear and well-balanced, and our attention is focused on the contrast in type between the two girls, who are very well characterized.

This picture can be compared with the composition called *Friends*, page 121.

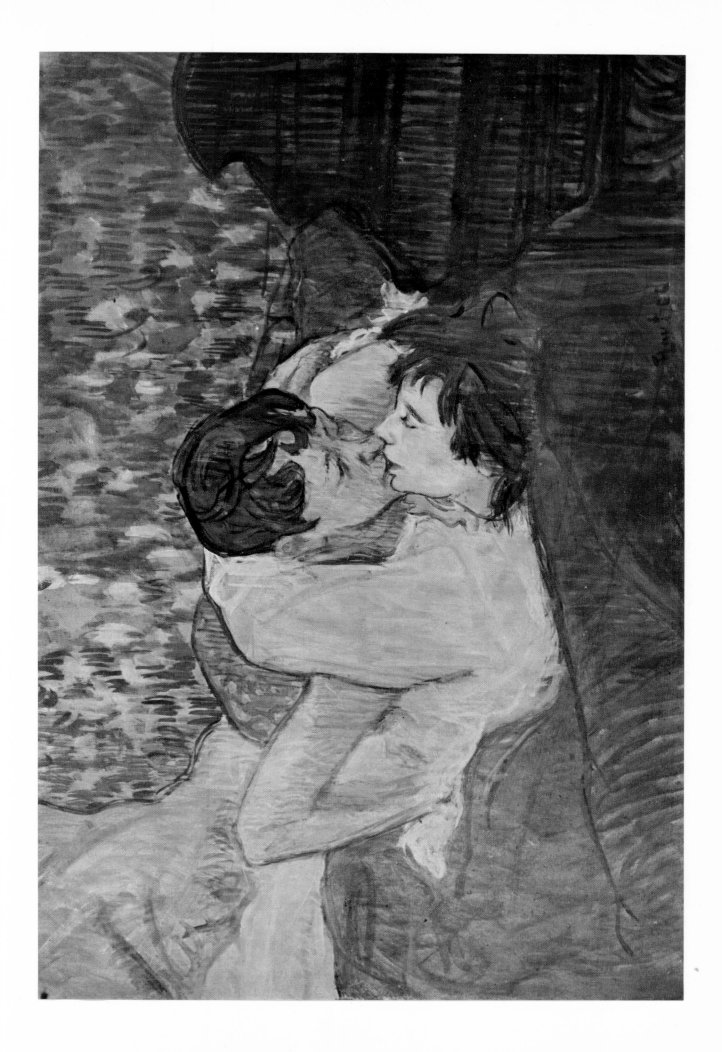

Painted in spring 1893, Paris
M. BOILEAU IN A CAFÉ
31 1/2 × 25 5/8"
The Cleveland Museum of Art (Hinman B. Hurlbut Collection)

Very little is known about the subject of this portrait except that
he was a friend of Lautrec, as is borne out by the *dédicace* in the top
left corner. All that can be established is that he was well-to-do,
a *bon viveur*, and a familiar figure in the fashionable cafés of Paris.
All of this has been admirably suggested, and with great economy
of means, by Lautrec, who has conjured up the essential personality
of the man by the tilt of his bowler-hat, by his way of holding a
cigarette and a cane, and by the glass of absinthe and the dominoes
on the table in front of him.

Like *A Corner in a Dance-Hall*, this is a group scene, though here
no contrast of types is involved and the other figures have only been
included in order to provide a background atmosphere to set off
the sitter. The similarities in style and conception between these
two pictures are, however, obvious. Here one catches echoes of
Manet and Degas, and even of a picture such as Courbet's *Mère
Grégoire* (c. 1855; Art Institute of Chicago). Note how by framing
the figure between two shallow diagonals – the one of the floor
at left and the other the gap between the two tables at the right –
Lautrec has been able to reduce the effect of depth, so that the
sitter stands out in relief against a flat background. The figure in a
top-hat on the right is the artist's father.

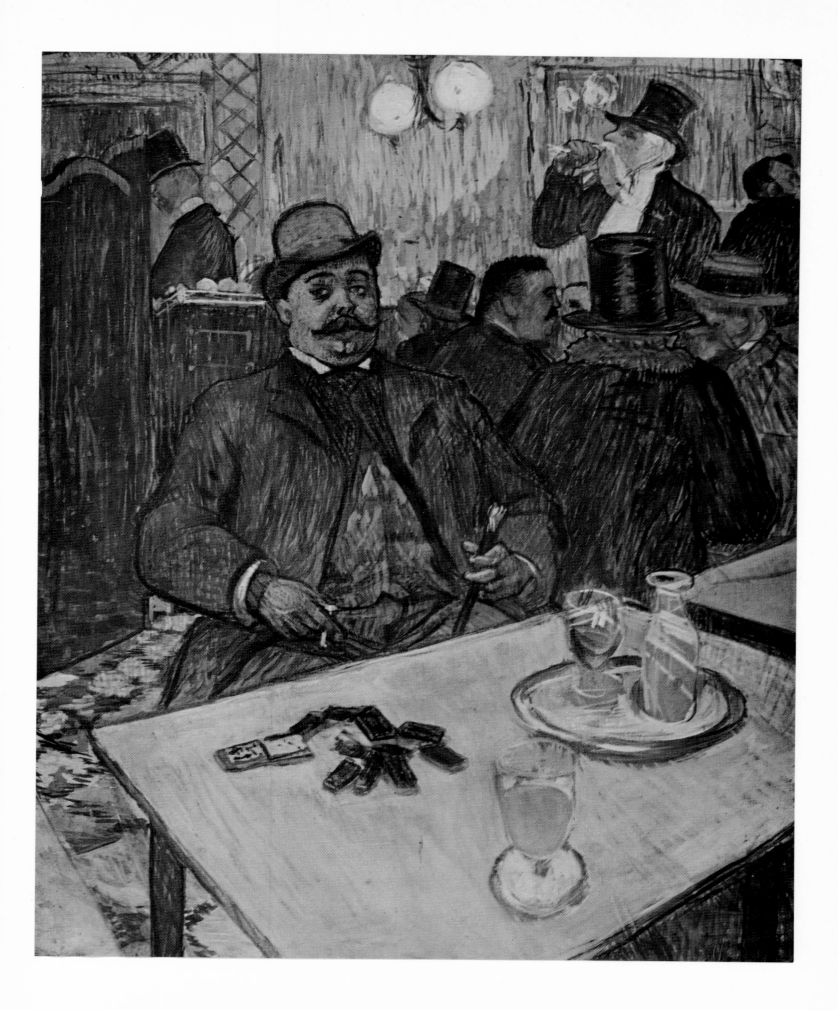

Painted in 1893, Paris
PORTRAIT OF M. DELAPORTE
AT THE JARDIN DE PARIS
29 7/8 × 27 1/2"
Ny Carlsberg Glyptothek, Copenhagen

M. Léon Delaporte, director of an advertising business in Mont-
martre, is shown as though he were a spectator at the Jardin
de Paris. This was an fashionable café-concert in the Champs-Élysées,
opened by Zidler and Oller of the Moulin Rouge in the summer of
1893, where people came towards midnight, after the Moulin Rouge
had closed, to see Jane Avril dance (see the poster, page 52). Here
the dancer is shown from behind, wearing an elaborate black hat
and approaching the bearded man seated at a table behind M. Dela-
porte. Typical of Lautrec's method of portraiture is the fact that
only the sitter is really in focus. His figure, which fills the whole
foreground plane, is shown in profile and, as it were, low relief
against a back-cloth which provides the setting: all the figures in the
background are broadly painted and blurred, almost as though they
were seen in a mirror. By this means Lautrec has evaded spatial
problems. Note the easy, naturalistic pose of the sitter, which is even
more marked here than in the previous plate: in this type of portrait
Lautrec evolved a wonderful alternative to the formal kind.

This picture was purchased in 1905 by the Friends of the Luxem-
bourg Museum and offered to the French nation. It was, however,
refused by the Trustees of the National Museums of France on the
advice of their chairman Léon Bonnat, under whom Lautrec had
studied in 1882.

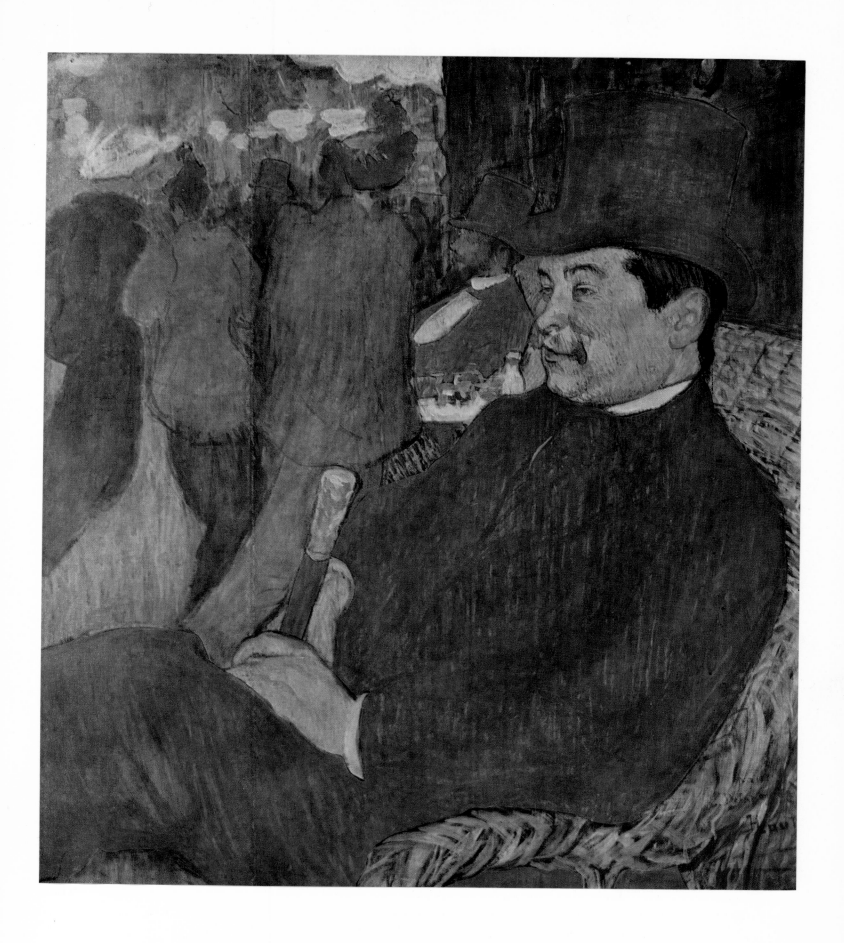

Painted in 1894, Paris
PORTRAIT OF GABRIEL TAPIÉ DE CÉLEYRAN
43 1/4 × 22"
Museum of Albi

The subject of this portrait was Lautrec's first cousin twice over, since his mother was a sister of Lautrec's father and his father a brother of Lautrec's mother. Lautrec and Gabriel Tapié de Céleyran (1869–1930), despite five years difference in age, were educated together as children and remained the closest of friends. Gabriel came to Paris in 1891 and was admitted as an *interne* to study medicine at the Hôpital St. Louis under the celebrated surgeon Jules-Émile Péan (1830–1898). From that moment he was the inseparable companion of his cousin, whom he met after they had both finished their work and accompanied on his nightly round of theaters, dance halls, and café-concerts. These two extraordinary and contrasting figures, the one an excitable dwarf with a large head, the other a tall, gaunt, gloomy youth with a small head, a stoop, and a shuffling gait, were a familiar sight in many parts of Paris.

Lautrec made use of his cousin's curious appearance in a number of paintings, drawings, and lithographs. Sometimes he appears in a group, often with the artist himself, as in *At the Moulin Rouge* (page 97), or as in the Ault & Wiborg poster (page 53) with a friend such as Missia Natanson, and sometimes alone. The earliest work by Lautrec in which he is represented is a caricatural drawing of 1889; in addition to the present portrait which shows "The Doctor" in a corridor of the Comédie Française, Lautrec made a second drawing of him in 1892; still others (page 11) date from 1897–1898. Lautrec loved to tease and browbeat his cousin, who accepted it all with exemplary good humor. For "The Doctor" was very attached to Lautrec and had a great admiration for his artistic abilities.

Gabriel Tapié de Céleyran presented his doctoral thesis in 1899 – an event commemorated in one of Lautrec's last paintings, *An Examination at the Faculty of Medicine* (1901) – but, having qualified, soon abandoned the profession and retired to his country estates. In 1922 he shared with Maurice Joyant the labors of founding the Toulouse-Lautrec collection in the Museum of Albi, to which he contributed the pictures in his own collection.

It was through "The Doctor" that Lautrec obtained permission in 1891 to watch Dr. Péan operating (pages 28, 29), and he was so fascinated by the man and the spectacle that in one year he made over thirty drawings of this subject.

Painted in summer 1894, Paris
YVETTE GUILBERT TAKING A CURTAIN CALL
18⁷/₈ × 9⁷/₈″
Museum of Albi

Yvette Guilbert (1868–1944), the celebrated *diseuse*, was in every sense a phenomenon: a great artiste, a remarkable personality, and a performer whose repertoire was at once thoroughly popular and yet appealed to a more sophisticated audience. Unlike La Goulue and Jane Avril (pages 89, 95, 101), who were *canaille*, Yvette Guilbert came of a bourgeois family. She made her debut on the legitimate stage in 1886, but in 1889 changed over to performing at *café-concerts*. At first she was a failure, but after enlarging her repertoire in 1890, she was offered an engagement at the Moulin Rouge and the Divan Japonais.

By this time Yvette Guilbert had evolved a make-up and costume – low-cut simple dresses and long black gloves – to enhance her personality and distinctive features – a long neck, reddish hair, a comically up-tilted nose, and a broad, expressive mouth. Within a year or two she had become as famous as Bruant or La Goulue, and posters (designed by Chéret and others) advertising her appearances were stuck on walls all over Paris. In 1895 she performed in America. By her superb diction and dramatic instinct Yvette Guilbert revolutionized the method of presenting songs; at the same time many of her most popular numbers were distinctly libertine. However, to quote from *Le Figaro* of 1896: "She understands the art of making obscenities palatable by uttering them with a nonchalant air."

The first of Lautrec's works in which Yvette Guilbert appears are the poster *Le Divan Japonais* (1892) and *Aux Ambassadeurs: Gens Chics* (1893), in both of which she is no more than a distant silhouette. Lautrec and Guilbert did not meet until the summer of 1894 when he submitted a project for a poster to her. Yvette was shocked by the element of caricature in Lautrec's representation of her; nevertheless the image of Yvette Guilbert which was, and is, most clearly impressed on the mind of the public was that created by Lautrec. She figures more largely in Lautrec's work than any other "star" of the 1890s, yet although she sat to him for several drawings he never painted a straightforward portrait of her. The present work is a photographic enlargement of a lithograph by Lautrec, over which he has worked with *peinture à l'essence*.

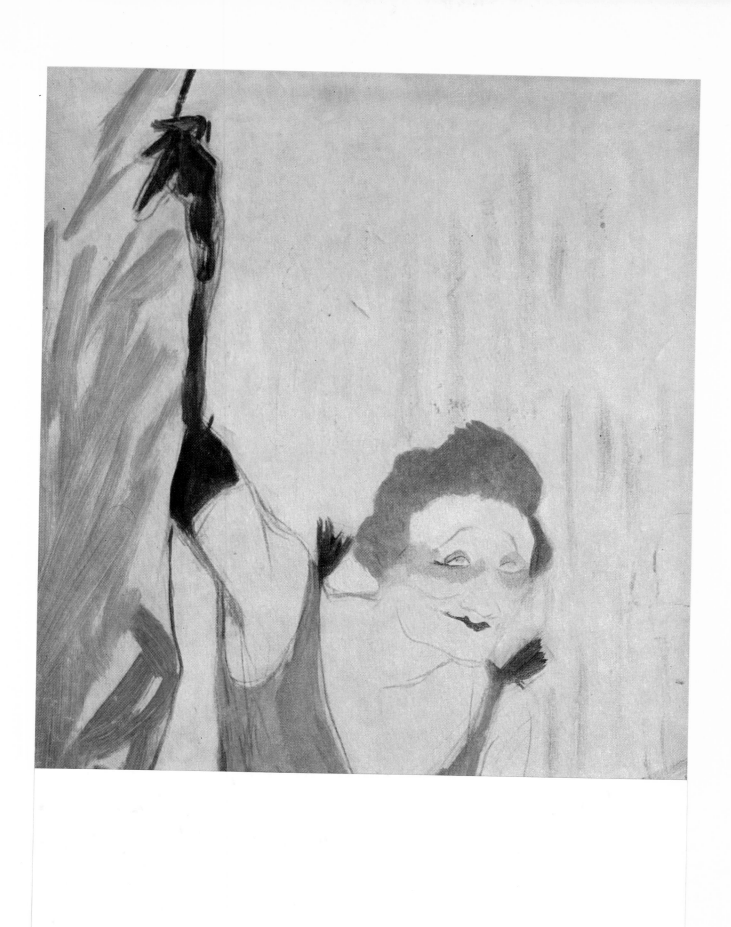

Painted in 1894, Paris
RUE DES MOULINS: THE INSPECTION
31³/₄ × 21¹/₄"
Collection Chester Dale, New York

Between 1892 and 1895 Lautrec spent much time in houses of prostitution, even living for several weeks in 1894 in the most fashionable and luxurious establishment in the Rue des Moulins. Thus he was familiar with every aspect of the daily routine there and was able to make paintings of the girls performing their toilet, or making their beds, or playing cards in an off moment, and even of the laundryman delivering a bundle of washing which is being checked by *madame* in her dressing-gown.

Among these paintings are some glimpses into the more intimate life of the girls, as for example here where they are shown parading for the medical inspection to which they were obliged to submit at regular intervals as a precaution against the spread of venereal disease. In spite of its unpleasing subject and the possibilities of indulging in salaciousness, Lautrec has made a picture which is neither pornographic nor erotic. If we compare it, for example, with similar works by Félicien Rops (1833–1898) or Rouault, we shall see at once the great difference in approach. Where the others exploit the element of eroticism or grossness, Lautrec accepts what he sees without comment and is content to set it down on canvas naturalistically. There is no primness and no sense of shame in the posture or expressions of these two girls, who are subtly characterized, nor has Lautrec tried to disguise their indifference by introducing a note of *espièglerie* in the manner of Boucher. The inspection is merely a part of the boring routine of their daily life and they are presenting themselves un-selfconsciously. One of the most remarkable and estimable characteristics of Lautrec's artistic vision was this ability to see and record impartially.

116

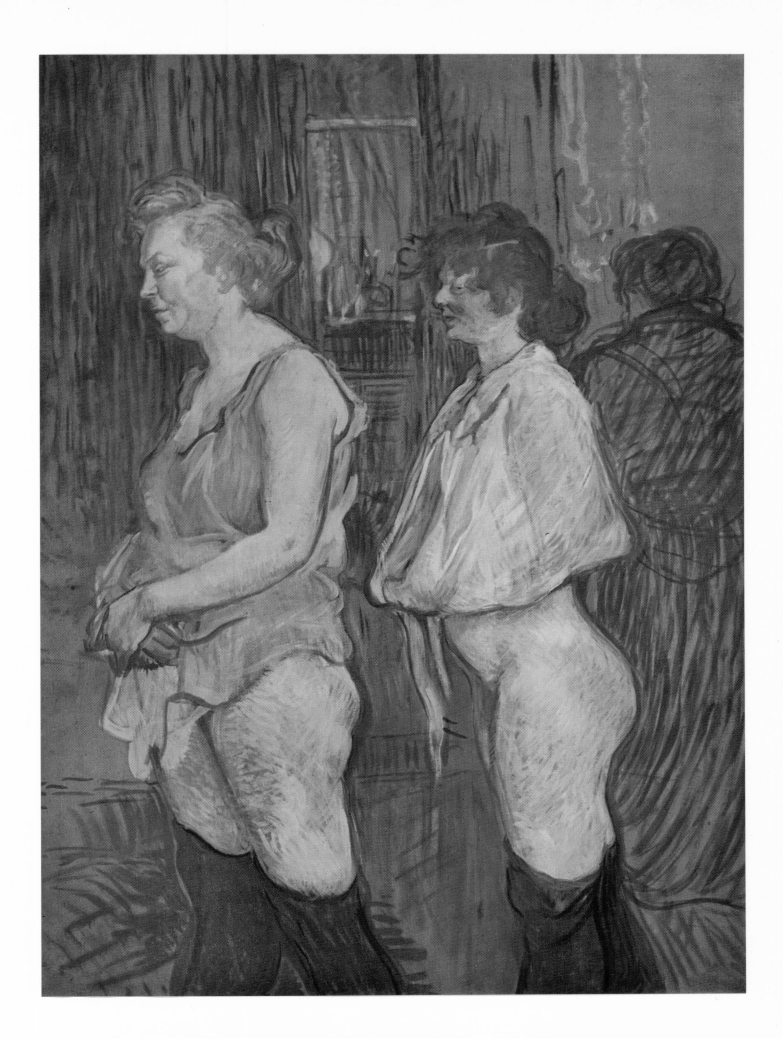

Painted in 1894, Paris
THE SALON IN THE RUE DES MOULINS
43 1/4 × 51 1/8"
Museum of Albi

Lautrec's innumerable studies of life in the *maisons closes* – between
1892 and 1895 he painted more than fifty pictures and made hun-
dreds of drawings – were destined to culminate in one great painting
entitled *The Salon in the Rue des Moulins* (Museum of Albi) which
he executed in 1894–1895. Ours is not, however, the final picture but
the elaborate pastel sketch which immediately preceded it. It is rather
broadly executed, has been left unfinished in many parts, and is
pallid in tonality. The painting which followed it, on the other hand,
is very finely and carefully painted and is carried out in an extra-
ordinary harmony of pinks, mauves, and reds with notes of green
and black which create a hot-house atmosphere evocative of the
place itself. Exotic decoration was very much favored in these
establishments and here, for example, the scene has been set in an
oriental salon. The girls are lolling around, in various stages of
undress, waiting languidly for the arrival of the clients. On the right,
primly erect, her hair piled high and falling in a fringe over her
forehead sits the *madame*, responsible for order and decorum.

This is one of the few important compositions which Lautrec made
from memory and imagination. For it was elaborated by him in the
studio during several months from studies of virtually all the
individual figures, as well as of the architectural features and the
furniture; there is also a study of the group of two women in the left
background, while the half-figure of the girl lifting her petticoat on
the right is based on a drawing made in 1893. This same salon appears
also in an earlier picture *Le Divan* (1893; São Paolo Museum) and it
was in the Rue des Moulins that Lautrec made most of the drawings
for his important series of lithographs *Elles* (1896; page 47).

Note how, in the manner of Seurat and Gauguin, Lautrec has here
evaded the spatial problems involved by avoiding modeling and
relying on a combination of profile and full-face views.

Lautrec probably did not finish painting his great composition
until late in 1895; its completion marks the end of his artistic interest
in *maisons closes*.

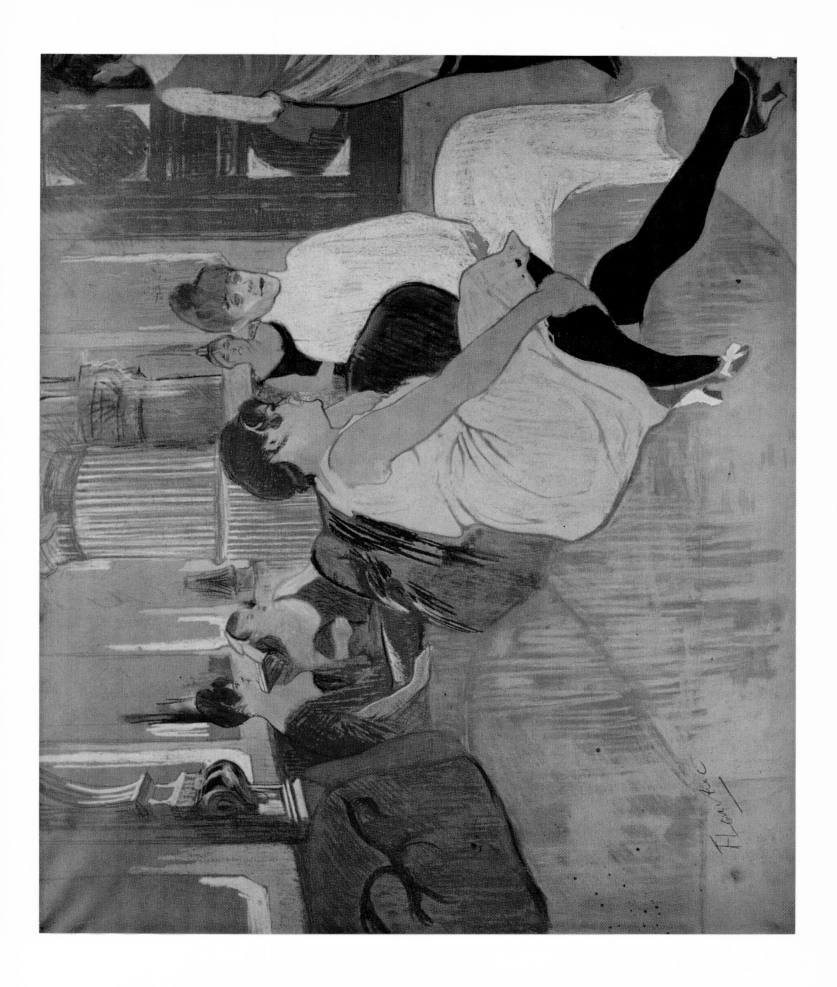

Painted in 1895, Paris
FRIENDS
17³/₄ × 26³/₈"
Collection Dr. H. R. Schinz, Zürich

This picture too is probably based on drawings made by Lautrec in the Rue des Moulins. Lesbianism was apparently the only sexual aberration which fascinated him; from 1892 onwards it figures fairly prominently in his work. A certain number of Lesbians are seen among the crowds in the dance-halls (page 45) and cafés of Montmartre in pictures such as *Au Moulin Rouge: Les Valseuses* (1892; Modern Art Museum, Prague), *Deux Femmes Valsant* or *Deux Femmes au Bar* (both of 1894). But Lautrec also sought them out in their special haunts, notably the bar La Souris, run by Madame Palmyre, in the Rue Bréda, and the brasserie Le Hanneton, run by Madame Armande (page 135) in the Rue Pigalle. Here he found material for several drawings and lithographs in 1897–1898.

This is unquestionably one of Lautrec's most beautifully painted and most successful brothel pictures. It should be compared with *The Kiss* (page 107).

120

Painted in spring 1895, Paris
MISS MAY BELFORT
31 1/2 × 23 5/8"
Collection Leonard C. Hanna, Jr., New York

May Belfort was an Irish girl who sang sentimental and popular ballads. She made her debut in London around 1890 and then went to Paris, where she appeared at the Eden-Concert, the Jardin de Paris, Olympia, and Les Décadents in Montmartre. At the beginning of 1895 Lautrec was attracted to Les Décadents because Jane Avril was dancing there, and it was in this way that he discovered May Belfort. This performer dressed in frilly, Kate Greenaway dresses in plain colors (she appears in yellow, red, and mauve in paintings by Lautrec), wore a mobcap tied with a large bow of colored ribbon and played a babyish act with a little black cat in her arms, singing:

> *I've got a little cat*
> *I'm very fond of that...*

Her repertoire also included old English and Irish songs and Negro melodies. May Belfort did not have a long career, however, for soon after this picture was painted she was struck down by illness and had to give up performing.

In a few months' concentrated work, Lautrec painted no less than five portraits and made six lithographs of May Belfort. He also designed a poster for her when she appeared later in 1895 at the Petit Casino. In all of these she is represented as a performer, but in another lithograph of 1895 she appears as a fashionably dressed customer at the Irish and American Bar in the Rue Royale. In 1896 Lautrec designed a menu and a New Year's card for her.

Note how, in this picture, Lautrec has followed the example of Degas in lighting the figure by reflected light from below so that the face and dress appear flattened, while the background in semi-darkness has no depth. It is instructive to compare the present picture with the *Portrait of M. Samary* (page 82) painted six years earlier, because this reveals how little stylistic change occured in Lautrec's work after he had evolved his personal idiom..

We can judge of the popularity of English performers in the Paris café-concerts at this period by the fact that in 1895–1896 Lautrec depicted three others: May Milton, Cissie Loftus, and Ida Heath.

Painted in 1895, Paris
TRISTAN BERNARD AT THE BUFFALO STADIUM
25⁵/₈ × 31⁷/₈"
Collection Mr. and Mrs. Philip Isles, New York

Tristan Bernard (1866–1946) was one of the most spirited and versatile of Lautrec's friends. Beginning life as a lawyer, then as a businessman, he subsequently became a well-known journalist, author, playwright, and sporting impresario. Lautrec first met him in the editorial circle of the *Revue Blanche*, an aesthetic literary magazine which became famous after it had been taken over by the Natanson brothers in 1891 (see page 132). In the first number of the series Bernard made his literary debut with an article entitled "Du Symbole dans la Chanson du Café Concert."

Bernard and Lautrec had many things in common: a quick tongue, a love of practical joking, a flow of witty epigrams and stories, a taste for good living, and an enthusiasm for all kinds of sport. In 1895, when this picture was painted, Bernard was editor of *Le Journal des Vélocipédistes*, as well as Sporting Director of both the Vélodrome Buffalo and the Vélodrome de la Seine, the two most popular bicycle tracks in the Paris region. Bicycling was all the rage at that date and Lautrec used to go off with Bernard every Sunday to watch the races, though the latter has written that Lautrec seemed to be more interested in "the setting and the people" than in the results. Through Bernard, Lautrec met most of the professional racers.

Tristan Bernard was also famous as a literary host, and his Wednesday evening receptions, to which Lautrec often went, were frequented by such people as Henri de Régnier, Pierre Louÿs, Romain Coolus, Léon Blum, Vuillard, Bonnard, K. X. Roussel, Vallotton, and Lucien Guitry.

One of Lautrec's wittiest and most original portraits: the face and the expression of the model count for nothing, but the artist has nevertheless been able to evoke by the stance, the clothes, and the setting, a great deal of the personality of the subject. What could be more characteristic, though incongruous, than the spectacle of this stout little man, with a rakishly perched bowler-hat and a bushy black beard, standing in the middle of a vast race track surveying an empty grandstand and two bicyclists who are exercising? This is an excellent example of Lautrec's economical use of the artistic means.

124

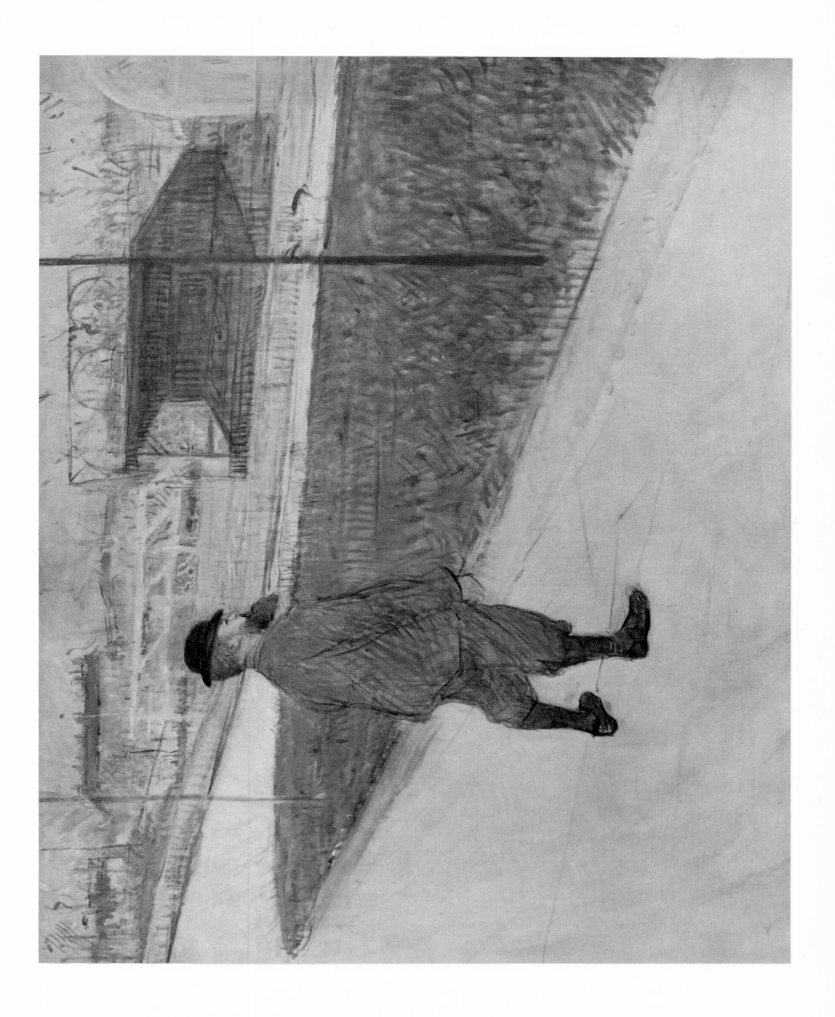

Painted in winter 1895, Paris
MARCELLE LENDER
DOING THE BOLERO IN "CHILPERIC"
57 1/2 × 57 7/8"
Collection Mr. and Mrs. John Hay Whitney, New York

Marcelle Lender, a young actress noted for her beautiful figure, fine clothes, and gracefulness, first caught Lautrec's eye at the end of 1893 when she was appearing with the actor Brasseur in the fantasia *Madame Satan* at the Théâtre des Variétés. At that time Lautrec made three lithographs of her. But in February 1895 she achieved an astonishing popular success in a revival of the operetta *Chilpéric* by Hervé at the same theater. Captivated by her performance, which included two brilliant dances, a *fandango* and a *bolero*, Lautrec went twenty times or more to watch her. On each occasion he made innumerable rough sketches (as with Yvette Guilbert), and from these he made six lithograph portraits of her during the year (pages 36, 54). One of these is a back view of Lender dancing. "I only go there to look at Lender's back." Lautrec is reported as saying. "Look at it carefully because you will never see anything finer."

Lautrec's picture shows King Chilpéric (Brasseur) seated on his throne and surrounded by his court watching his Queen Galswintha (Lender) perform a *bolero*.

This picture, like *The Salon in the Rue des Moulins* (page 117) with which it is almost contemporary, is exceptional in size and conception for Lautrec and was the product of long and careful thought and many sketches made in the theater. In no other big composition did Lautrec attempt to apply so much pictorial science, but in the process his picture lost much of the feeling of reality. At the same time, only the stage is involved in this picture and Lautrec has deliberately played up the element of artificiality. There is less sense of depth in this picture than in any other; no attempt is made to create a perspective with the lines of the floor boards (see pages 77, 83, 89, 97); the eye does not penetrate beyond the feet of the page-boys in blue; the other figures and the scenery have been devised simply to form a compact, static framework to contain and emphasize the rhythmic movements of the dancer. Again Lautrec has used reflected light from below; as a result all the faces look like masks, in each of which one expressive feature is picked out.

This picture has generally been dated 1896, but since Paul Leclercq (see page 139) remembers being offered it as a gift by Lautrec in 1895 it must be earlier than supposed.

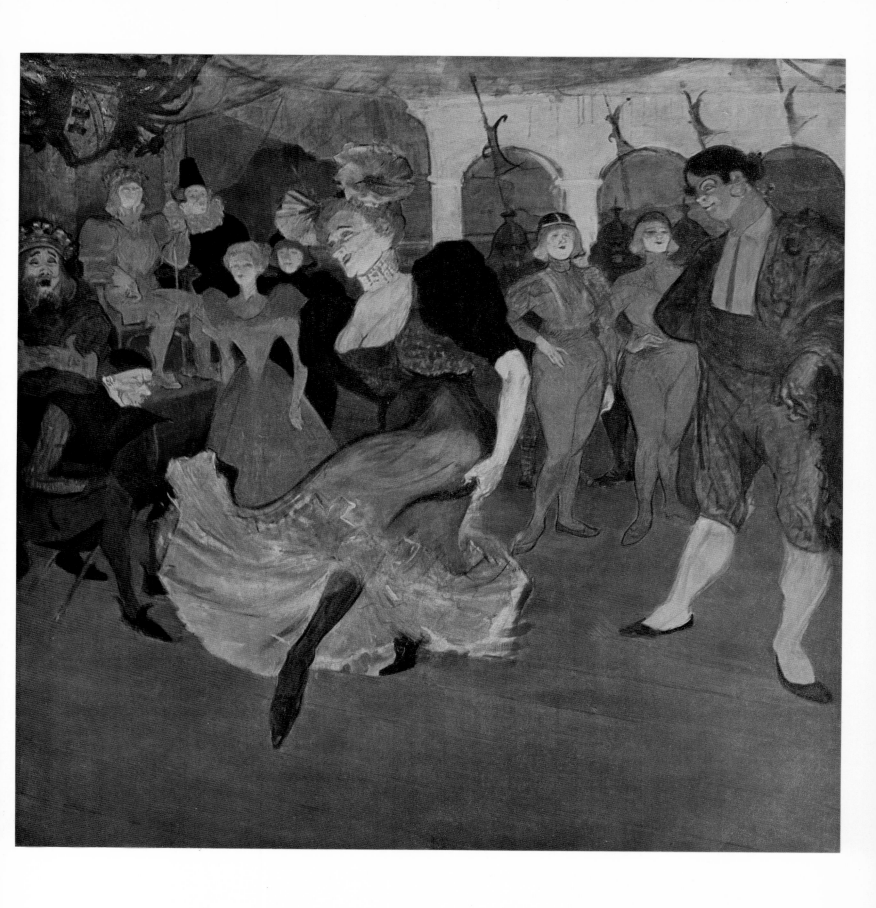

Painted in 1896, Paris
WOMAN AT HER TOILET
25 5/8 × 20 7/8″
The Louvre, Paris

At the beginning of 1896 Lautrec was at work on a series of lithographs in color which were published in May as an album entitled *Elles*. With on exception – a portrait of Cha-U-Kao *(Frontispiece)* – all these lithographs represent women in bed or performing their toilet, and seem to be based on drawings he had made earlier in *maisons closes*. Much of the inspiration must have come from Degas. Probably his work on these lithographs encouraged Lautrec to forget about clothes and scenic effects for a while and concentrate instead on the anatomy of the human figure. At all events, in 1896 he made several studies including the present one, of women in various stages of undress which appear to have been posed for him in the studio. In another picture of this date – *Model Resting* (Collection Bernheim) – posed by the same girl we can identify much of the same furniture.

From the technical point of view this is one of the most accomplished pieces of painting in Lautrec's *oeuvre*. It is also curious in that it is one of the rare works in which he has not been concerned with a face. Presumably an exercise in the manner of Degas (compare page 25), whom Lautrec admired so much.

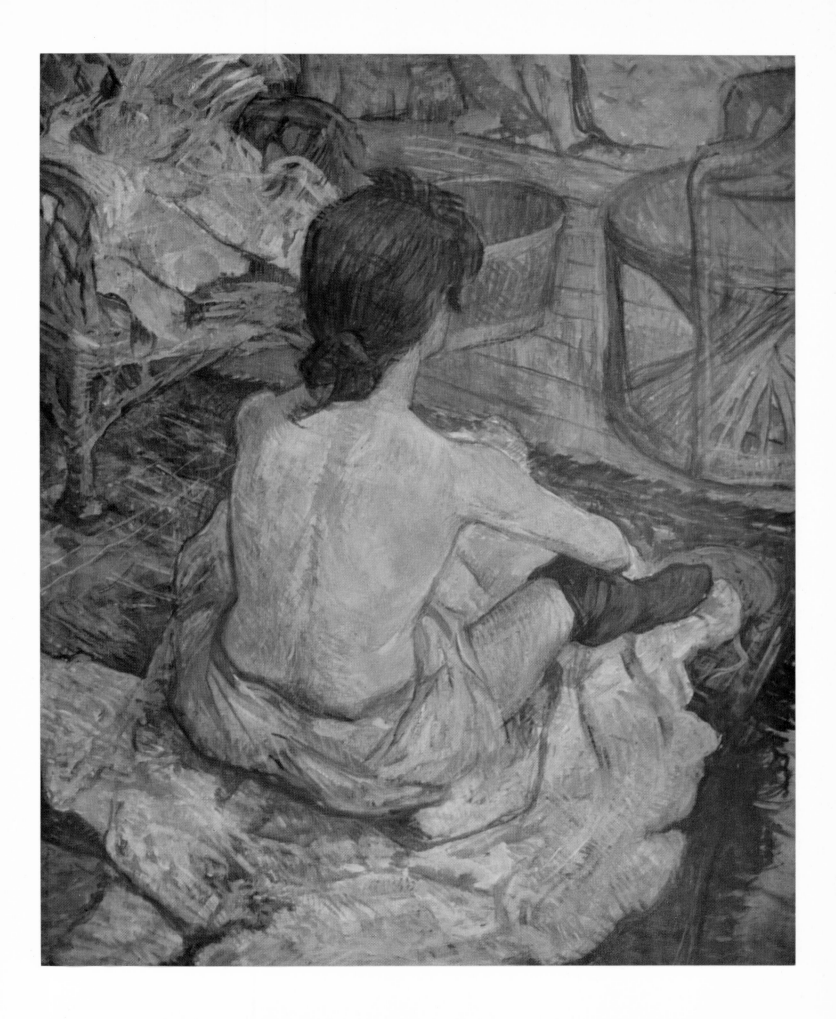

Painted in 1896, Paris
MAXIME DETHOMAS AT THE OPERA BALL
27 1/2 × 22"
National Gallery of Art, Washington, D. C. (Chester Dale Collection)

This is a portrait which can be compared with the earlier one of
M. Delaporte (page 111). Both are given an imaginary setting: the
latter as a spectator at the Jardin de Paris; M. Dethomas at a masked
ball at the Opera. The present picture is, however, different, for it
is not a portrait in the accepted sense, since the artist has not been
concerned either with analyzing the sitter's character or with catch-
ing a likeness. The serious figure in dark clothing – whose features
are only partially visible – exists rather as a foil to the revellers in
the background. We are told even less about his personality or
appearance than we are about that of Tristan Bernard (page 125)
in another portrait which is comparable.

Maxime Dethomas (1868–1928), a painter and engraver, was one
of Lautrec's closest friends from the early 1890s till the end of his
life. He was very tall and corpulent, but also an exquisite and gentle
man of whom Thadée Natanson writes: "He was so frightened of
wearing anything that might draw attention to himself that even the
black of his clothes seemed duller than that worn by others." And
Paul Leclercq (see page 139) adds that what fascinated Lautrec about
Dethomas was "his ability to preserve an impassive appearance even
in a place of amusement." This we may take as a revealing comment
and apply it to the present picture.

In 1895 Lautrec spent part of the summer on the Normandy coast
with Dethomas, who drew a portrait of him (now in the Museum of
Albi). In 1897 they made a trip to Holland together and visited the
Frans Hals Museum at Haarlem. Dethomas' work was greatly
influenced by that of Lautrec.

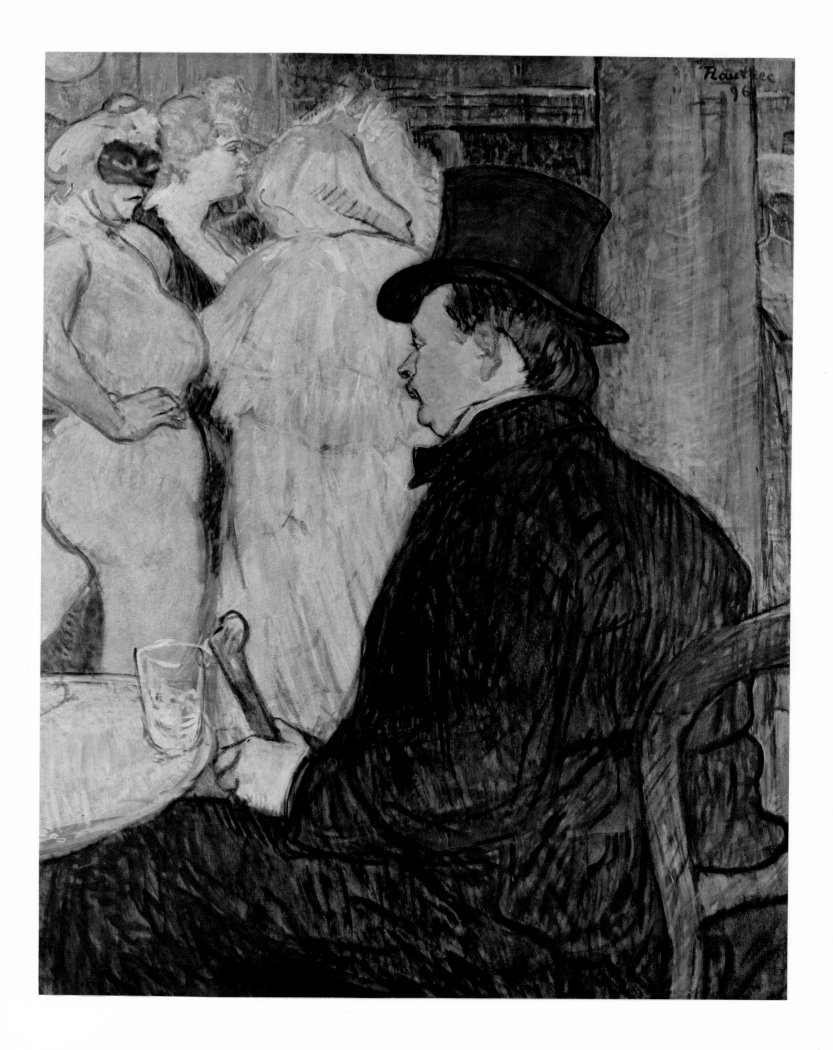

Painted in 1896, Paris
PORTRAIT OF CIPA GODEBSKI
22 $^1/_2$ × 17 $^3/_4$"
Collection Edward G. Robinson, Beverly Hills, California

Lautrec's close connection with the circle around the *Revue Blanche* started at the beginning of 1894 and for the next five years he was on terms of intimate friendship with the three Natanson brothers – Alexandre, Thadée, and Louis-Alfred – who edited it. The Natansons were well equipped to edit an *avant-garde* review because they were fairly wealthy, had a flair for discerning what was creative in the art and letters of their own generation, and were at pains to surround themselves with the most interesting writers and artists of the day. They were very hospitable people who entertained continually, and through them Lautrec came to know Tristan Bernard, Félix Fénéon, Romain Coolus, Jules Renard, and many others. Lautrec's first contribution to the *Revue Blanche* was a lithograph *Carnaval*, which was published in March 1894, after which his work was reproduced there regularly. In 1895 he designed a poster for the review.

Cipa Godebski (1865–1909), son of a Polish sculptor living in Paris, was the half-brother of Mme. Thadée Natanson – born Missia Godebska – who figures in so many paintings and lithographs (page 53) by Lautrec and the Nabis. Lautrec seems to have met him in the Natanson circle in 1894–1895, and in the spring of 1896 spent some time with him and Vuillard at the Natansons' country house at Villeneuve-sur-Yonne. Paul Leclercq has recorded that at that time Lautrec and Godebski proposed to collaborate in producing a collection of aphorisms to be entitled *Le Célibataire.*

An astonishing and very subtly characterized portrait which is so broadly painted that it has almost the appearance of a sketch. This is one of the very few works in which Lautrec seems to have tried deliberately to capture the effect of a snapshot.

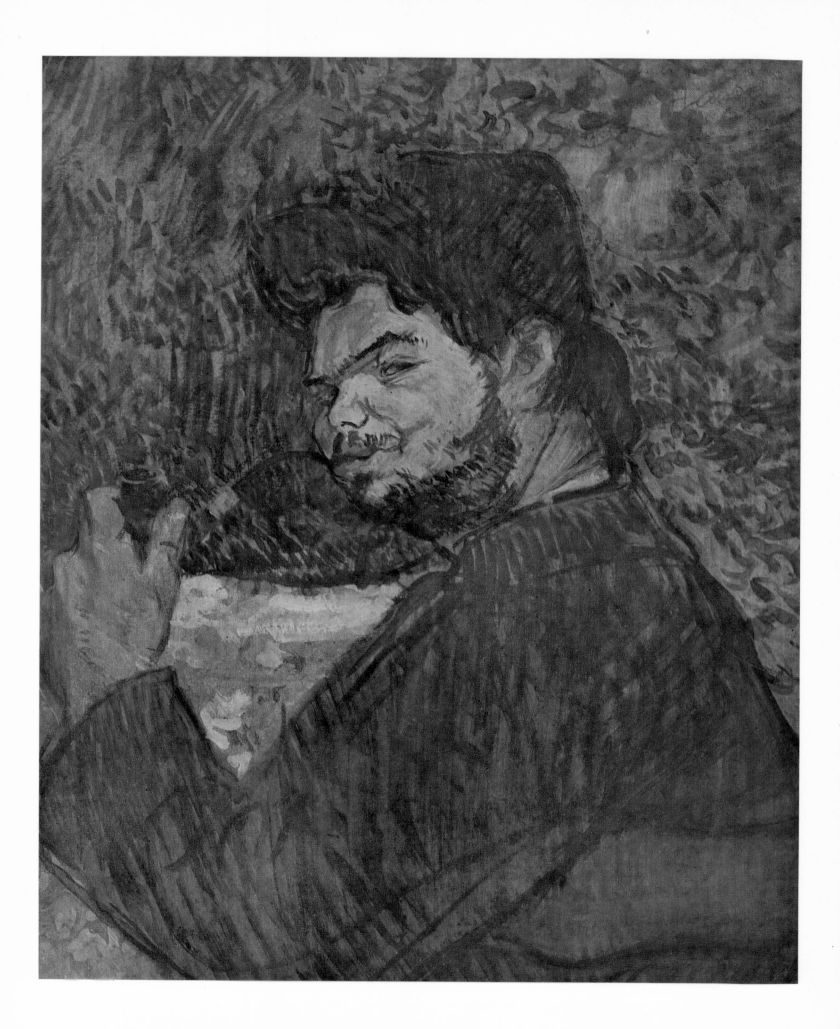

Painted in winter 1896–1897, Paris
A BOX AT THE THEATER
21⁵/₈ × 18¹/₂"
Collection Hans Mettler, St. Gallen, Switzerland

In 1897–1898 Lautrec was often to be found in one or another of the Lesbian haunts in Montmartre, particularly La Souris and Le Hanneton. Both provided him with material for drawings and lithographs. In the foreground of the present work sits Mme. Armande Brazier, proprietress of Le Hanneton, with a friend. The man in a top-hat in a box behind them is Tom, coachman to one of the Barons de Rothschild, whom Lautrec had observed and made drawings of in one of the bars near the Madeleine. Tom appears also in the background of the drawing *Chocolat Dancing*, made in March 1896, and in the poster advertising the Irish and American Bar (1896).

Here Lautrec's interest has shifted from the performers on the stage to the audience, and the contrast is nicely pointed between the solitary and intent Tom, and Mme. Armande, who seems to hold more attraction for her friend than the spectacle they are supposed to be watching. The two women are also well characterized by their hats, clothes, and expressions. Note the daring way in which the whole composition is balanced on the apex of an inverted triangle, also the false perspective of the curving partitions between the boxes and of the spatial indications in the upper part of each. These devices have enabled the artist to present this scene as a sort of bas-relief.

Lautrec also made a colored lithograph of this composition (see page 55), which was published in January 1897. The present painting, which must have preceded it, probably dates therefore from the end of 1896. A comparison of the two reveals that the same simplifications were made and that Lautrec took advantage of the change of medium to emphasize the surface rhythm of the structural elements at the expense of luminosity and characterization.

134

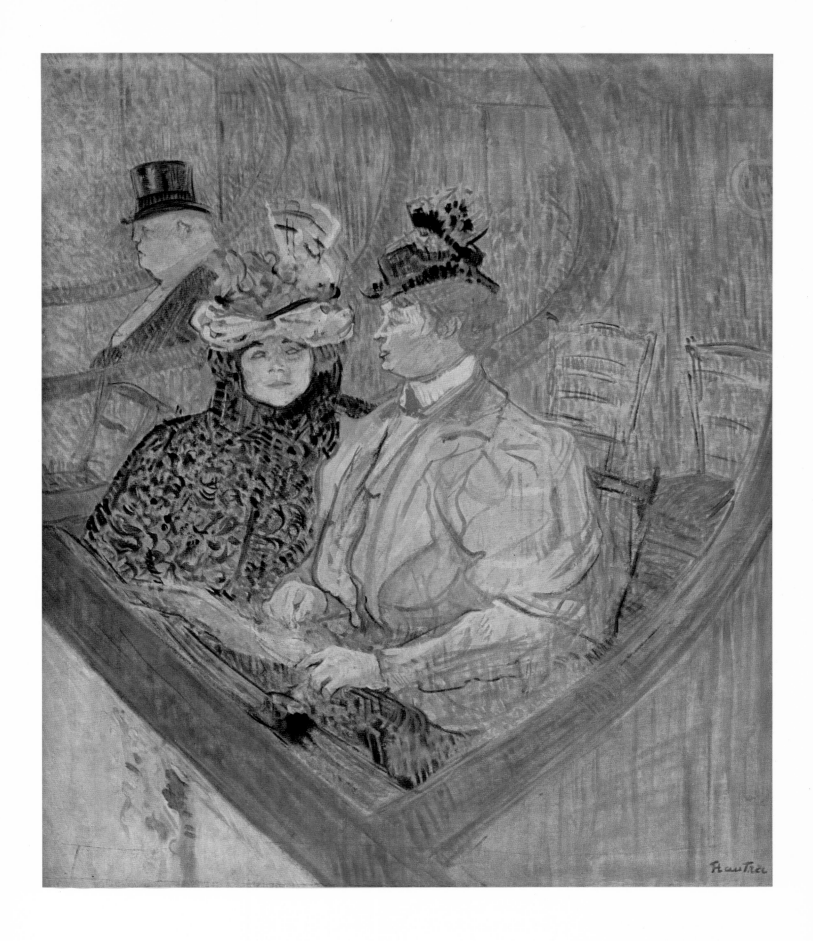

Painted in summer 1897, Paris
PORTRAIT OF BERTHE BADY
$27\,^1/_8 \times 22\,^7/_8''$
Museum of Albi

Belgian by birth, Berthe Bady made her name on the Parisian stage
in 1893–1894, acting with Lugné-Poë at the Théâtre de l'Oeuvre.
Lautrec had known Lugné-Poë since 1891–1892 (when he was sharing
a studio with Bonnard) and he always took a special interest in his
theatrical productions. Thus in 1894 Lautrec made two lithographs
of Lugné-Poë and Bady in their great roles and designed the program
for the production of *Le Chariot de Terre Cuite;* in 1896 he colla-
borated with Sérusier and Ranson in executing the décor for Jarry's
Ubu Roi, and designed programs for productions of Oscar Wilde's
Salome and *La Lepreuse* by Henry Bataille (showing Berthe Bady
in the leading role); and in 1897 he designed the program for the
production of Ibsen's *Rosmersholm.*

The Théâtre de l'Oeuvre, founded by Lugné-Poë in 1893 became
the home of the symbolist drama in Paris and Berthe Bady was one
of its leading actresses. Her great roles included Rebecca West in
Rosmersholm, Petra in *An Enemy of the People* and Kaia in *The
Master Builder* (all Ibsen), as well as Rachel in *Beyond Our Powers*
(Björnson) and Annabella in *T'is Pity She's a Whore* (Ford; trans-
lated by Mallarmé). She also played the lead in *L'Image* and *La Vie
Muette* by Maurice Beaubourg, *Einsame Menschen* by Gerhardt
Hauptmann, and *La Belle au Bois Dormant* and *Ton Sang* by Henry
Bataille, whose mistress she was for a long time.

This picture, for which a drawing also is known, is exceptional in
Lautrec's work in that it is an off-stage portrait of a famous actress.
Though lively and well composed it is nevertheless very conventional.

136

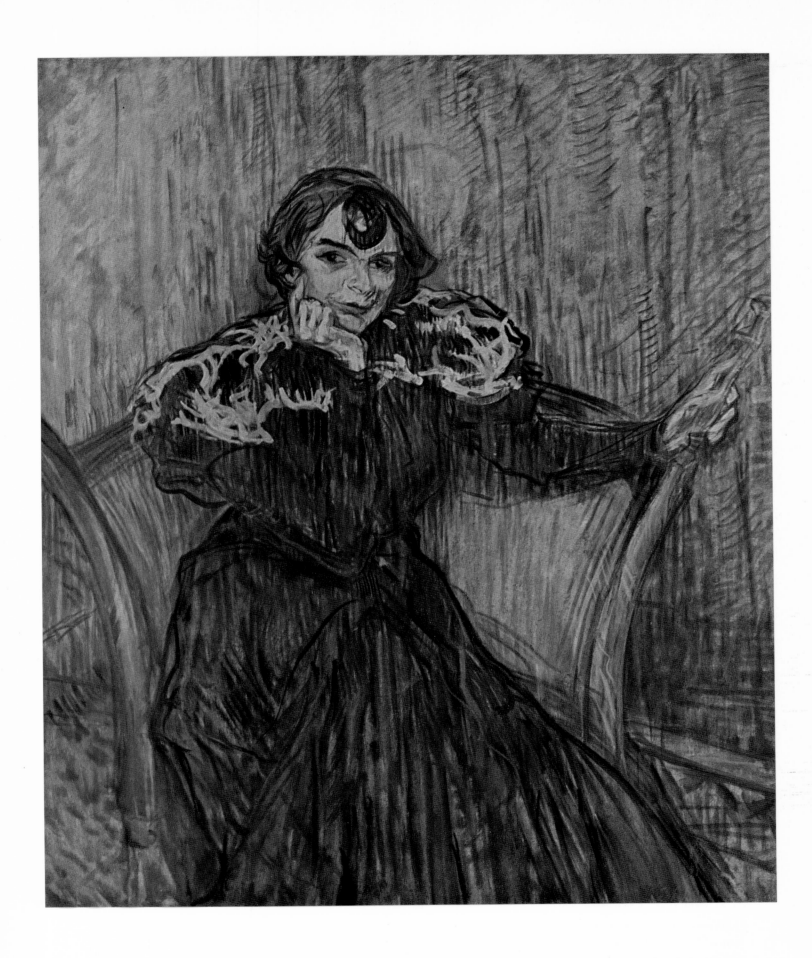

Painted in summer 1897, Paris
PORTRAIT OF PAUL LECLERCQ
21¹/₄ × 25¹/₄"
Louvre, Paris

Paul Leclercq (b. 1872), a writer, was the founder and first editor (1889–1891) of the *Revue Blanche*, though even after it had been taken over by the Natansons he retained a connection with it. His meeting with Lautrec occurred in 1894.

Lautrec began this portrait soon after moving into a new studio at 15 Avenue Frochot in Montmartre in May 1897. On the easel in the background is the (unfinished?) painting *Conquête de Passage* (Musée des Augustins, Toulouse), a composition which figured as one of the lithographs of the series *Elles* (1896; page 47). Leclercq, who became one of Lautrec's closest friends, has written a fascinating volume of memoirs, *Autour de Toulouse-Lautrec*, in which he describes the painting of this portrait: "For a month at least I went regularly three or four times a week to the Avenue Frochot but I remember clearly that I did not pose more than two or three hours in all. As soon as I arrived, he would ask me to sit in a large wicker armchair while he, wearing the little felt hat which he always kept on in the studio, would plant himself in front of his easel. Then he would stare at me through his spectacles, screw up his eyes, reach for a paintbrush and, after he had carefully studied whatever he was looking at, place a few strokes of rather liquid paint on his canvas. While he was painting he remained silent and, licking his lips, seemed to be relishing something with an exquisite taste. Then he would start singing the *Chanson du Forgeron* (a traditional French bawdy song), would put down his brush and announce peremptorily: 'Enough work! The weather's too good.' And off we would go for a walk through the quarter."

In 1898 Lautrec designed the book-jacket for Leclercq's novel *L'Étoile Rouge.*

This portrait shows clearly the influence of Whistler, an artist whom Lautrec greatly admired.

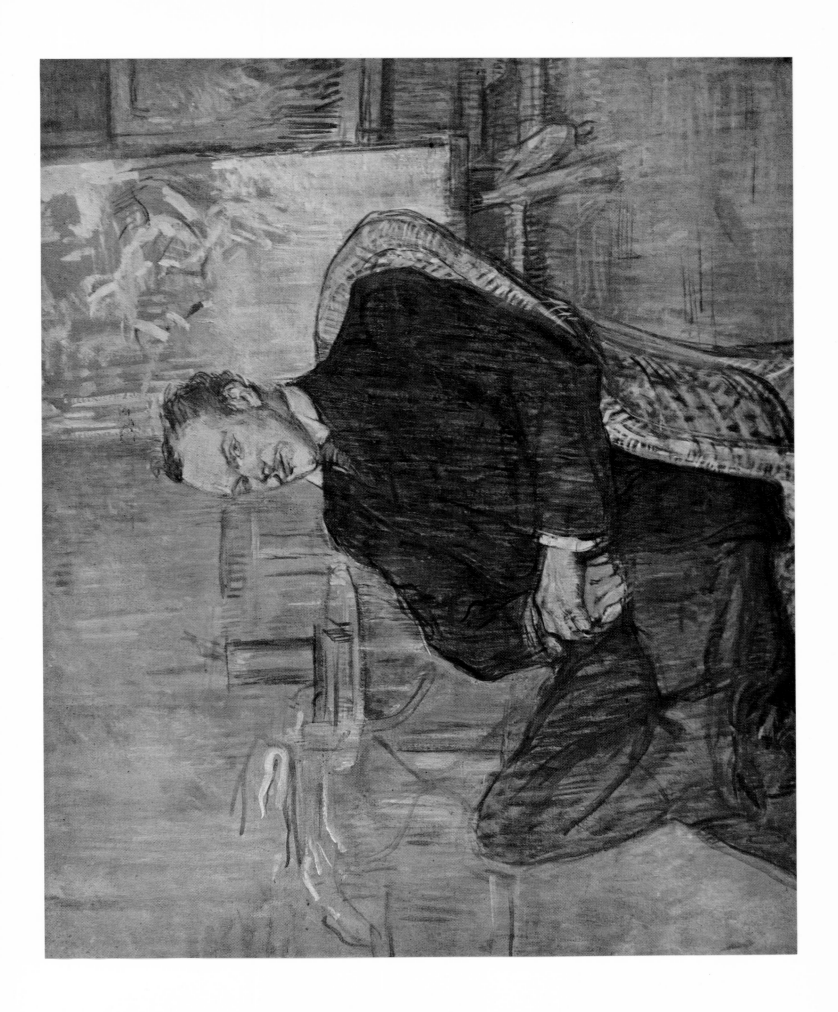

Painted in 1897, Paris
CROUCHING NUDE
18 1/2 × 23 5/8"
Collection Maurice Exsteens, Paris

One of a number of similar studies from life made at this time in which Lautrec seems to be setting himself new "impositions" (see page 78). As in the Louvre's *Woman at Her Toilet* (page 129), this picture must have been posed by a model in the studio, for it is an exercise in painting the naked body. The pose may have been copied from one of the Japanese prints in Lautrec's collection. At the same time there is an obvious suggestion of Boucher and Fragonard, that is to say that here Lautrec establishes a link between himself and the French tradition. More immediately of course the subject may have been borrowed from Degas.

This picture reveals many of Lautrec's weaknesses as an artist. The painting of the body is uncertain, and in trying to make a picture out of an academic study Lautrec has come to grief badly. The painting of the background and of the bed or divan on which the nude is crouching is so confused, flimsy, and two-dimensional that there is nothing to support the weight of the heavily modeled body. Degas never made this sort of mistake.

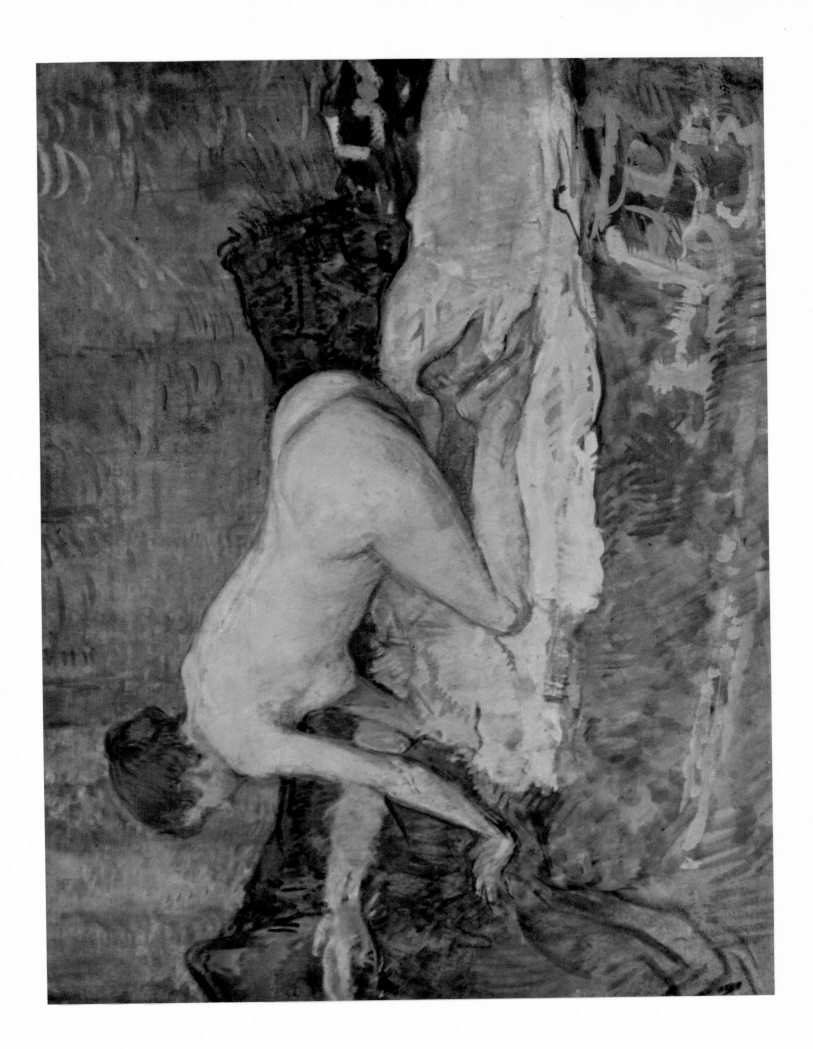

Painted in 1897, Paris
NUDE IN FRONT OF A MIRROR
$24^3/4 \times 18^7/8''$
Collection Mr. and Mrs. Ira Haupt, New York

This is one of the most curious and remarkable paintings in the whole *oeuvre* of Lautrec, for it is almost the only one in which the unpleasantness of the subject is underlined and tinged with bitterness. From here to the paintings of similar subjects which Rouault made in 1905–1908 is but a short step.

The painting here, especially of the body, is much more vigorous than that of the previous plate, and the subject has been more felt by the artist. Note the great change in Lautrec's palette: the whole tonality is darker and more resonant than before. Note too the decreasing importance of line as a pictorial element. This is the first step toward the more painterly style which Lautrec was to use in his late works.

142

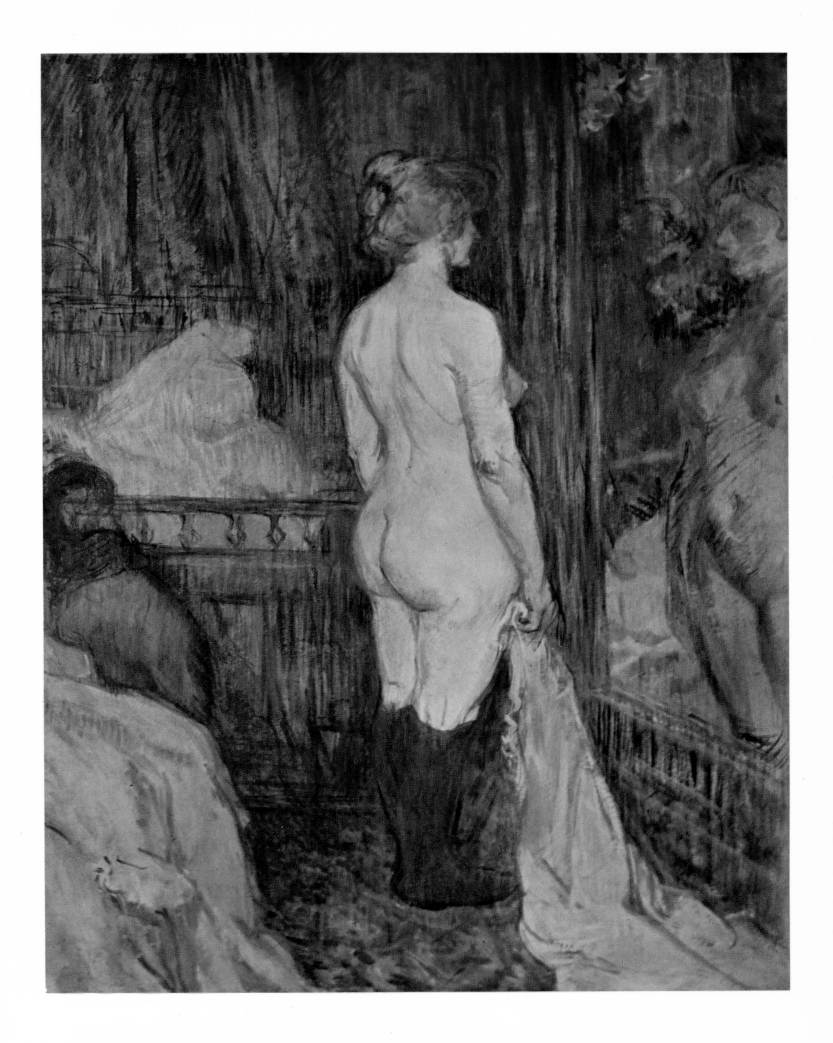

Painted in winter 1899, Paris
IN A PRIVATE ROOM AT THE RAT MORT
21 1/2 × 17 3/4"
Courtauld Institute of Art, Courtesy of The Home House Trustees,
London

This picture was painted some two years after the *Nude in Front of a Mirror* (page 143). In the interval Lautrec had passed through a crisis of alcoholism followed by a complete mental and nervous collapse. At the beginning of 1899 he had been interned for three months in a sanatorium. After his release Lautrec left Paris for a long convalescence in the country, but apart from a few pictures painted at Le Havre in July, he does not seem to have started working again seriously until he returned to Paris in November. At this time he became very friendly with Edmond Calmèse, the owner of a livery stable near his studio in the Rue Fontaine, and this friendship was reflected in a great many paintings, lithographs, and drawings of horses, carriages, dogs, and riders executed during the next twelve months (see page 27).

Lautrec was not slow, however, to yield to the temptations of the city. During his convalescence he had remained sober and had made a good recovery, but once back in Paris he rediscovered his old haunts and his dissolute companions and began to drink heavily. The present picture is a portrait of a well-known *demi-mondaine* Lucy Jourdan, and is said by Schaub-Koch to have been commissioned by her lover the Baron de W. The man on her left is not, as has been suggested, the Australian painter Charles Conder. Appropriately, Lautrec has imagined her partaking of a tête-a-tête supper in a private room at a fashionable restaurant Le Rat Mort in the Rue Pigalle.

This is one of the best examples of the painterly style which Lautrec developed during the last two years of his life. Gone is the biting, swinging line of his earlier work; here he has begun to rely on tonal values.

The result, Lautrec's nearest approach to traditional *belle peinture*, is less incisive than before, but in some ways subtler. The effect of the light shining through the gauze head-dress and catching the auburn hair, the slit eyes, and the contemptuous smile of the woman is managed with considerable mastery. The handling of the still-life, on the contrary, is clumsy. *Gens Chics* of 1893 represents a similar subject handled in Lautrec's earlier manner.

144

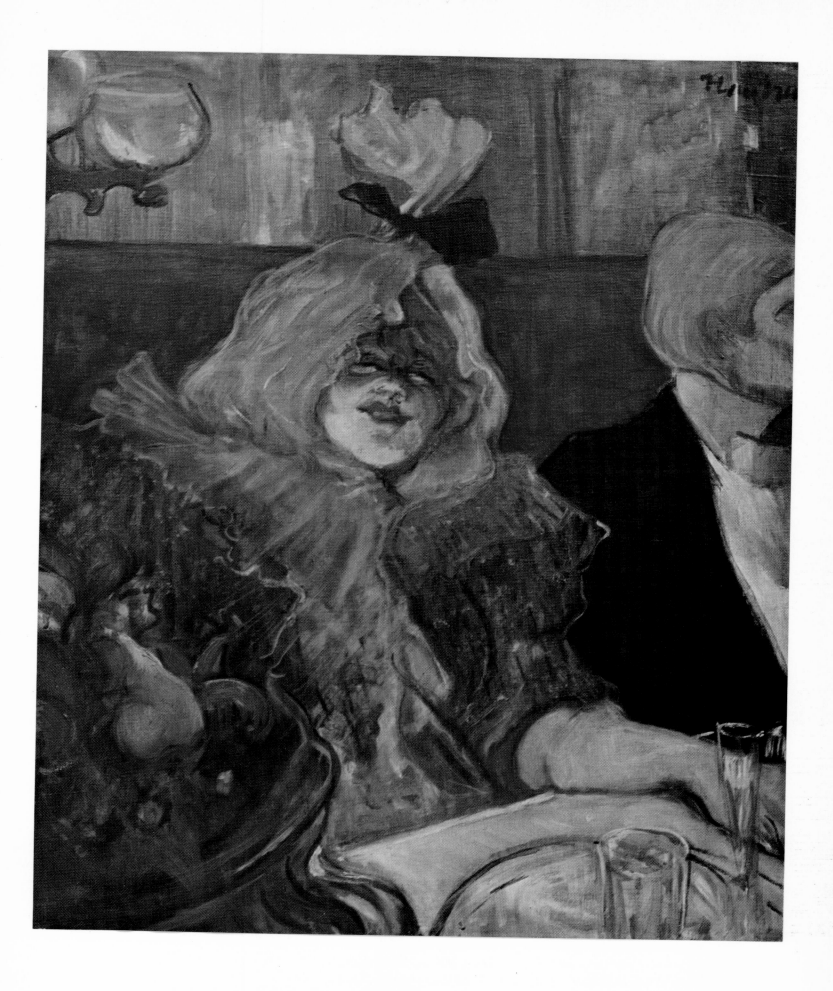

Painted in spring 1900, Paris
WOMAN AT HER TOILET: MME. POUPOULE
24 × 16"
Museum of Albi

Here Lautrec takes up again a subject which he had treated more than ten years earlier (page 85). There is, however, a great difference in treatment between the two works. In the earlier picture Lautrec was concerned with emphasizing the character of the woman and her artifice, whereas here he has been interested in finding the correct tonality for the painting of her hair and her dressing gown. In this picture Lautrec pays homage to Manet as well as to Degas, but unfortunately he had neither the virtuosity of the one, nor the superb craftsmanship of the other. This is not merely a colorless picture, it is also flat and lacking in vitality. One need only turn the pages of this book to discover how monotonous and subdued Lautrec's use of color was in his paintings: in his lithographs exactly the opposite was the case.

This picture is generally dated 1898, but there exists another version of this subject, very similar in style and coloring and with the same woman (though seen from a slightly different angle), which is signed and dated "1900." There seems good reason therefore for revising the date of the present work.

146

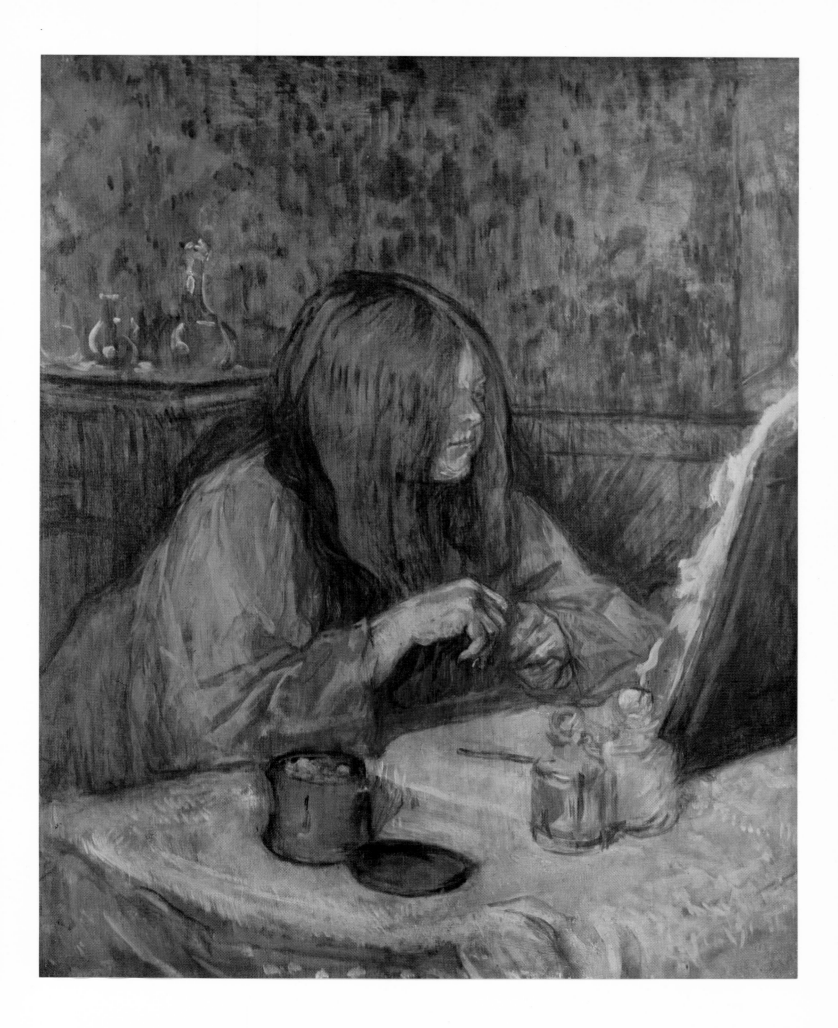

Painted in spring 1900, Paris
THE MODISTE
24 × 19³/₈″
Museum of Albi

Among the schemes thought up by Lautrec's friends to provide distraction and prevent him from drinking was that of interesting him in the displays at the fashionable dressmakers in the Rue de la Paix. But Lautrec found the whole atmosphere artificial and the poses of the mannequins too studied to be of interest to him artistically. He did, however, paint this portrait of a friend who was a *modiste*, Mlle. Renée Vert (Mme. Le Margouin), who had a shop at 56 Faubourg Montmartre. Lautrec had known Renée Vert for many years – he had made a drawing of her arranging hats in her shop in 1893, and had subsequently used this as a menu decoration – because she was the mistress of his friend Joseph Albert, a painter (page 76). Albert had been responsible for introducing Lautrec's work into the Salon des Artistes Indépendants in 1889, and in 1893 had sponsored the inclusion of two of his posters at the Salon des Peintres-Graveurs Français. In recognition of these kindnesses, Lautrec made a lithographic portrait of Albert entitled *Le Bon Graveur* (1898) and several drawings of Renée Vert in 1899–1900.

It is interesting to compare this picture with *The Laundress* (page 81), which resembles it in many respects. In the present work the handling of the paint is freer and the effect of light better.

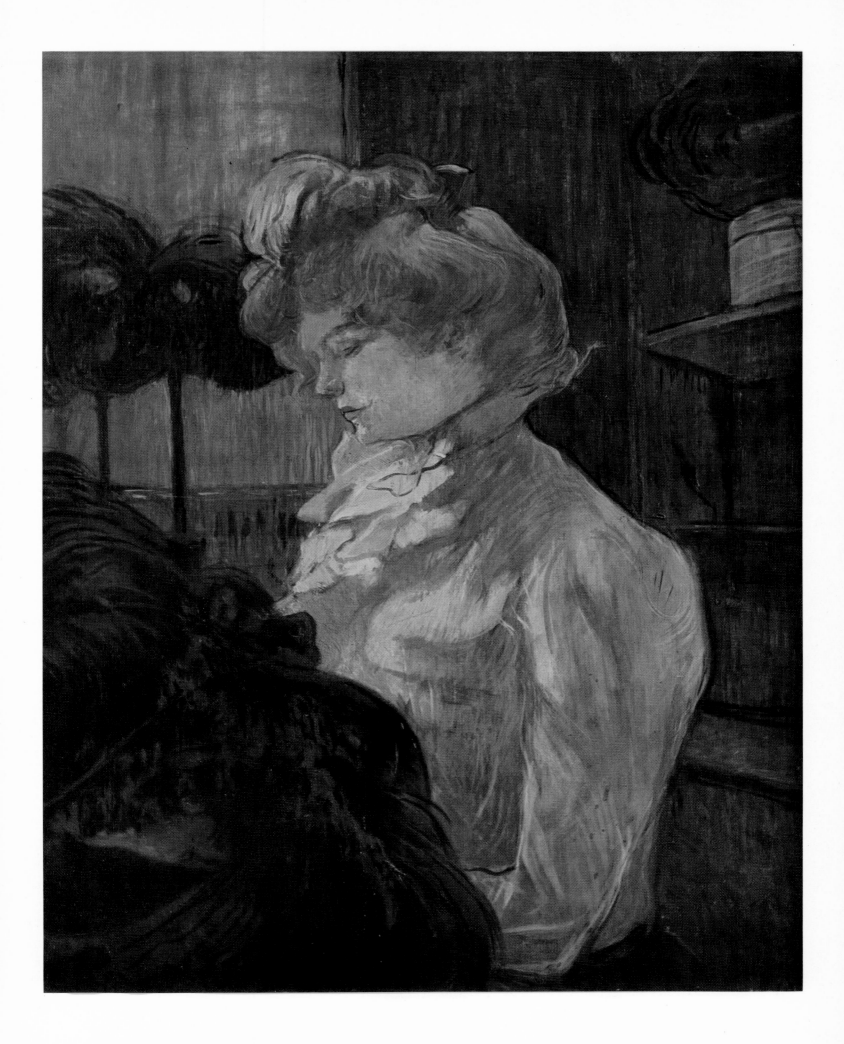

Painted in spring 1901, Bordeaux
"MESSALINA"
38 1/2 × 31"
Collection Henry Pearlman, New York

In May 1900 Lautrec left Paris once more to spend several months
in the country at Malromé and elsewhere. But instead of returning
to Paris he moved to Bordeaux in December and took a studio in
the Rue Porte-Digeaux. There he began to interest himself again in
the theater and went regularly to the Opera. He saw first a revival
of Offenbach's popular operetta *La Belle Hélène*, with an actress
called Mlle. Cocyte in the leading role. At once he made several
drawings of this production and wrote to Maurice Joyant, his friend
and dealer in Paris: "Here *La Belle Hélène* is delighting us; it is
admirably staged. I have already caught the spirit of it." Not long
afterwards he attended the opening performances of a new operetta,
Messaline, by Isidore de Lara, in which the leading role was taken by
Mlle. Ganne. This production appealed to him even more, for he
set to work seriously to make some pictures of it and wrote again
to Joyant: "Have you any photographs, good or bad, of *Messaline*
by de Lara? I am enthralled by this show, but the more documen-
tation I have the better I shall be able to work." However, Lautrec
was drinking heavily and spending much time in brothels, so that his
work did not progress as fast as he hoped. Then in March 1901 his
health broke down again and for a while he had to stop painting.
Nevertheless by mid-April he had completed no less than six pictures
of *Messaline* which he sent off to Paris. Thus the present painting was
executed some time between December 1900 and April 1901.

Unfortunately Lautrec's last pictures cannot be regarded, as some
writers would have us do, as heroic attempts at self-renewal; on the
contrary, they are a sad, and not too prolonged, end to a short but
brilliant artistic career.

Brief Bibliography

Catalogues

Adhémar, Jean, *Oeuvre graphique de Toulouse-Lautrec*, Paris: Les presses artistiques, [1951]. (Catalogue of exhibition held in the Bibliothèque nationale.)

Toulouse-Lautrec: His Lithographic Work [New York: 1950]. (Catalogue of the loan exhibition of the collection of Ludwig Charell for the benefit of the Museum of Albi, at the galleries of M. Knoedler & Co., Mar 22–April 15, 1950.)

Delteil, Loys, *Henri de Toulouse-Lautrec*, Paris: Privately printed, 1920 (Vols. X and XI of *Le peintre graveur illustré*).

Dortu, M. G., *Toulouse-Lautrec*, Paris: Editions des Musées nationaux, 1951. (Catalogue of exhibition held at the Orangerie des Tuileries, May-August, 1951 to commemorate the fiftieth anniversary of the artist's death.)

Exposition Henri de Toulouse-Lautrec, [Paris: 1931]. (Catalogue of the exhibition of April 9–May 17, 1931 at the Museum of Decorative Arts, Paris, for the benefit of the Société des amis du Musée d'Albi.)

Julien, Edouard, *Toulouse-Lautrec au Musée d'Albi*, Albi: Impr. coopérative du Sud-Ouest, 1952.

Monographs and Articles

Adhémar, Jean, "Lautrec et son photographe habituel," in *Aesculape* (Paris), December, 1951, pp. 229–34.

Astre, Achille, *Henri de Toulouse-Lautrec* (with an introduction by Gustave Geffroy), Paris: Nilsson, [1938].

Coquiot, Gustave, *Lautrec*, Paris: Auguste Blaisot, 1913.

Duret, Théodore, *Lautrec*, Paris: Bernheim-Jeune & Cie., 1920.

Esswein, H. & Hymel, A. W., *Henri de Toulouse-Lautrec*, Munich: R. Piper, 1905 (Vol. III of *Modernen Illustratoren*); Munich and Leipzig: R. Piper, 1912.

d'Eugny, Anne, "Toulouse-Lautrec et ses modèles," in *L'Amour de l'Art* (Paris), No. 7, 1946, pp. 188–95.

Jedlicka, Gothard, *Henri de Toulouse-Lautrec*, Berlin: B. Cassirer, 1929; Erlenbach-Zurich: E. Rentsch, [c. 1943].

Jourdain, F. & Adhémar, J., *Toulouse-Lautrec*, [Paris]: P. Tisné, [1952] (Collection Prométhée).

Joyant, Maurice, *Henri de Toulouse-Lautrec* (2 volumes), Paris: H. Floury, 1926–1927.

Landolt, H. P., *Henri de Toulouse-Lautrec: Drawings and Sketches in Color*, New York: Macmillan, 1955.

Leclerq, Paul, *Autour de Toulouse-Lautrec*, Paris: H. Floury, 1921; Geneva: P. Cailler, 1955.

Mack, Gerstle, *Toulouse-Lautrec*, New York: A. A. Knopf, 1938.

Natanson, Thadée, *Un Henri de Toulouse-Lautrec*, Geneva: P. Cailler, 1952.

Novotny, Fritz, "Drawings of Yvette Guilbert by Toulouse-Lautrec," *The Burlington Magazine* (London), June 1949, pp. 159—63.

Tapié de Céleyran, M., *Nôtre Oncle Lautrec*, Geneva: P. Cailler, 1953.